Found Tribe

Found Tribe

edited by
Lawrence Schimel

STARMAN FISHER Publishing

Acknowledgments:
The editor gratefully acknowledges the publications in which some of these stories, often in different versions, first appeared. The specific acknowledgments appear on page six.

Book Design: Judith Rafaela
Cover Design: Janice St. Marie

ISBN 1-890932-20-5
First edition
Printed in Canada

Library of Congress Cataloging-in-Publication Data

Found tribe : Jewish coming out stories / edited by Lawrence Schimel.--1st ed.
 p. cm
 ISBBN 1-890932-20-5
 1. Coming out (Sexual orientation)--United States. 2. Jewish gays--United States--Biography. 3. Gay men--United States--Biography. 4. Gay men's writings, American. I. Schimel, Lawrence.

HQ76.2.U5 F68 2002
305.38'9664--dc21 2002018521

Sherman Asher Publishing
PO Box 2853
Santa Fe, NM 87504
Changing the World One Book at a Time™

For Michael Lassell,
whose friendship remains dear
from across the ocean...

Acknowledgments

"Introduction" © 2002 by Lawrence Schimel. Published by permission of the Author.

"Fighting in Restaurants" © 2002 by Jonathan Wald. Published by permission of the Author.

"Pink Triangles and Yellow Stars: Growing Up Jewish and Gay" © 1995 by David Bergman. First published in *Men's Style*. Reprinted by permission of the Author.

"My Journey Home Leads Through the Trees" © 2002 by Andrew Ramer. Published by permission of the Author.

"Salt" © 1996 by Arnie Kantrowitz. Adapted from *Under The Rainbow:Growing Up Gay*, St. Martin's Press. Reprinted by permission of the Author.

"Redefining Passover" © 2002 by Andrew Martin. Published by permission of the Author.

"Myself, My Family, and the World" © 2002 by Julian Padilla. Published by permission of the Author.

"House of Worship—Coming Out to My Brother on Passover"© 2002 by David Rosen. Published by permission of the Author.

"Choreographer"© 1986 by Edward M. Cohen. First published, in an earlier version, in *Out* Magazine under the title "Father Knows Best." Reprinted by permission of the Author.

"My Father's Tatoos or Family Outing" © 2002 by Lawrence Schimel. Published by permission of the Author.

"A Scout Is..." © 2002 by David Ian Cavill. Published by permission of the Author.

Contents

Introduction

Lawrence Schimel

For many years, Jewish gay men have often felt isolated from their religious background or have had to remain in the closet, leading many to feel as if they were wandering alone in a spiritual or emotional desert, cut off from both the present and the past, in an exile that was sometimes self-imposed out of fear of rejection or was, more often, actively enjoined by the community. Today, no longer necessarily forced to hide either their sexual or religious identity, Jewish gay men are finding space and acceptance within both the Jewish and gay communities, in addition to creating their own communities that are both queer and Jewish.

The road of acceptance or sense of self is not, and has not been, an easy road for gay Jews. As Jews we are intricately tied to the past of our entire people; each Passover, this history is made personal when we say, "when *I* was a slave in Egypt" and not "when the Jews were slaves in Egypt." *Found Tribe* is an attempt to collect some of our Jewish gay history, to serve as a reminder of various parts of our struggles for freedom, and to help create understanding and bridges to a future of acceptance. I envision a future where even non-homosexual Jews might, as during the seder, claim these personal stories as part of the general Jewish history and part of the social responsibility of every Jew to fight for freedom, and not just for oneself but for all.

Despite the general absence or mention of lesbian acts or relationships in the Torah, especially when compared to the specific commentary and prohibitions focusing on homosexual acts between men, until recently our Jewish lesbian sisters have been much more progressive and vocal in writing about their queer Jewish lives than their Jewish gay male siblings, whether in books devoted exclusively to the subject, such as Evelyn Beck Norton's landmark anthology *Nice Jewish Girls: A Lesbian Anthology* published in 1982, in the inclusion of lesbian concerns within the larger focus of Jewish feminism, or in fictional works reflecting lesbian Jewish lives

by authors such as Judith Katz, Elena Dykewomon, Sarah Schulman, Karen X. Tulchinsky, Lesléa Newman, and many others. I mention this as part of the explanation why *Found Tribe* restricts itself to expressing the voices of gay Jewish men only, whose struggles and experiences have not often been heard (in particular the emotional damage that many men face when confronted with the Leviticus passage); this book is greatly indebted to the struggles and groundwork laid by these aforementioned women, to the co-gendered books and projects such as Christine Balka and Andy Rose's important *Twice Blessed: On Being Lesbian, Gay, and Jewish*, and to the many mixed-gendered Jewish groups, organizations, and synagogues that today exist to nurture and support Jewish queers.

At the same time, I feel it is important for both the Jewish community and the gay community to focus on some of the issues specific to being both a gay man and Jewish, and the various ways men have managed to reconcile the possible conflicts between these two identities, on both religious and social levels.

Both for Jews and for homosexuals, the act of naming is an important ritual, for defining oneself on both a personal and a public level. Jews and homosexuals have often been subject to abuse, both physical and verbal, simply for being, and must struggle to find and maintain a sense of self-worth in the face of such hostility. Being able to embrace both of these identities without shame, to proudly name ourselves as members of these two communities, is an important step that gives many of us our personal sense of dignity and history.

Names hold power, and thus the declaration of a name—to take on one's Hebrew name, to declare "I am gay"—can bring with it a sense of one's belonging. But names can also be used for exclusion, to restrict. Who has the right to bestow or deny the name of Jew (or gay) is an important question and one that continues to be a struggle for many, especially when the interests of the individual are perceived to be in conflict with those of the community. Bringing together these stories by men who define themselves by these two powerful names will, I hope, be a small monument of the gay

Jewish communities and help inspire others who are still in the process of finding their own names and the strength of voice to declare them.

While many people consider the act of "coming out" to be restricted to the provenance of sexuality, in the ultra-secular worldview that predominates gay subculture today, coming out as "religious" is often met with the same prejudice, hostility, and misinformation and misunderstanding as declaring one's homosexuality can provoke in the heterosexual mainstream culture. *Found Tribe* considers the negotiating of these two identities—gay and Jewish—from a myriad of perspectives, without intending to prioritize any over another.

Especially in the U.S., where Jewish culture and traditions are predominantly Ashkenazi, there is a pervasive sense of singularity associated with the label Jewish, instead of the vast plurality of traditions and experiences of Jewish life and history.

Likewise, the label gay for most people, regardless of their sexual-orientation, presupposes certain facts and assumptions about the person thus denominated and his sexual practices, which may or not be the case.

The question of sex is one that every gay Jew must grapple with. Various interpretations declare that certain acts between men are specifically forbidden, but homosexual relationships, per se, are not prohibited. And there is a gray area of sexual acts that are not explicitly mentioned, which may be permissible.

The question of sex is also one that seems omnipresent in gay subculture, particularly when compared to non-gay communities. Which can make the issue of sex especially fraught with emotional difficulty for Jewish homosexuals.

The gay sexual media fetishizes almost every other "minority," yet Jews are conspicuously absent from gay pornography, which subtly promulgates and promotes a myth that Jewish men are not sexually desirable. Video pornography continues to prioritize a blond, California "surfer boy" look, although increasingly, and in large part thanks to the "bear movement," dark-haired men with chest hair (the look of many Jewish men of Eastern-European heritage) are more and more often portrayed as desirable. I'm still wait-

ing for a porn actor to have an openly Jewish surname (whether it is a pseudonym or not). My anthology *Kosher Meat* was a small attempt to redress the balance and introduce Jewish sexuality into the gay erotic subculture, at least the print component thereof. Although it challenges the Jewish tenet of sexual modesty, I think it is vitally important for us to have Jewish gay male role models that are both sexual and sexy, to counter the generally sex-negative and often homophobic messages we are bombarded with by the society at large, not to mention the (subliminal) emotional repercussions of our absence from the gay sexual media. When confronted with magazines with titles such as *Foreskin Quarterly*, it's easy for Jewish gay men to feel inadequate or develop an internalized anti-Semitism in the face of a gay culture that eroticizes a scrip of flesh that they, as Jews, lack. (While many non-Jews are also circumcised, they do not struggle with the same internal conflict provoked by the religious inevitability of the Jewish covenant with G-d that circumcision honors.)

But while sex is perhaps the most visible /conflict/ between Judaism and homosexuality, it is by no means the only dilemma with which gay Jews must grapple. Family is such an important fundament of Jewish life and upbringing, and how to find acceptance from one's family or create a family of one's own is an important concern of almost all the writers herein.

The stories in *Found Tribe* offer a type of midrash, the commentary and interpretations of men who grapple with this question of sex and sexuality and with other parallels and differences between the identities of gay and Jewish: questions of assimilation, of gay activism and the Jewish sense of tikkun olam, of defining oneself and one's family, and much more. I hope this collection helps bring strength, courage, and comfort, to Jews and non-Jews of every sexual orientation: for men who are struggling to come out as gay or reconcile their Jewish background with their secular identity; for parents and siblings trying to learn to accept the sexual orientation of a child or brother; for congregations trying to combat homophobia and embrace and welcome their fellow Jews; for non-Jews looking for insight into and understanding of the lives of their partners, friends, and family. The tribe is waiting for you, with open arms.

Fighting in Restaurants

Jonathan Wald

FIREFLY
San Francisco
1997

Ten years after I came out to them, my parents and I were having Passover dinner at a hip San Francisco bistro called Firefly, and we were having our worst public fight ever. We'd been arguing for years, my parents and I, about love, and most of our arguments took place in restaurants: the better the restaurant, the worse the fight. Sometimes the argument would continue in the car on the way home; but once we unlocked the front door and stepped into the house, that was the end of the conflict. We'd go to our rooms, shut our doors, and never mention the fight again.

That night at Firefly, ten years after I told my parents I was gay, the waiter brought us upscale Jewish comfort food—brisket, roast chicken, crispy potatoes, and matzo ball soup—and I asked my mom and dad if they thought parents always loved their children.

"No," said my father.

"No," said my mother.

I was stunned. Not by their answer, which I'd feared for years— I was stunned that they'd actually, finally admitted it. This night, it seemed, was going to be different from all other nights. I took a deep breath and got more specific.

"Is there anything I could do that would make you not love me?"

"Of course not," said my dad.

My mother said nothing. I stared at her. She avoided my eyes.

"Is there?" I repeated.

The smell of our food was rich and comforting, and I was on the verge of tears. My mother looked around, as if for a way to escape. She couldn't find one. So quietly, to herself as much as to me, she admitted: "There's nothing your sister could do, but there is something you could do that would stop me from loving you."

My throat tightened. I could barely breathe. Something unspoken for ten years— something felt but never said—was finally coming out into the open.

"What could I do—" I managed, my teeth clenched and my voice higher than usual, "that my sister couldn't—that would stop you from loving me?"

IRONWOOD CAFÉ
San Francisco
1987

My dad eventually ran out of questions about my first year of college. He and I were having a rare dinner alone—my mother was out of town on business—and without a third person's contributions, our conversation flagged. To cover the silence, dad focused on his food. He took a sip of his merlot. He looked oddly nervous as he examined his cassoulet. And then he asked me if I was dating anyone.

It was the summer after my freshman year, ten years before that night at Firefly. I'd come out to myself and my friends earlier that year, and now I needed to tell my parents the secret I'd known since I was nine. We all knew there was something we weren't talking about, and the avoidance was becoming unbearable. But I was deeply afraid of their reactions, so I made excuses. I came up with a policy about my sexuality: I shouldn't be required to volunteer the information, but if someone asked me about my sexuality, I promised myself that I wouldn't lie.

My father's question was the opening I had waited for, and it came as a surprise. After all, I'd been training my parents for years not to ask me about my life. When I realized I was gay, I started keeping secrets from my parents. It must have been painful for

them, feeling us grow apart, but saying nothing was better than facing the rift that I imagined the truth would create between us. So throughout grade school and high school I volunteered less and less about my life, and my parents asked me fewer and fewer questions. When they did ask, I barked shorter and sharper answers, until finally I stopped answering at all. By the time I went off to college, my parents knew better than to ask me personal questions.

So when my father asked if I was dating anyone, I should have been relieved, grateful; but instead, I was taken aback. Faced with the reality of my impending confession, I panicked.

"No," I snapped. I dug into my smoked pork tenderloin with sweet corn, artichokes, and cherry tomatoes. My dad looked pained.

And in the silence that followed, I got very scared. I realized that dad's question might be the best chance I would ever get, and that my rebuff might scare him away from ever asking me anything again. So even though he hadn't explicitly asked me if I was gay, I tried to pretend that he had. Only one other table at the Ironwood Café was occupied—our cozy neighborhood bistro would soon close down and be replaced by a stellar Asian fusion café—and I fervently wished the restaurant were louder, so that I could be less conspicuous. I prayed that the waiter would stay away. I took a deep breath, looked down at my food, and whispered, "I have something I need to say."

My father was a good liberal Jewish intellectual, who did what he thought others wanted of him. He went to college in the sixties, marched in the segregated South, and dedicated himself to public interest law, representing abused and neglected children. Dad believed equally in doing right in the world—supporting civil rights, women's rights, and gay rights—and doing right by his family—showing his wife and children unconditional love.

My mother was a good liberal Jewish intellectual too. A lawyer like my father, mom sued the federal government over the misuse of public lands. She too grew up in the sixties, and she too was an ardent believer in civil rights. And most of the lawyers my mother worked with were gay. So my parents' politics required them both to be gay-friendly, at least in theory.

Dad took my admission fine, that night at the Ironwood. He listened thoughtfully, he said he loved me no matter what, and I believed him.

I never actually told my mom.

GREENS
San Francisco
1987

A few weeks after I came out to my dad, I volunteered at a fundraiser for my mother's law firm. I was assigned to hand out nametags to the wealthy guests at the front of the Greens, right by the Zen Bakery bread counter. It was an easy job, and I was staring out the picture windows at the Golden Gate Bridge when a couple of my mother's colleagues came up to me. They knew I was about to leave San Francisco to spend the summer in New York City, and they had a question to ask me.

"Are you going to spend a lot of time in the West Village?" one of the men ventured.

I had no idea what he was talking about.

"I guess so," I responded. They looked at me expectantly; I looked back confused. "There are other nice areas in New York too," I elaborated.

The lawyers smiled at each other, and then walked over towards my mother. I could tell that they were talking about me, and I wondered why. I tried to hear what they were saying. A waiter blocked my view of them with his tray of modern vegetarian hors d'oeuvres. A donor came up to the table and asked for her nametag. I went back to work.

It wasn't until I got to New York and went to the West Village for the first time that I understood what had happened: my father had told my mother I was gay, and my mother had told the gay attorneys at her firm. I was pleased—obviously, I thought, neither my father nor my mother had an issue with my sexuality. End of problem.

STARS CAFÉ
San Francisco
1991

My mother called the waiter over to complain that her water glass hadn't been filled. I slumped down in my chair, mortified. "Don't be embarrassed," she said. "If we're paying this much money, the service should be perfect."

My parents were more Jewish than they would ever have admitted, certainly more Jewish than they would have liked. They hated religion on principle, as the cause of strife in the world. My father had been Bar Mitzvahed, and our family went to Passover Seders, but it was more for the Jewish love of food—the Brest's amazing roast potatoes and the Rosenhan's chopped liver—than it was for the ceremony, which got shorter and shorter every year.

My sister hated religion too. She was—and still is—much more interested in boys and horses. When she was 13, her Girl Scout leader wanted the troop to sing Christmas carols, and asked any Jews in the group to raise their hands. No one did, until finally my sister's hand crept up slowly.

"Jennifer," queried the sensitive troop leader, "are you Jewish?"

"No way!" My sister was indignant. "Somebody in my family is Jewish, but it isn't me. I think it's my brother."

And it was. In fact, I'd convinced my parents to send me to Hebrew School because I was gay. My mother and father couldn't comprehend their nine-year old son's request, and I certainly couldn't tell them the truth: that I felt guilty that I would never have children, that I wouldn't pass on the family name. I thought, at least I can pass on this other male family tradition, the Bar Mitzvah. That, I thought, would make my parents love me.

But having a Bar Mitzvah didn't change my relationship to my parents, and neither did coming out. I continued to hide from my parents, particularly about dating and sex. We kept up our innocuous talk of politics, art, academics. My parents grew accustomed to my secretiveness, and learned about film and theater and art history so they could have something in common with me. And

knowing that I loved good food, they frequently took me out to eat at top notch restaurants—the better the restaurant, the longer the meal, and the more time they got to spend with me.

I could have been more moved by their caring. Instead, I battered them with questions.

That night at Stars Café, we were surrounded by women in gowns and men in tuxedos, the glitterati of San Francisco on their way to the opera. My mother watched every couple that went by with fascination; my dad considered ordering another bottle of wine; I was about to explode. My free-range chicken with apricot salsa was growing cold, and my voice was way too loud: Why hadn't they questioned me about my personal life when I was in high school? Hadn't they suspected that I was gay? Didn't they care enough to ask?

I would never have admitted that, as hard as I had encouraged my parents to ask, I had pushed them away even harder. In my mind, I had begged my parents throughout my teens to ask me about being gay. I'd left gay pornography in my room; I'd brought a gay friend home; I'd pleaded to stay up late to watch a TV movie about AIDS. I was furious that they hadn't gotten the hint and confronted me about my sexuality.

Now, four years after I came out to my father, something was still making me very mad, and I couldn't stop myself from picking fights. I pushed the issue: "When I was in high school you never asked me anything. I wanted you to ask!"

"We didn't want to pry," my mother countered, hurt and defensive.

"People who love each other ask each other questions!" I yelled.

The opera-goers stared at us, a pitiful crying family. Their looks were clear: we were not worthy of grand opera; Stars Café was not a stage; we weren't in a scene, we were only making one.

My mother looked like I'd slapped her. "You didn't know that we loved you?"

"No." I spat. "You didn't act like it! You never seemed interested in me. How could I have known?"

My mother tried not to cry.

AUREOLE
New York City
1994

For most of the ten years after I came out to my parents, I
didn't know why these questions I kept asking were so important to
me. They were obviously painful to all of us, and my parents re-
peatedly refused to answer them. Yet I would not stop asking. Like
a shark, I bit in and would not let go. When one line of questioning
failed, I actively searched for new variations, new ways of getting
my mom and dad to admit something I was afraid even to think
about.

And in 1994, I finally made progress. I was living in New
York at the time, and my parents had flown to the East Coast to see
the opening night of a play I'd directed. The play was a disaster
and I knew it, a poorly conceived production poorly executed. Af-
terwards, I stood in the lobby, watching the meager audience file
out, and I waited in terror of my parents' reactions. My dad emerged
first, and offered me genuine congratulations. He was as enthusi-
astic as always about my work, and I was grateful for his compli-
ments. My mother said nothing.

Our celebratory dinner at Aureole was the most expensive
meal we'd ever had, and I was determined to ruin it. I looked down
at my pan roasted pheasant with crisp confit spring rolls, melted
cabbage, forest mushroom ragout and aged balsamic vinegar, and I
asked my parents if there was anything I could do that would dis-
appoint them.

My mother ignored my question and stared at the table next
to us, where a group of young Wall Street lawyers were showing off
to each other and to their girlfriends, buying bottle after bottle of
three and four hundred dollar wines.

I tried to regain my mom's attention. "You're embarrassing
me," I snapped. One of the lawyers was about to top off his half-
full glass of cabernet with a bottle of merlot. His girlfriend was
skeptical. My mother shushed me.

"Maybe," said Wall Street's girlfriend, "you shouldn't mix
those."

I told my mother she was being rude. She continued staring at the next table.

"Don't worry, baby," said Wall Street. "They're both good!"

My mother shook her head contemptuously. I raised my voice and repeated my question: "Is there anything I could do that would disappoint you?"

My mother finally turned back to me. She narrowed her eyes and looked as if she were making a complex calculation. I felt confused and inarticulate. "Why," she finally allowed, "do you want to know?"

"Because," I sputtered. "I already feel like I'm disappointing you, I just don't know why. I figure if we put it on the table, at least we'll be able to deal with it."

My father continued to insist that nothing I could do would disappoint him. But my mother looked thoughtful. The cheese plate arrived.

"Well," my mother admitted, when the waiter had described the options and whisked away, "I guess there is something you could do that would disappoint me."

My mouth opened and closed. My father shifted in his chair uncomfortably.

My mother spread a piece of morbier on a slice of freshly baked bread and continued: "It would disappoint me if you became a lawyer. It's not your calling. Be an artist. Express yourself. That's what I think you want."

I wanted to keep talking, but my mother's tone said the discussion was over. After dinner, my parents went off to their hotel, and I headed to a lower east side porn theater, to satisfy an overwhelming urge to have sex.

I skipped the movie and headed directly downstairs, to the dark, maze-like warren of rooms. My breathing was shallow and my cheeks flushed as I followed the first man who propositioned me into a cubicle. He immediately turned my face to the wall.

I had made two firm rules about what I wouldn't do sexually: I wouldn't swallow cum and I wouldn't get fucked in public. I turned back around and leaned in to kiss the man, but he backed away. He shook his head slightly and ripped open a condom. It was fucking

or nothing. I tried to speak, but I couldn't say a word. The man took my silence as acquiescence.

He turned me back towards the wall, and began fucking me, painfully. Roasted pheasant and three types of sorbet churned in my stomach; the man thrust harder and harder; I held tight to the wall and tried not to vomit up the best food New York City had to offer.

The man left after he came, and I followed him outside. I tried to strike up a conversation; I offered to go home with him; I attempted to give him my phone number. The man got in a cab and sped away.

For the rest of the night, I lay awake in bed, terrified. I thought about the evening: the play, the dinner, the sex. I knew without question that if I didn't change my life somehow, I was going to kill myself.

FIREFLY
San Francisco
1997

So that year I moved back to San Francisco, minutes from my family's house. And for the next year I didn't have sex, I didn't make art, and I rarely saw my parents, refusing as many of their repeated dinner invitations as I could. I was paralyzed—until that night at Firefly.

My mother's admission shocked us all into silence. My father was staring at his brisket. I was desperate not to cry.

"What could I do," I managed to whisper, "that my sister couldn't, that would stop you from loving me?"

My mother looked trapped. She looked down at her plate. "Well." she finally continued. "You could be careless, and get sick."

For a long moment, none of us spoke. I understood her euphemism. I knew she was saying I could have unsafe sex, and get AIDS. But I also knew that wasn't what we were really fighting about. My mother didn't mean she wouldn't love me if I got sick—she would have been the first person at my bedside if I had any

kind of illness. No, she was talking about something far deeper, something going back years and years.

I looked at my mother. I was remarkably calm and clear as I said, very quietly, "My sister could do that too."

"Oh," said my mother. "Oh." The significance of the conversation sank in. "You're right." She placed her knife gently onto her plate and sat back in her chair.

My parents and I never had another public argument.

IN-AND-OUT BURGER
Los Angeles
1999

A year later, I moved to Los Angeles to go to film school. I also had my first short story published, in a collection of writings about gay Jews and sex called *Kosher Meat*. The story was about my infatuation with a German on Fire Island. It was explicitly and graphically sexual, it featured a number of potentially unflattering anecdotes about my parents and their quirks, and it was all true.

My mother had told me, right before I left for school, that I shouldn't shy away from making art about my family, even if it might make her uncomfortable. "As long I've screwed up your childhood," she reasoned, "At least I can feel like I've given you content for your art."

Nonetheless, I decided not to show my parents my *Kosher Meat* story. I figured even if they were finally comfortable with my sexuality, they didn't really want to hear the details.

So I was surprised to get a call from my mother on my cell phone, as I waited on line at the In-and-Out Burger drivethru. Mom told me she'd just heard about my story—turns out some of her colleagues had seen it in a gay bookstore, and had told her about it. I panicked.

"Have you read it yet?"

"No, not yet," my mom replied, "but—"

"Don't!" I barked.

The cashier at the drivethru window thought I was yelling at him. He looked confused. I tried to explain the situation with hand signals. He didn't understand.

"Why not?" my mother asked. "Isn't it about Judaism and food? What's the collection called? *Kosher Meals?*"

I almost choked. "Meat!" I screamed. "Kosher MEAT!"

"Oh," said my mother.

"What?" said the cashier.

"It's about sex!" I hissed into my cell phone.

"Oh," said my mother. "Oh."

The cashier looked bored. He'd heard it all before. I handed him my money and waited for my mother to speak. "Well," she finally continued, "your father and I want to read it anyway."

"I don't think you really want to know the details of my sex life!" I protested. From the cashier's expression, he didn't want to know the details of my sex life either. He gave me my change and thanked me for coming.

"Yes we do," my mother assured me, as I accelerated onto Sunset Boulevard with my burger and fries. "That way we know what we should be worrying about!"

Pink Triangles and Yellow Stars: Growing Up Jewish and Gay

David Bergman

I am Jewish and I am gay. These two facts have never seemed to me to be irreconcilable, although they have often ground against one another like geological plates, tilting against each other, driven by forces deep within. Yet despite this scraping, the Jewish and gay aspects of my personality have most often sat quietly beside one another, keeping each other company, a kind of psychic koffee klotch, where they tell each other little secrets and pieces of advice. I imagine my Jewishness looking a bit like Golda Meir, only kinder. The gay side is a younger, more excitable man. The Jewish part tries to mentor the gay part, providing the patience and understanding millennia of survival and oppression have taught it.

I know that speaking of identity this way distorts it—makes it seem more fixed and stable than it really is. I'd prefer to think of identities as interconnected affiliations that have their histories and their seasons, and if I now concentrate on being Jewish and gay, those are only two of any number of affiliations I have. A couple of years ago, I was listed in an anthology as a Southern poet. It's true I have lived in Baltimore for over twenty years, but I was born in Massachusetts and grew up in New York City, and had never thought of myself as a Southerner. Still, in going through the anthology, I was surprised to see that my work had much in common with other Southern writers. Identities can sneak up on us without our realizing and they can persist without being cultivated.

When I was coming out I agonized over being gay—it obsessed me. Now I am neither agonized or obsessed. Both are part of my history, my experience, and it strikes me that those who advocate the deconstruction of identity politics are also running away from their histories—doing away with the ever-changing terms in

which we view ourselves. Rather than wanting to find an end to my personal history, I'm interested in how one sort of experience sets the stage for another for that is how I see being Jewish and gay—as though one was a preparation for the other, as if my Bar Mitzvah led directly to homosexuality.

Because I was Jewish, realizing I was gay didn't come as much of shock as it comes to some people. I had a boyfriend for a while, a beautiful young man, who had grown up in a small farming town in the Maryland foothills. He had been a member of the choir at the Lutheran church his family had attended for generations. Although he had this rich chocolate brown hair, I always imagined it to be lighter and blonder. He had, however, the creamy, hairless body of the wholesome American boy. His legs, which he liked to wrap around me, were particularly long smoot,h and firm, not the stumpy, hairy peasant things I walk around on. He was agonized by how his sexuality had betrayed him. He had been brought up thinking that he was part of the majority, with all the rights and privileges of being at the center of American life, and now he had lost that status. Being gay had pushed him into the margins, and he resented and mourned that loss.

I never entertained the belief that I was part of the majority. Does any Jew? Even if you're brought up in New York as I was, you don't feel that you're the average Joe. To the contrary, everything conspires to remind you that as a Jew you're a tiny fract, tinyion of the population, and that you would be entirely overlooked if you weren't so insistent and scrappy. In fact, since Jews make up less than two percent of the population, and gays make up (let's be conservative) eight percent, when I came out, I joined a minority four times larger. No wonder gay life seemed so much more expansive to me—so densely populated.

But no matter how small a minority Jews made up, I was constantly told as a boy growing up during the fifties that I had a significant part to play in the world. The very hatred Jews meet with was the most telling sign of just how significant we were. "Thirty percent of all Nobel Prize winners have been Jewish," I was told. Even our suffering, I was taught—and the queer-to-be pricked up his ears—was part of being a "chosen people." It just figures that

"the unchosen" would regard us with envy, incomprehension, or fear. If you were special, you were going to suffer, and I was assured—for my parents are loving people—that I was a special person.

When I first came out and I learned how many famous people were gay, I felt as if I was relearning an old lesson. Like Jews, gays have a feeling that our contribution to the intellectual and cultural life of the country greatly outweighs our numbers. If Jews make up thirty percent of the Nobel laureates, what percentage of Tony Award-winners do gays and lesbians constitute? Making a catalogue of famous queers is a habit that goes back at least as far as Christopher Marlowe's *Edward II*. Even before I went to Hebrew school—that long, painful apprenticeship to manhood—where the list of important Jews of the past and present was as much a ritual as learning to recite the Kaddish, I was presented with a litany of my famous co-religionists. The ones on television were particularly important to recognize: Jack Benny, Milton Berle, Shari Lewis, Leonard Bernstein (I could miss Saturday morning services but never a Young People's Concert, which was in our household a far more sacred service), and Mike Wallace (a distant relation through marriage). "The three most influential thinkers of the twentieth century," I was told by one of my interchangeable Hebrew school teachers, "Marx, Freud, and Einstein, were all born Jews!"

We needed to learn which famous people were Jewish because they often had to disguise the fact by changing their names. Petite, blond Dinah Shore was Jewish, even though she looked like a WASP. But hiding the fact that you were Jewish was not considered a sin. In fact, such dissimulation was considered praiseworthy. Judaism, I was taught, unlike Christianity, doesn't elevate martyrs. Just being a Jew was martyrdom enough. Our teachers held up as a model for emulation the Spanish Jews who had pretended during the Inquisition to convert but who secretly kept the faith. My parents gave me Lewis as a middle name, its spelling carefully chosen just in case a more virulent strain of anti-Semitism swept across America and I had to change my last name. As some fathers provide their sons with baseball mitts when they are born, mine provided me with an alias.

Yet this sense that you couldn't tell who was Jewish simply by the more obvious racial characteristics came into play when I was coming out. Gaydar is not so different than Jewdar—both groups are on the alert for signs of fellowship. Perhaps I have never held the zealous belief that every closet case should be exposed because I was raised with an exaggerated sense of the swings of prejudice in which self-preservation may require the ability to hide who you really are. Indeed part of the excitement of being gay as well as being Jewish is the sense that you belong to a loose secret fraternity.

But what most prepared me as a Jew for being gay was the sense of danger that permeates life. A Jew in the fifties was taught that he had enemies no matter how safe suburbia seemed. I was taught—it was the lesson of the fifties—never to be too comfortable, never to let down my guard. My father, who is among the gentlest, kindest men I know (he left all the spanking to my mother) had before World War II marched in all kinds of May Day parades as a union organizer and sympathizer of left-wing causes. In the fifties he was investigated by the F.B.I. My brother and I were told not to worry if strange men came to our school—venerable P.S 156— and asked about us. They were just doing their jobs.

Nothing ever happened to my father, but when I began having sex with men—which happened many years after I realized that I was gay—I had to decide whether to put my energy into hiding the fact or to confront whatever prejudice I would encounter. I figured that just as the Nazis had hunted down Jews, and just as the F.B.I. had investigated my father, the State would always find out what it wanted to know. It seemed clear to me that any energy spent hiding was wasted. One didn't need to look for trouble; trouble would find you. You just needed to be prepared to face it when it came.

I'm not the first person to draw this comparison between being Jewish and being gay. Marcel Proust, that other literary *feygellah*, comes to much the same conclusion. According to Proust, sodomites form a race that know "a persecution similar to that of Israel." Just like the Jews, sodomites keep their public distance from one another, but they rally to each other's aid just "as the Jews rallied around Dreyfus." In fact, Proust reminds his readers that sodomites take "pleasure in recalling that Socrates was one of

them, as the Israelites claim that Jesus was one of them." Lesbian poet Adrienne Rich has also claimed the connections. Even more recently Larry Kramer has argued that just as Jews were wiped out by Nazi policies, so gays are being systematically destroyed by government bureaucracy.

I suppose it's not surprising that those who draw the connection between Jews and homosexuals are themselves Jewish homosexuals. It isn't surprising, but it is sad. Non-Jewish homosexuals don't necessarily make the connection. In fact, anti-Semitism—although not rife in my experience—is certainly present. I don't know what to make of the general gay belief that Jews make "hot" sex except to say that I have profited by this stereotype and hope that I have done my part to keep up the folklore.

I do know that I was blocked from a full-time appointment at the university where I teach by an old Southern queen who believed that the one Jew teaching English was enough. I also suffered the conversation of his drunken friend at a department party, who denounced Jews as the source of evil in American society second only to "niggers." It was not pleasant. But poetic justice prevailed in this case and when that senior faculty member retired I was promptly given his position.

Recently Andrew Sullivan, the gay Catholic and British editor of *The New Republic*, argued that gays can't demand civil rights on the same basis as other minorities because gays can pass as straight whereas other protected minorities supposedly can't pass. By inference it suggests that Jews don't need protection from anti-Semitism because Jews can pass. As Tony Kushner—another gay Jew—has pointed out, the fact that one needs to hide is clearest evidence that civil rights protection is needed. It doesn't seem odd that Andrew Sullivan should ignore Jews in his analysis of civil rights—he is after all Catholic and English. He was never taught as a child to understand what it meant to be oppressed. But Jews, who have sworn never to forget how irrational hatred and systematic state prejudice brought about the Holocaust, should know better. They ought to be able to empathize. When they don't, it breaks my heart. It feels like one ventricle has stopped beating in harmony with the other.

Last spring I found myself in the middle of just such a heartbreak. The Jewish Student Association (JSA) at Towson State University where I teach organized a Holocaust memo Ml Service. I didn't know about it until one of my students, Kristin, asked if I would take part by reading a poem. The service was co-sponsored by the Student Life Association, the Black Student Union, and DSOC—the Diverse Sexual Orientation Coalition, the campus gay and lesbian group, for which I serve as faculty advisor.

The high point of the service was supposed to be a speech by a Holocaust survivor, Aaron Seigman, a professor who teaches at another area university where he runs the Program in Behavioral Medicine. He was going to be introduced by a member of Towson's history department, Arnold Blumberg, a man in his sixties who teaches diplomatic history. I run into him every now and then since we both use the bus.

A few days before the memorial service, Seigman learned that a gay student association was one of the sponsors of the event. He refused to speak and called Blumberg, who refused to appear as well. The Jewish Student Association quickly found another survivor to speak who pointedly brought out the way the Nazis had used the prejudices of various groups to divide and weaken the opposition. "Prejudice is prejudice," this fiery old man, who had escaped from two trains headed for death camps, told us. "It doesn't matter against whom."

A few days later, I wrote Blumberg, saying I was sorry he had not attended the ceremony, which had been very moving. But when I invited him to a panel discussion on Religion and Sexual Orientation that the Committee of Gay, Lesbian, and Bisexual Concerns, a group of faculty, staff and students, had organized, his reply was astonishing. First he attempted to limit the Nazi slaughter of gay men. He wrote me, "The only two groups which were the objects of Nazi determination to exterminate an entire people...were the Jews and Gypsies...my central message would be the uniqueness of the Jewish experience."

But not only did he feel the need to erase the monstrousness of the Holocaust, he went on to attack my students as Nazis themselves. "My attention has been called to the fact that earlier this

semester, the Gay Students on this campus involved the Jewish students in a protest against a talk given here by Oliver North." Many students had been quite angered that this right-wing hero—whose speech, one might add, is very far from free—had been invited to appear on their campus at their expense. Blumberg, who did not attend the lecture, did not hesitate to characterize the protest he did not see. "They busied themselves with hooting the speaker into silence. Anyone who would involve themselves in such activities cannot protest Nazism when they themselves have become Nazis." In fact, the university's president had personally thanked me for helping to keep the students' protests orderly.

Blumberg claimed that the gay student group had "hijacked an occasion represented to me as belonging to the Jewish Students Organization," Seigman was even clearer about this accusation. He told a reporter for *The Baltimore Jewish Times*, "I feel very strongly that events commemorating the Holocaust should not be used for any other purpose...I object to co-opting the event in order to propagate the point of view that homosexuality is a legitimate alternative lifestyle." Both men operate on two assumptions: First, that the holocaust is a strictly Jewish disaster and, second, that any other group is merely "co-opting" the event for its own uses. Of course, both assumptions are wrong, as is the assumption that the gay student group had done anything but add its name in support of the Jewish Students Association's event.

It is true that homosexuals were only sent to work camps, not to extermination camps; that most died from starvation, overwork, and deliberate cruel treatment, even shooting at the hands of guards who regarded them as less than human, rather than the gas chamber. I can't believe anyone could see these as significant differences. In some way one might speak of the uniqueness of the homosexual experience, because Jews were set free from the camps by the Allies, who tried to reunite them with relatives and resettle them elsewhere. Homosexual survivors were reimprisoned in occupied German's new prisons. But I do not want to enter into the debate of *who suffered more?*, trivializing the debate by comparing levels of misery. There's enough suffering to go around.

One of the clear signs of bigotry is the question, "Why does your suffering count?" One of the signs of a sociopath is his inability even to recognize the suffering of other people. We live in an age of sociopaths and serial killers. But the psychopath isn't just the teenager mowing down bystanders at a drive-by shooting; it's the citizen who dissociates himself from the suffering of other people, the person who says, "Well, it's not me, so why should I care?"

Discrimination against lesbians is different than discrimination against gay men. Discrimination against Jews is different from discrimination against blacks. But if we respond only to our individual forms of discrimination, we will not be better people. We will have to cultivate our suffering as the only suffering worthy of recognition; we will have to deny not only our own well-being, but the well-being of others. We will be narrow, self-obsessed, self-righteous and disconnected from the larger society around us, the entire range of human emotions and experience.

I began by saying that the Jewish part of me has set the stage for the gay part. But that is not wholly adequate as a metaphor, for it doesn't suggest the ways the gay part has modified the Jewish part, or the ways they interact. Nothing makes me feel more like a queer than attending a Bar Mitzvah, but nothing makes me feel more like a Jew than sitting at dinner with a bunch of church queens. Just as one set of associations is about to limit my understanding of the world, the other functions as a way of opening up new experiences. And just as one identity seems happily to be at rest with the other, something happens that sets the two in opposition.

Not too long ago, I visited the Holocaust Museum in Washington with my parents. They can't stand as long as I can, so we split up so they could pace themselves better. The museum was filled with school-aged children, not just Jewish children learning about their history, but kids from all backgrounds, learning a lesson of human history.

There is an area of the museum devoted to the other groups that the Nazis rounded up and sent to concentration camps—leftists,

Gypsies, Jehovah's Witnesses, homosexuals. A monitor in one corner played a five minute video loop, and I watched it once.

When the section on homosexuals came on, the group crowded around the screen nervously began to break up, and people thoroughly dispersed at the end. I continued to stand there, intending to see it through again. I was alone, feeling very self-conscious, feeling that I was the only gay man in the entire museum. Then I noticed a second man standing at a distance, a tall, lanky man in his forties with a Lincolnesque cragginess of expression. Together we watched the loop once more as school kids and their parents walked past.

My Journey Home Leads Through the Trees

Andrew Ramer

My obsessive desire for a Christmas tree began in 1955 when I was four. My parents wouldn't get one. At age six I begged them to send me to Christian Sunday School with my best friends, the twins. Instead they sent me to Hebrew School, which was not what I wanted. At age seven I had my first crush, on the ruddy blond college student who drove the Good Humor ice cream truck around our neighborhood. I pined for him all fall and winter, and when ice cream season returned in spring and I found another young man driving his truck I was heartbroken for the first time. There was Ned, the dark-haired Jewish high school boy down the street, who wore tight blue jeans (we called them dungarees then) and white tee shirts with the sleeves rolled up. I walked the dog by his house several times a day, hoping he'd be out mowing the lawn or raking leaves. But he got his girlfriend pregnant, had to marry her, and moved away.

I heard the word homosexual for the first time in seventh grade, and still remember the terror I felt when I came home and looked it up in the dictionary: "The unnatural attraction of one man for another." I knew that applied to me, but I was sure it was a gentile disease and that I was the only Jew in the world who had it. I would pleasure myself looking at pictures of sexy men I cut out of magazines. I did it in the walk-in closet in my bedroom, which makes me the only person I've ever met who literally had to come out of one.

I hated Hebrew School, but my mother wouldn't let me quit. One day when I was studying for my bar mitzvah the rabbi came in for my lesson holding a little green velvet bag and told me he was going to teach me how to put on teffilin. I had never seen them

before, and when he took them out of the bag they were so old and ugly that I cringed and said, "Don't touch me with those filthy things." He put them back in their bag, left the room, and did not return. Having learned my haftarah but not that one important ritual, in March of 1964, shortly after my parents' divorce, I became a Jewish man.

I got an ulcer the same year, and my mother sent me to see a shrink, every Thursday after school, but instead of telling him what was troubling me I made up friends and dreams for every session. I knew that men had sex with other men, although I had no idea what they did, but I didn't want to just have sex, I wanted to be in love, and two men being in love was something I had never heard about. Therapy did not enlighten me. All I knew was: "Get married and have nice Jewish children." They didn't teach us about David and Jonathan in Hebrew School, and although I lived on the same Long Island that Walt Whitman had, and went to a shopping center named after him, we didn't read a single word by him in public school.

When I was fifteen my mother remarried and we moved to Orange County, California. Overnight I went from a largely Jewish high school to a larger one that only had a dozen Jews in it. The boy who was assigned to show me around the school quit when he found out I was Jewish. "I know your kind," one of my teachers said to me on the very first day of class, Sex Ed class as it turned out. "You sit in the back row and don't open your mouth." I told no one at school or in my family what was happening, and learned nothing about my own sexuality in that class, but it was so difficult being a Jew that dealing with liking boys was out of the question.

I graduated from high school in June of 1969. A few days later I flew back to New York City to spend time with my father and stepmother Pat, who lived in Chelsea. One morning during break-fast a friend of Pat's called to say that a bunch of fags had rioted the night before in the Village. After breakfast we walked down to Christopher Street to see what had happened. Allen Ginsberg was there, in front of the Stonewall Inn, talking to the milling crowd. I knew he was a famous poet, I knew he was a Jew, and I was delighted to find out that there were two of us, but I still didn't want to be that way.

I went off to college determined to fix myself and met a nice Jewish girl the first week I was there. When I confessed to her that I was afraid I liked boys, Marsha said, echoing the lyrics of a popular song, "You can be anything you want to be." She was the first person I'd every told, and I was grateful to her for her answer. I wanted to be straight, I wanted to have nice Jewish children, and she assured me that I could do all of that if I set my mind to it. She told me that everyone has something to overcome, a cross to bear, I suppose. I grew to love Marsha and I loved the sweetness of our sex life, but I still hungered for boys. Living in Santa Barbara, right near the beach, there were lots of hunky blond surfer boys to tempt me, peeling out of their wetsuits when I went walking.

It was the end of the Sixties. The Beatles had gone off to India to study meditation, and I began to explore Hinduism and Buddhism. But I felt disconnected from my own roots, and began to study with a traveling hippie rabbi. I asked him to finally teach me how to put on teffilin and he invited me to his house. His coffee table was covered with pornographic magazines. I had never seen any before. Most of them had pictures of men and women on the cover, but a few were of men with men. I was nervous, excited, and afraid. When he took out the teffilin and learned over to begin my initiation into the world of Jewish bondage, wrapping one black leather strap around my right arm, he breathed his sour breath on my face and tried to kiss me. I leapt up from the couch, left his house, and did not return.

Marsha's family and mine began to celebrate holidays together. She and I would lie in bed thinking of Hebrew names for our children and fight about whether or not we would have the boys circumcised. (I said no, she said yes). The experiment in transformation was going well, but not well enough. Realizing that I needed more powerful help, I went to Israel for my junior year in college, convinced that the Jewish State was a vast mikveh that would wash away my attraction to other men. But all those dark men in tight pants and unbuttoned shirts, touching each other in ways that American men don't, made me went to be touched too.

I was living in a collective house with several other students. Our common interest was exploring alternate ways of being Jew-

ish. None of them knew that my Bible in those days was a book called *The Way of the Hopi*, or that my spiritual haven wasn't the Western Wall but the Church of the Holy Sepulcher, where I went to pray several times a week. And none of them knew my other secret either.

My housemates and I were studying Talmud. One day our teacher mentioned that she'd seen and liked the movie made from D.H. Lawrence's book *Women in Love*. I hadn't read it and decided to see the film. Alone for a matinee, watching Gerald and Rupert wrestling naked, listening to Rupert tell his wife at the end that he loves her but wants an equal and opposite love with a man, I feel ebullient. Men *could* love other men! It was in that dark Jerusalem theater that I finally came out to myself. (Years later I learned that another gay Jew, Larry Kramer, wrote the screenplay.)

Primed by the film, I was ready to fall in love. Marsha's and my good friend from Santa Barbara, Ann, was living on a kibbutz, and came down to see me in Jerusalem with a man who was living there too. The moment I opened the door to let her in and saw him standing behind her, the doors of my heart flew open. Not a dark sexy Sabra but, like the Good Humor man I had my first crush on, Manny was blond and bearded, and it was only later that I found out his big secret. His name wasn't really the Jewish-sounding Manny he went by, but Manfred. His father had been an active Nazi who fled to Canada after World War II, which is where Manny was born and raised.

One blond and bearded, the other dark and bearded, we made an excellent pair, walking the streets of Jerusalem arm in arm, wearing matching scarves we bought on King David Street, talking about everything under the sun except what was happening between us. Manny had come to Israel to expiate his guilt, and falling in love with me was a guilt he wasn't ready for. I wasn't either, and both of us rushed off to our girlfriends the moment they arrived in Israel to visit us. (But I still have my scarf. I wonder if he has his.)

At the end of the year I went to Berkeley for my senior year and lived around the corner from Marsha, with three students whose parents were all Holocaust survivors. They spoke to them on the phone very day and went home every weekend. They were too weird for me (I couldn't wait to leave home), so I moved down the street

to a crazy druggy co-op where my friend Ann was living. One day I looked up from my lunch tray and saw a slim dark handsome young man walk into the dining hall and sit down at the in-crowd table. He seemed like a rich Jewish kid from the San Fernando Valley, very different from my previous roommates. He was cocky like Ned whom I had my second crush on, and I fell in love with him before his fork had reached his mouth. But I was in the schleppy crowd, so I knew he would never notice me. Then, wonder of wonders, Ann started dating him. Soon Marsha and I were double-dating with Ann and Paul, who wasn't a Valley Boy, but half-Palestinian, born and raised in the Bay Area. Over the course of several months I fell more and more in love with him, and feeling braver than I had been with Manny, I told Paul what I was feeling. That's when he told me his secret. He'd had two relationships with men and was in therapy trying to be straight, which was why he was dating Ann. But he was still open to being my friend.

A friend gave Paul two tickets to see Arthur Miller's play about the Salem witch trials, *The Crucible*, in San Francisco and he asked me if I wanted to go with him. I did, we enjoyed the play, but missed the last bus back to Berkeley. There was no BART under the bay yet, so we spend the night at his parents' house, nearby. In their finished basement, on a small red couch, I made love with Paul for the first time, made love with a man I was in love with, which was just how I wanted it to be.

I told Marsha the next day. She wasn't surprised. I told her (and myself) that being with a man once had gotten it out of my system, but by the end of the week I knew otherwise. It was a painful breakup for both of us. I'd called my father the morning after Paul and I first made love. He was great and continued to be my main support. I told my mother a few weeks later, knowing she would have more of a problem. She cried for weeks and begged me not to tell anyone else in the family, so I didn't. After the shock wore off she let me know that she was more upset by Paul being Palestinian than she was by his being a man. (Good thing I'd never slept with Manny).

Walking the streets of Berkeley with Paul was better than davening. His smell was more fragrant than the spices from

havdalah. The way his rib cage rose and fell when he slept was holier than any prayer I'd every heard in temple. Alas, although our sex life was delicious, our relationship was tempestuous. We broke up; we got back together. I moved to Seattle to get away from him, and he sent me fourteen page love letters, so I returned. We stayed together for another six months, during which time he had sex with a woman downstairs and then with our mailman. That was not what I wanted, and so, worn out and in pain, I went to New York to live with my father and the woman he got together with after my Irish-Catholic stepmother Pat left him for her third Jewish husband.

I had no friends in New York so I started going to the gay synagogue, which in those days met in a church in Chelsea. I didn't enjoy the services, which reproduced everything I hated about services as a child, but I did like the sense of being in a gay Jewish community. One evening during the Oneg someone spilled his coffee on me and the man standing behind me. He and I went to the bathroom to clean up, and it was only there, in the tiny mirror over the sink, that we saw each other for the first time. I turned to him, we started kissing passionately, and I went home with him that night. He was the only convert in the room, a tall blond man with big blue eyes, but just like Paul, Danny had no interest in monogamy. Nor did Bruce, the next man I fell in love with. He was handsome, Jewish, working on his Masters at Columbia, and liked to remind me that he was smarter and more spiritually evolved than I was. Some time after we broke up he was walking down the street, Beacon Street in Boston I think, when he had a vision of Jesus and converted to Catholicism.

Then, finally, finally, finally, right before my father died in 1980, I met Michael, a Nice Jewish Boy, who lived fifteen houses down the block from me in Park Slope, Brooklyn. A mutual friend who lived in the middle of the block introduced us. His family hated me for corrupting him, which I hadn't (he was corrupt at an age when I was still looking at pictures in my bedroom closet) and they really hated me after he and I got our first Christmas tree. On the other hand, my mother and the rest of my extended family, who I'd finally come out to, all adored him, although they weren't happy

about the Christmas tree either. Michael and I liked the same things: left-wing politics, Georgia O'Keeffe paintings, Adrienne Rich poems, Sweet Honey in the Rock concerts, and we found a synagogue that we loved, led by a woman rabbi. Everyone sat on the floor around a large mound of dirt covered with candles and broken mirror bits, but then the rabbi moved and neither of us every found another synagogue we liked as much as hers.

One of my most vivid memories of our three-year relationship (which did not end because of infidelity) was our first Hanukkah together. Michael and I were standing in the bay windows of his apartment, with his little brass Hanukkah menorah sitting on the windowsill. It was a dream come true, lighting candles beside my Yiddish-speaking boyfriend with the beautiful dark hairy chest and the sexy spaces between his teeth. We were standing with our arms around each other, warmed by the glow, when he turned to me and said, "Here we are, two pacifists, observing a holiday that's about a war our ancestors won against the Greeks. Only, our ancestors were homophobic. And the Greeks weren't. I wish the Greeks had won."

My Hebrew name is Shabbetai, the same as the great Jewish false messiah Shabbetai Zevi, who lived in the seventeenth century. He abolished the commandments, wheeled a fish around in a baby carriage, and when the sultan in Constantinople captured him and gave him the choice between death and conversion he thought about his most famous predecessor, nailed up on a cross, and became a Muslim. One of his followers later alleged that Shabbetai Zevi, wearing teffilin, had intercourse with a boy and declared that this was a great tikkun, a great act of spiritual rectification.

The last time I went to temple was a year ago, for the bar mitzvah of the older son of one of the people I lived with in Jerusalem. After his younger son gets his bar mitzvah in two years I'll probably never go again. After years of angst I've come out as my own kind of Shabbetai. I've abolished the commandments, I collect transparent plastic fish that come in different colors and look beautiful when light shines through them, but I haven't converted to any other religion like Shabbetai Zevi did, or maybe I've converted to parts of all of them. I'm the sort of Jew the biblical proph-

ets were always railing against, for worshiping the Queen of Heaven in Her sacred groves. I find God in nature, not inside and not in prayers. I find God when I'm walking through the trees, although I haven't had a Christmas tree in years. I find my gayness and Jewishness married together in my body, not in my head, where I struggled to make sense of them for so long. And I'd like to be with another Jewish man, a man with my kind of heresy in his background too, who wants to do tikkun with me—without teffilin. I still don't know how to put them on, and I have no intention of ever learning.

Salt

Arnie Kantrowitz

Early in 1965, with my wrists still bandaged from my first suicide attempt, I came out to my mother.

"Arnold," she said, taking my hands in hers to inspect them, "tell me. There must be a reason. What made you do this terrible thing?"

"I'm a homosexual," I said matter-of-factly. (She wouldn't have understood the word gay, which had not yet entered the public lexicon.)

I was a twenty-two-year-old English instructor at an upstate New York college, and in my hour of desperation had first reached out to my father, whom my mother had divorced half a dozen years earlier. He had turned over the job to my mother, and my Italian-American stepfather had driven all night from southern New Jersey so she could reach me. There was no way to tell her all about the isolation and fear of discovery that were part of my daily life. I was too tired and too depressed to explain any further.

Tears filled her eyes, but she responded immediately, "This is no reason to die. Everyone has something to live with."

Then she took me into the kitchen and stood me near the stove, reaching for a box of coarse kosher salt I kept on the counter. She turned on a flame, took a handful of the salt and sprinkled some of it on my head, throwing the rest in the fire and repeating the sequence two more times.

Finally, she spit three times over her left shoulder and began to mumble in Yiddish, turning from a bleached American matron into a Russian-Jewish peasant right in front of me. "What are you doing?" I asked in disbelief.

"Shh," she said. "I'm saying a kine-ahora, a curse against the evil eye."

Once I was recovered, I moved to New York City and landed in the office of a psychiatrist named Norman Levy. Mercifully, I soon discovered that he was gay, too, and after a few years of hard work (including a second suicide attempt) I was ready to come out to the rest of the world, though he was not. I became a gay activist, and in 1970, along with scores of new friends, I defiantly marched in the first Gay Pride march while he stood quietly on the curb. I came out to William Birenbaum, the president of the college on Staten Island, where I had resumed my teaching career, and he was supportive; so I came out to my classes, who gulped and took it in stride. Emboldened by my new gay comrades in arms, I demonstrated and petitioned and lobbied for my rights and began to write and make appearances on TV, which meant that eventually the rest of my family had to be told.

My mother was none too thrilled at my self-acceptance. Folding her arms steadfastly across her chest, she dropped both her superstition and any attempt at understanding and announced that my psychoanalysis had been in vain. In her eyes, I was sick. Outraged, I broke off all contact with her.

My father amazed me by rising to the occasion and telling me to live by my own rules as long as I wasn't hurting anyone; however, he was opposed to my political activism and didn't want to discuss the matter any further. My stepfather, short on education but long on experience, said, "I always thought you were a fag," but he showed no ill will to go along with his benighted vocabulary. My younger brother Barry, a businessman whose heterosexuality made our mother proud, was somewhat dismayed and said, "I won't condemn it, but I can't condone it." When I protested that he wasn't offering me very much, he said, "Do you expect me to throw my arms around you and be glad you're my brother?" I told him he could keep his arms to himself.

Then, late in 1971, my brother and I were suddenly thrown weeping into each other's arms when our mother died suddenly of a heart attack. She was only forty-seven years old. I was tripping on acid in bed with a date when the phone call came and knocked

the wind right out of me. In the days that followed I wept for my loss and for my guilt. It had been six months since I had spoken with her, and now there would be no chance to persuade her that my life was not a failure, that being gay was something more than a maladaptation. The funeral was a blur of my mother's relatives, many of whom didn't even recognize me because I hadn't seen them for so long. I knew it was the wrong moment to raise the subject of gay liberation, but once the mourning period was over, I returned to my activist's agenda with renewed fervor.

I chose the Passover seder of 1972 to make my announcement to my father's family. It was the one time a year my uncles, aunts and cousins all gathered. I was much closer to them than to my mother's family. We traditionally laughed and sang together, and once my Old World grandparents were gone, we paid minimal attention to the religious side of the evening. Although the subject of gay liberation had been in the news, thanks to the demonstrations staged by my friends, it was not yet a topic for polite conversation at the table. Therefore, I took each relative aside and made my little announcement discreetly, or so I thought.

Uncle Sam was the oldest and the sweetest. He played "Romania" and "Hora Staccata" on the violin, and as a permanent bachelor had aroused my curiosity about whether we might have the same sexual orientation (which would have been a relief since I have no other gay or lesbian relatives), but there was no way to raise the subject with him.

Aunt Dotty was a timid widow who shared an apartment with my divorced father, where she played Chopin on her baby grand. She had become my friend when I moved in for a year to recover from my suicide attempt. Uncle Al, the youngest of his generation, played jazz and starred in local theatrical productions as Tevye in *Fiddler on the Roof*. He had more personality in his little finger than uncles in most other families ever dreamed of. Each of them, as well as my four cousins, their children, maintained an embarrassed silence once I had spoken. I had assumed this added tidbit of information would create no change in our loving bonds, but I had established myself as different from them, and now there was a strange new distance between us.

It erupted into open warfare the following year when I appeared on *The Jack Paar Show,* which was broadcast on national television a week before the seder. Thinking the family would be proud of me, I called my father to alert Uncle Sam, Aunt Dotty and the others to watch. When Paar turned the microphone over to us, I said, "I love a man, and I'm not ashamed of it. . . .Some of you are sitting next to your own children or brothers or sisters who are gay and afraid to tell you because they're afraid you won't love them anymore. You may be loving their lies. Why not give them a chance to be themselves?"

The next day my favorite cousin, Dotty's daughter Adrienne, called. "The family saw you on television," she said. "They met, and even though I tried to talk them out of it, they agreed it would be better if you didn't come to the seder."

"But why?" I asked, genuinely amazed.

"It was a terrible fight. Everybody was all upset. They said you were shaming the family's good name. Uncle Sam finally said that as far as the family was concerned, you were dead."

I was hurt. "Tell them what I did was honest," I said, "and that I'm going to go right on doing it. It's my name, too. Good-bye."

My father, it turned out, had not been interested enough to watch the show. He was more worried about whether there would be room for my brother's fiancee at the seder. If she weren't invited, he opined, he might not go himself.

"But I wasn't invited, let alone my lover," I exclaimed.

"Do you think I should take Barry and his fiancee out to dinner?" he asked. I realized that I had been rendered utterly invisible.

At that time, I was living with my erstwhile lover, Bob, in a communal house in the SoHo area of Manhattan. At Easter, he invited me to visit his Roman Catholic aunts in Brooklyn, a stumblingly awkward but heartwarming encounter. And on the night of Passover, I made dinner for the half dozen members of the commune, none of whom were Jewish, doing my unskilled best to put together homemade potato latkes and tzimmes and brisket with store bought chicken fat and gefilte fish. There was no seder ceremony, but there was as much family spirit as we could muster.

A few days later Uncle Sam called and asked if he could visit. I opened the door to find him smaller and paler than I had remembered, a frail old man.

"This is where my lover and I sleep," I informed him as I gave him a tour of the house.

"Remember Grandma's chicken soup?" he rhapsodized in a nostalgic non sequitur." Do you want to go to lunch?"

At the local restaurant he sniffed at the menu, looking for something to suit his kosher palate. I had never thought of it as a goyische place, only as a straight one. During lunch he warily suggested first a sex change, then hormone shots to overcome my "difficulty." I assured him that I was happy as I was.

Then I returned the subject to the family seder. He explained that my aunt had invited some business friends, and my outspokenness would have proved embarrassing.

"But why did you declare me dead?" I asked.

"Everybody got me all excited. I never even saw the show." Then I heard an unexpected sound. Uncle Sam was crying! I gave him a tissue. "Next year will be different" he promised. "Next year I'll make the seder. . . ."

During that period, New York's gay community was struggling to enact legislation that would protect our employment and housing rights. Time after time we demonstrated in the streets and went to City Hall, only to be rebuffed. Among our staunchest opponents were members of the orthodox Jewish community. Jewish newspapers warned of Jehovah's wrath through earthquake and flood if this law were enacted. Hassidim arrived in busloads to testify against our rights. On my bulletin board, I hung a photograph of a bearded man in a black hat and coat, holding up a sign which read: "Torah intellectuals say *feh* to homosexuals." I felt more distant than ever from my people.

I kept in touch with my brother and a cousin or two, but I remained persona non grata at the seder, except for one year when it was held at my cousin Adrienne's house. At first I was told there wouldn't be enough room for my new lover, Will, a non-Jew, but eventually we were allowed to come, only to discover that my cousin had room for nearly forty people, few of them Jews. Will was so

nervous that he fainted right into his chicken soup! Everyone was very solicitous, but there was still something amiss, and when the seder was moved back to its original venue, I was once again omitted from the guest list.

For some months in the early 1980s, I visited Beth Simchat Torah, New York's gay and lesbian synagogue. There was a great effort at community, and many, many people feel at home there, but I could never quite get comfortable. My Jewish experience was a family thing, not a matter of ritual, and the weekly repetition soon grew stale for me. The Torah portion at my bar mitzvah had been recited phonetically, which had inspired a denunciation by an elder of the shul, so I have never felt really at home in the house of God, aside from the fact that I wasn't too happy about being considered an abomination. I went about my own business, finding spiritual sustenance in my own way, and growing to feel at peace with myself. Will and I broke up after a couple of years, and eventually I settled down with Larry Mass, a Jewish doctor and writer, who might have made even my mother proud. We've been together for nineteen years now, including a wonderful trip to Israel, where I planted trees for the relatives I was rarely in touch with.

Uncle Sam never did make a seder, and I continued to be ignored for the years that followed. Little by little, the family began to diminish. I had lost not only my mother but Aunt Dotty as well, and then at the end of 1986, my father succumbed to diabetes. As we planned the funeral, the rabbi asked if my brother or I were married, and when he dutifully noted down my sister-in-law's name, I said, "You can also refer to Arnold and his partner, Lawrence," and I assured Larry that we would be acknowledged. But when it came time to describe the family, the rabbi referred only to my father's "brothers and sons" and never mentioned anyone's mate. I went up to him after the service and told him," Rabbi, you have caused me great distress. Invisibility is not acceptable to me."

"I thought it would be easier this way," he explained.

"It's harder," I informed him. And then, hoping he would worry that I might defect to Christianity, I added piously, "But I forgive you."

In spite of the grief and anger we shared, or perhaps because of them, Barry and I eventually grew closer, and ultimately he was able to embrace me and tell me that he's glad to be my brother. I'm glad too, especially since he made me the doting uncle of his daughter, Jordan.

Nearly two decades after the original seder debacle, the family decided to gather to celebrate Uncle Sam's eightieth birthday. He was living in a nursing home, and since his health had deteriorated, no one expected him to last for long, so we agreed to put aside our differences in his honor and meet at a restaurant near his facility. I asked Larry to accompany me for moral support because I was a little nervous about seeing relatives I had encountered only at occasional funerals over the years. In spite of all that had happened, I still felt a strong loving connection to the people we had been long ago, before my coming out, and I wanted to see Sam while there was time.

When he saw us all together in his honor, tears sprang to Uncle Sam's eyes as well as to ours. Realizing how few of us there were left, we put the past behind us and became a family once again. By that time the subject of homosexuality was no longer a forbidden one, and as awkward as it may have been, relatives made an honest effort to inquire about my life and to discuss issues like AIDS, gay marriage and gays in the military. It had cost a great deal of time, but I was finally accepted into the family on my own terms.

On our way to the seder at Uncle Al's house the following spring, Larry and I learned that a good deal of the problem had never been about me, personally. It was a matter of generational etiquette. Al's son, who was driving, casually told us, "I could never confide in him about my love life either. My dad can't talk about sex at all. None of them could."

At the seder, the family members were introduced to some of my aunt's friends. It went like this: "This is my son Andy and his girlfriend Laura. This is my niece Adrienne and her husband Roger. This is Arnold. . . and this is Larry."

Instead of taking umbrage and starting another long silence, I realized that they really had no language to describe us, so I took my aunt aside and made some suggestions, which is how we turned

ourselves into a real couple in the family's eyes. It's not about pornography or sin or shame. It's just about us.

When Uncle Sam died a year later, we gathered in his honor once more. At his graveside, I read a poem I had written to honor him. I had done the same for Uncle Al's seventieth birthday. I poured my best feelings into those poems, my childhood memories and my adult observations, and everyone knew they were true. I had become the voice of my family.

This year, after the seder, I stayed over and had the chance to spend a few hours with Uncle Al, more time than we have ever spent alone together, and all the more precious because now, nearly eighty years old, he has retired and moved to Florida. We waxed nostalgic about people long gone, about the old neighborhood and family stories from a hundred years ago. He spoke of his hopes for his wife and children, and I spoke proudly of Larry, and when it was time for me to go, he hugged me and said, "I love you." Not too bad for a kid who started out with a shower of salt.

I like to think that maybe if my mother had lived a little longer, she would have been moved by the amazing changes that have occurred in the last thirty years. Maybe she would have even become my advocate and directed her indignation toward the homophobes in our culture instead of toward me. And perhaps instead of pouring salt on my head, just maybe she would have given me her blessing.

Redefining Passover

Andrew Martin

My mom's end of the table was always more fun. My sister and I sat to her left and right respectively. The rest of the family and/or invited guests sat down along the long glass table in our dining room. My dad sat opposite my mom with all the ceremonial props spread out before him. He had marked his *Haggadah* years ago so he wouldn't miss any of the important parts, and at the same time, he could skip over the parts that would bore us all.

The book told us when we were supposed to eat and when we were supposed to drink, but the three of us paid no attention in our own little corner. My mom would always start by reaching in and grabbing a spoonful of *charoset*—trying to sneak a bite without getting caught. Almost on cue Robin and I would do the same thing—attempt to snap apart a small piece of matzah and put a spoonful of the mixture of apples, walnuts and Manachevitz wine on the flat bread—trying to stay as inconspicuous as possible. Abby almost always blew our cover though. She would sit under the table and immediately jump to her hind legs just hoping that a crumb or two would fall through the glass tabletop. She never did figure out why our spilled food wouldn't fall down to her—and frustrated by this, she would let out a whimper.

"Gail," my dad would interrupt himself from the service, "enough," he would say and look back down at him book attempting to read the Hebrew spelled out phonetically.

Our Seders were never the longest events to sit through, and in the end, even though my dad led us in prayer, my mom was the real one in control. When dinner was ready, it was time to eat—even if it meant cutting *Dayeinu* short by three or four verses.

Passover was always my mom's favorite holiday. She loved having us all together around the dining room table. She loved

entertaining friends and family. She loved cooking and baking a meal that everyone always enjoyed. She loved setting up the dining room with glass plates she and my father were given when they were married and sterling silver flatware and crystal wineglasses given to them by my great grandparents. She loved having an excuse to buy calla lilies and gladiolas to arrange all over the house. Out of any holiday we celebrated throughout the year, this one was certainly the most important for us as a family.

Passover was no longer the same for my mom the year I went away to college. The trip from New Orleans back to Toledo was too far to come for only a night or two—but her Seders still took place. When my sister left two years later for college, and my mom had no one on her side of the table to sneak pre-meal snacks with, she did not quite view the holiday in the same light. Instead of having people over for the holiday, my parents chose to go out to homes of their friends. Without Robin and me around, the magic of Passover began to fade.

After I graduated, I decided to move to New York City. I know I chose New York for specific reasons—I had always wanted to live there, but I think I may have been too scared of finding myself too early. For the first time I began to admit to myself that the feelings I was having for other men may not be wrong. In fact, it was obvious by just walking down the street, that many other men felt the same way I did. I noticed for the first time gay men holding hands and displaying affection toward one another without really caring what the world around them thought.

I was actually almost pushed into the dating world without even knowing it. I was working for a production company at the time, and we had a release party for one of the films. That night I met a guy named David, and we ended up getting along pretty well. We figured out we had a lot in common— including the fact we both liked sushi.

We agreed to meet at a small sushi bar in Hell's Kitchen the following Friday. I was looking forward to our dinner because I had not met too many other guys with whom I had much in common since I moved to New York.

A little while into dinner I remember David looking at me and asking, "how long have you been dating men?"

"I don't date men," I said.

"Well, what do you call this?" he asked.

I put down my chopsticks and stopped chewing the tekka maki I just shoved in my mouth. He looked back waiting for me to swallow so I could respond, but the last thing I wanted to do at that moment was answer the question he had just asked. We sat in silence a few seconds longer until David asked,

"You are gay, right? I mean, I just figured...."

"Yeah, I mean I think so—I just never—or haven't done this... yet—but it's OK. I've been meaning to," I said.

I felt awkward, but every time I looked up from my plate of sushi, David just gave me a big smile. To be honest, as the dinner progressed after that conversation it really felt no different than going out to dinner with a new friend.

David and I ended up dating for the next few months, although every time I went out to meet him, I would have to make excuses to my friends about where I was going and what I was doing. It was actually ironic—for the first time part of me felt like I was doing something right—something natural by spending time with another man. But at the same time, part of me was still concealing this part of my life by hiding it from my friends—and more importantly from my family. My family has always been such an important part of my life, and I decided I needed to make talking to them a priority.

That spring I decided to surprise my parents and fly home for Passover weekend. For some reason my mom chose to have another Seder at home even if it meant no children at her end of the table. This was six months after my first date with David.

I arrived with no preconceived notions of what was going to happen at home that weekend. My parents were, of course, pleasantly shocked when they saw me through our kitchen window as I pulled my suitcase up the driveway. I could smell the Seder dinner being prepared as I neared the backdoor. My mom ran out and threw her arms around me. When her turn was over, my dad did the same.

Extended family and friends started arriving a few hours later. I know I had a lot on my mind, and my serene behavior must have seemed puzzling to all who knew me well. The Seder began and I sat quietly back in my usual place at the long glass dining room table. I know my mom took notice as my dad pressed through the ceremony—seeing how far he could get before the tenderloin came out of the oven.

The next day my parents both sensed I needed to talk. They knew there were some changes going on in my life, and I was in the process of making important decisions. I'm sure they assumed the biggest issue on my mind was whether I had decided if I was going to law school the following fall. But I also knew, through talking to my sister, that they were concerned because they did not really know what I did with my free time anymore, if I was happy, if I had even made any friends in the city.

I told them that my decision to attend law school actually was not the most trying issue on my mind—I had a few other issues that were more in the foreground. I remember I paused, took a deep breath and these words came out of my mouth. "I haven't really made any life decisions yet, but I wanted to tell you that over the past few months I had made some new friends. I actually started dating men."

My dad immediately became quiet. My news was probably one of the last things he expected to hear from me right then. I'm not exactly sure what went through his head at that moment—disbelief, concern, anger, doubt—but he certainly kept his distance the rest of the weekend.

I looked at my mom and could see tears gathering in her eyes—but at the same time, I could tell my news did not shock her. She mentioned something about a parent's wish for her children and if I had thought about the fact that she may never have grandchildren. She thought it might be a good idea to get out for awhile and take a walk in a nearby park.

The two of us left the house with Abby and drove over to Wildwood. We walked in silence for a long time, and then my mom turned to me and told me about some of the problems she was having with my dad—how her newfound spirituality placed an obstacle in the

way of their relationship; and how this news was not what my father needed to hear right then because she knew he would not deal well with it. She told me she already knew—she had known for years. A mother always knows, she said, and she just wondered when I was going to be ready to tell her. She embraced me as she expressed how happy she was that I came home for Passover. Her Seder felt a little more complete because I was at the table, and she was reminded of Seders we had when Robin and I were younger.

We walked and talked for a few more hours through the park that afternoon. When we returned home, we both knew my dad would remain quiet. My mom later told me that he thought he was almost positive it was a stage I was going through and that it would pass. My mom knew differently and tried to explain it to him—how I never had a girlfriend; how I probably did not just come home that weekend to celebrate Passover again.

And then I received a phone call three days after I returned to New York.

"Andy, I just wanted to let you know that I love you—and no matter what you will always be my son."

"I know, Dad. I'm still the same person," I responded.

"I know you are. It was nice to have you home again for Passover. You made us both very happy. You know how special this holiday is for Mother."

House of Worship—Coming Out to My Brother on Passover

David Rosen

> *Our God and God of our fathers,*
> *be Thou ever mindful of us,*
> *as Thou hast been of our fathers,*
> *so that we may find enlargement, grace, mercy, life*
> *and peace*
> *on this Feast of Unleavened Bread.*
> — "The Passover Seder Service," Union Haggadah

I came out to my brother on Passover—right before our family Seder in 1978. It all sounds so neat and tidy put just like that, doesn't it? It wasn't. I sound so out and proud and certain. I wasn't. My family sounds just so Jewish. We weren't.

This all took place when I was a freshman at college, the youngest of my parents' four kids, and the only one who elected not to follow in the firmly established, multigenerational Rosen family tradition—of going to college at the State University of New York at Buffalo. This was the acknowledged path-of-least-resistance. My two brothers and sister all attended this college while living at home. Oddly known as SUNY/Buffalo, and boasting the unlikely logo of a cheerful tropical sunburst, the school's main campus was a mere three-block walk from our family's often cloud-covered, and frequently snowbound, house.

It was a gray-and-white, stately old three-bedroom, two-story, freestanding house with lots of room for frequent stagings of interior drama. My youth was spent amid news reports of race riots, Vietnam War protests (with local sit-ins and tear-gas battles on area campuses), regular grade-school air-raid drills ("Everybody Duck-and-Cover!"), horrifying assassinations of political and spiri-

tual leaders (one sad cortege after another, coffins wrapped in flags), and close to home, the rising threat of muggings and neighborhood-gang wars. Yet through it all, my Mom insisted that dinnertime conversation be uplifting and trouble-free. Long before the New Age phenomenon made its way to the East Coast, my mother was our own resident guru of Don't Sweat the Big Stuff. Dinners at the Rosen household were mostly failed attempts at "Ozzie-and-Harriet" blandness, punctuated by heaping helpings of Shake and Bake, Tater Tots, and individual portions of Jell-O instant pudding topped with a dollop of Cool Whip and a maraschino cherry, if we were good.

Other than this nightly struggle to keep at bay the collapse of civilization, my parents had one other all-consuming obsession: their favorite pastime was without a doubt a spy-versus-spy sort of spelunking into every subterranean nook and cranny of their kids' never-really-private lives. My siblings, each after turning 16 or so, responded by vociferously challenging every act of parental interference with (long before the advent of Walkmans) their cranky-nasty-hurtful volume settings pumped up high. I got the message, loud and clear: College=Fun; College while living at home with my parents? A living Hell. There were slammed doors, late-nite screaming matches, and never-ending histrionics. There were high-pitched teary scenes worthy of Chinese opera. My Dad pounded table tops, threw silverware, upended chairs. My Mother liked to faint. So, as I hit my teens, I somehow knew deep down, as the God of my fathers was my witness, my tomorrows lay elsewhere.

My ticket to ride was a letter that arrived with little fanfare when a small, private liberal-arts college (that almost no one we knew ever heard of) showered me with the promise of various and sundry financial scholarships. This would be my one big chance to make the great escape from my parents' overprotective clutches. My Mom and Dad were, yes, exceedingly generous and loving— yet, in their all-intrusive and unequivocally demanding way, they were expert at playing the highly coveted roles of oh-so-stereotypically Jewish parents. "I am not your friend, I am your Mother," went Mom's battle cry. "We only want the best for you . . ." would begin Dad's every, sweet, manipulative shpiel. "C'mon—

It's in your own best interest. . ." he'd continue, blah, blah, blah. Translation: It's for your own damn good that we are torturing you to distraction with our suffocating over-concern.

So, in the fall of 1977, I trotted off to the kinda tiny, sorta ivy-covered campus of little-known Elmira College, smack dab in Nowheresville, Southern New York State (a celebrated nearby town is called Horseheads). Nevertheless, I now realize I spent my college years in a halcyon, dappled, golden-light drenched Brigadoon of a setting. What Elmira is famous for (other than its nearby penitentiary) is that the college houses a Center for Mark Twain Studies (this due to the fact that Samuel Clemens summered near there with his wife Olivia Langdon for years and years at her parents' hilltop Quarry Farm. His teeny octagonal study now rests on campus). So, not really sure why (I can't say I cared all that much for Mark Twain back then, or even now, for that matter), I answered the siren song of new literary treasures to be discovered there (and relative freedom from parental espionage), and I signed on for a free-as-a-bird free ride as an English major there. Did my family have any idea I was leaving home so I could finally be gay?

Did I? It would take me all of one month and a few days to hook up with my first boyfriend, a dark-and-dreamy sophomore art major named Michael. "I live for art and sex, that's it," was his manifesto. In his arms, I learned a lot about both.

Was it the newfound beauty, the utter revelation of unabashed lovemaking with another man that gave me fortitude to come out to my brother Rick later that year? Was it because I was sleeping with someone so sensual and handsome that I finally felt proud to be a sexual human being, of any persuasion?

I'd soon show Michael off to my mother and father at a parents' weekend. And I made them take my "new good friend" and me out to dinner at the town's most expensive restaurant. From then on, my Dad would forever refer to Michael as "you know, your handsome artist friend, what's his name?" Or "The good-looker who paints those designs your Mother likes?"

The day after our own little Guess Who's Coming to Dinner? Michael gave my parents a tour of his studio, and Mom had stared, transfixed, at his oversize, multi-layered, abstract color-fields in

textured roses, mauves, and russets. She didn't really know from anything abstract art, nor was she an avid original-art collector (save for her well-chosen menageries of crafts-fair butterflies, frogs, turtles, and birds. She also bought bells). But taken aback by this unexpected rush of art Nirvana, Mom gushed and gushed with her flirty version of high aesthetic praise: "Oh Michael, I wish I could have some dresses and scarves and sheets and drapes in those colors and textures. Like tapestry. . . Gorgeous!"

A couple of years later, she and I would together go ga-ga over an exhibit of Sonia Delaunay's art at Buffalo's Albright-Knox Museum. Now, these glorious geometric patterns had indeed made the jump from canvas to scarves, dresses, china, and so forth, and so stunningly fused the realms of art and life. Michael would later move to New York City and become somewhat famous for his canvases, lamps, tables, and chairs. My Mom and I would forever owe a great debt to him for our parallel first forays into the sensual realm of aesthetic enlightenment.

I wonder how often coming out to one's family is linked with the utter unexpected joy, release, and transcendence that accompanies finally finding someone to love or having fabulous sex or recognizing something truly elemental, archetypal, and aesthetically fulfilling about yourself. Or about the world around you, and your place in it. When you—even for one fabulous moment—feel that maybe yes, something core and key has just fallen into effortless place. Click. Ah. . .Nice! It strikes you unawares and makes you hyper-aware.

All I think I could articulate at the time was that hanging out, learning about art, and having sex with Michael almost always felt right, and to this day, more than 20 years later, a whiff of turpentine or gesso or oil paint still holds the power to conjure up past pleasures from this golden time.

But, back at the Rosen ranch, during the year before I flew my Buffalonian coop, my so-called life was as easy and as vexing as 1-2-3. (1.) I had yet to have sex with anyone; (2.) I often thought of my parents as my closest friends; and (3.) I absolutely revered my brother Rick. This was decades before the *X-Files* and no one

knew the Truth was Out anywhere, but now I do believe Rick bore a striking resemblance through his high school and college years to young David Duchovny. He played guitar and sang in clubs. Girls adored him. I adored him (when I wasn't feeling jealous). Rick was not-at-all nerdy but smart, an experienced college senior, a sometimes jock, and, even though he had gaggles of friends, he still liked doing stuff with me, his needy three-years-junior brother. We did stuff like midnight bowling and going out for pizza and shopping for clothes, taking downhill ski lessons, and, once a year, skipping off to sailing camp on Lake Chautauqua. Rick thought it was great I was going away to school. My sister Dale and oldest brother, Bruce, were suitably "wink-wink, we understand, really we do," envious for what they missed out on. My parents, on the other hand, had a decidedly hard time wrapping their heads around this Going-Away-to-College concept. So every single day, and sometimes twice a day, throughout my high school senior year, Dad would pull me aside and say stuff like "Don't tell your Mother I said this, but you know, your not being here will be unbearable for her. You've always had a special connection. And you'll always be her baby!" Mom would say: "Your father, you know, is the real mother hen here. He hates to see his brood leave the nest. This is rough on him, emotionally, I mean. But he'll never ever admit it." What I personally found unbearably rough on myself were the endless daily drills in Going Off to College 101, lessons in budgeting and "bachelor" cooking, laundry and such.

Mom and Dad were absolutely gleeful about the scholarships. "It couldn't hoit" (as my Dad was often wont to boast to his cronies, or the newspaperboy, or anyone who'd listen, for that matter) that I was getting my college paid for, and paid for not by him! "They gave my youngest son the scholar an offer he couldn't refuse, a full scholarship to a private school, no less." He'd kvell and kvell for years.

That my parents would over-kvell with exaggerated overkill about this, along with all of their children's each and every accomplishment, should come as no surprise. In this way, my parents were following The Script—handed down from the time of the Ark to every living-and-breathing, card-carrying, quintessentially Jew-

ish parent. My parents lived entirely, relentlessly, for their kids. They made every sacrifice for their kids, so their kids would do better than they did. They'd lived through the Depression; they'd lived through The War (Dad's Sergeant Major nameplate from WWII still graced his home-office desk). They'd been there, they'd suffered, they'd endured rationing! All for us apparently not-grateful-enough kids, somehow. They knew first-hand the value of a dollar, or even a penny. "We used to walk to save the nickels the trolley cost; that's how bad it was" and "You kids are so cavalier about your money" were often-reprised, counterpoint refrains. Especially whenever we'd ask Dad for some bucks. He'd open his bulging wallet, sigh, and rifle through his cash, and sigh some more. "When you're on your own, making your own fortune, you can buy anything you want. You think this green stuff grows on trees?"

Sigh. My Mom and Dad: They were just so . . . Jewish. Not bad for a couple that were actually of mixed-faith. It only recently has dawned on me, now that my father and mother are dead some ten and fifteen years, respectively, that my family—the eternally kvelling Paul and Ethel Rosen and their brood of four—were, in the strictest sense, "passing" as Jewish. You see, my Mom was raised Lutheran. Sure, the story goes, that my Mom took some classes with a favorite rabbi after she'd been long dating my father. But, truth be told, she never really converted (you know, with the sacred baths, and all the woo-woo arcana that officially makes it stick). Poof—you are now a Jewess. Nope, not her. OK, sure, I myself have always bristled at the thought of anything "official." (Maybe it's true that the youngest is often born to rebel.) So I like it just fine that Mom did the Jewish thing her own, unconventional, way. Besides, we all knew my mother was an acknowledged expert on How To Be Jewish. Because she had taken classes and learned about the holidays and such, she was our in-house Judaica authority. "Ask your mother," Dad would answer when we asked him stuff like "Why do Jewish boys have to have a Bris? Why not girls?" Or, more immediately important, why we had to give up pizza for Passover. Yes, Dad's Jewish-last-named My Three Sons were all bar-mitzvah-ed. (It wasn't yet quite so fashionable for girls to be bat-mitzvahed, so my sister was spared or slighted, depending on

how you look at it.) And, sure, we'd light the candles, pass the challah, and say the Shabbos prayers each Friday night. But we were also just-enough, somehow undefinedly, super-socially, also pretty Christian. Hey, we're talking about growing up in a Midwest wanna-be locale, living in the shadow of the 1950s, confronted by the "turbulent" '60s, and hearing rumors about the Age of Aquarius and the Age of Assimilation. Folks wanted to blend in, big time. We succumbed to the pressures (and also managed to do our own bipartisan thing).

We celebrated Christmas with my Mom's family. We did restrain ourselves in our house, however, from having an Xmas tree (Channukah bushes had just begun to crop up among some factions, but we scorned them). Often there were Christmas presents and egg nog and stockings hung by the fake fireplace, and a train set that materialized like the miracle of The Three Kings in our treeless living-room each December 25th. Dad, the third-generation proprietor of Rosen Roofing Company, loved toys, gadgets, tools, tinkering, and games. He loved doing stuff with his kids. He was just like a kid on Christmas. . . on Christmas morning or any morning, for that matter. And he served on committees for our synagogue, the trendy Temple Beth Zion. All us kids went through years and years of religious and Hebrew school (eventually going so far as to teach there). There were B'Nai B'rith Bowling trophies in the den. Pretty convincing outward signs of being in The Tribe, huh?

But inwardly I was forever torn between divided loyalties, not just a little then, and now looking back. My upstanding Reform-Jewish family is coming into focus as a somewhat-in-denial, half-Christian, half-Jewish clan—a family that worked over-time at being Jewish yet had a whole mess of Christian hobbies.

I mean, if you did the math, more than half of my relatives were Christian (Dad was an only child; my Mom's side had many more aunts and uncles and cousins). So, most of my relatives liked ribbon candy and blinking lights and snazzy wall-hanging crosses made out of shellacked matchsticks. . . . What kind of Jews were we?

So, it was in this context of mixed-blessings that I, young WASP-wanna-be Dougie-Duvvy Rosen, also endured no small degree of sexual confusion throughout my youth. It is safe to say that

I had crushes on everyone: classmates, friends, teachers, rock stars, athletes, boyscout leaders, waiters, best friends, and such—of both sexes—ever since I can remember. I escorted my high-school best friend Lorna to the prom (silently aghast at her emerald-green gown), and was overjoyed to be able to dine and dance next to my Italian-stallion, body-builder heartthrob named John. (Unlike Lorna, this kid knew how to dress, and was always well turned-out.) Did I realize then how much I enjoyed it when he hugged and kissed me on both cheeks, whispering "I love you, Man," whenever we met or parted? How cool I felt when we made a pact to dress up every Friday—with ties and shiny polyester shirts and dress slacks. (No one knew from Casual Fridays in 1977; in Buffalo, it was often the day to wear something "fancy.") How John and I so yearned to be adult. How I longed to be one of a "couple of swells."

What you also need to know to understand the un-holy machinations of my coming out at Passover is that for my family, we, vaguely Christian, passing-as-Jewish-with-great-aplomb, followers of Abraham: The holiday of Passover was in all truth a shimmering centerpiece of special "family time," as they say, which we celebrated with unwavering gusto. It was a given: We liked being Jewish on Passover. The Passover Seder was as close to sacred as it got, a veritable food-fest extraordinaire, and an audience-participation extravaganza, our dinner-theater-in-the-oblong. Martha Stewart (yet to appear on the celebrity horizon, at that point) would have found no fault with my Mother's holiday table. As we all grew up, Passover became a great excuse for my folks to summon their charges home, to "do this for Mom" one more time, my Dad would beg, "will you, please?" Years later it would be my Dad who would call us back to Buffalo for a Waltons-esque family homecoming at Passover time. "Your mother's not doing so well; she's on oxygen at night for the emphysema, and they've discovered she's now got a little cancer in her lungs." We all came running. Or driving and flying, and, in my case, Greyhound bussing, with sympathy shortness of breath.

As fate would have it, it would be Dad who would be the first to leave this Earthly life, dropping dead of a heat attack one spring morning at the family cottage in Canada. (Think Henry Fonda in

On Golden Pond, except my Dad didn't make it.) Mom would out-live him for a five years, many days wondering why she was taking so long to die and when she'd be able to join him.

Now, turning my nostalgic gaze back to my coming-out Pass-over, I will never forget the care I took helping Mom set her Seder table—placing her best china, classic ivory-colored and edged in silver, in four settings per side, one at each end. The flatware, a simple pattern, I see in slow motion, each being lifted out of its majestic blue-velvet-lined box, each single, precious, piece handled as if it were a gem, and then nudged deliberately like a chess piece into place around the leaf-enhanced table. Three generations' worth of the Rosen family could now be accommodated.

Next, I placed all the familiar Passover touchstones. First the pewter seder plate with lustrous colored-glass inserts, which would hold the requisite roasted egg and lamb-shank bone, the horserad-ish root and the parsley, and the mixture of apple, raisins, nuts, and wine called haroses. Next, the satiny matzo-cover, with its se-quined blue Hebrew letters and the sparkly Star of David.

And last, the duo of candlesticks on a tray. Formany years, my dear (usually tasteful) mother—who always reminded me of a classy, feisty Katharine Hepburn (crossed with the ever-control-ling, petite spitfire Ida Morganstern)—signaled the start of Shabbos and holidays like Passover by lighting the five candles of her elabo-rate, Liberace-worthy, swirly-armed, silver candelabra. Trust me, nothing else in my youth was as campy. But, in later years, my mother grew weary of polishing silver (and dusting, and doing the laundry, and cooking, come to think of it), and she grew exceed-ingly fond of pressing into service a no-fuss, not-at-all-ostenta-tious, pair of pewter candlesticks (maybe acquired at the Hall-marks store in the Boulevard Mall). They were pretty but plain, and if you were in a generous mood, you could say lovely. I ovr-compensated, I guess, by assigning them metaphoric weight. I imag-ined them on their silver tray as a graceful couple—maybe two men—skating on ice, or maybe a pair of silent swans, adrift atop a mirror-still pond. Sometimes, when my mother recited the prayer over the candles, I can now admit with suitable yearning for what's gone, I would picture the comparable scene in *Fiddler on the Roof*

and have to hold back tears. It was all just too exquisitely beautiful:

> Boruch atto Adonoi Eluhenu melech ho'olom
> Asher kidd'shonu b'mitzvosov v'tzivonu
> L'hadlik ner shel shabbos.
> Praised art Thou, O Lord our God,
> King of the Universe, who has sanctified us
> By Thy commandments, and hast commanded us
> To kindle the Sabbath lights. Amen.

On Passover, "Shabbos" would be replaced with "Pe-sach," but Mom's prayer would elicit the same potent aesthetic and emotional response. Similar to the way I always cried at the lighting of the Olympic torch, I might add. Let the Rosen Family Games begin!

What followed—why this Passover night was different from all other night—would be the cameo star-turns we family players would perform. Mostly everyone would have a prayer or song. So after the chanting of the kiddush (by Dad): blessing the syrupy Mogan David wine, and the prayer for the matzo (Rick), and the dipping of the parsley in salt water (maybe Bruce), came my time to carry on the tradition of asking the Four Questions. My heart would beat a mile a minute and I would chant, "Ma-nish tannah ha-lilah ha-zeh mekol ha'laylos. . . . Why is this night different from all other nights?"

In 1978, only my brother Rick and I knew how different this night really was for me.

Earlier that day, when Rick and I found ourselves in the cellar hunting down canned goods and pans and other things for our mother, I announced that I had something I wanted to tell him.

"Shoot."

"It's pretty serious."

"Are you OK? Is it something bad?" Rick asked.

"No. I don't know. Just hard to talk about."

"You can always tell me anything."

"I'm gay," I blurted out. "There, I said it. I mean, you probably already know that. Maybe you didn't."

Rick was expressionless. Tears formed in him eyes. But he was studying to be a psychologist, and he tried his best to listen without judgment, with suitable (somewhat forced?) empathy. Rick had recently interned at a drop-in clinic, and so here in my Mom's makeshift pantry, he was marshalling his training into the fore, I could tell.

"I didn't know," he said. "But that doesn't mean anything. How do you know?"

"Well, I've met someone. His name's Michael. And I think I'm in love. Or maybe just in lust."

Rick started to cry, and there, amid the white-washed shelves laden with cans of Green Giant Green Beans and multi-pack rolls of Bounty Paper Towels, he motioned for me to come into his arms. He hugged me and told me that he loved me no matter what. He just wanted me to be happy. This was going well. I sobbed and sobbed.

"But how can you be so sure, Dave?" Rick mumbled. "Lots of folks experiment in college, you know, and go through homosexual phases and stuff. Just don't feel that this is so conclusive. Maybe it's just a phase, or something you want right now."

Maybe this wasn't going so well. The old "This is just a phase you're going through, kiddo" reasoning.

Rick continued, "I just don't want you to get hurt. How does it all make you feel?" Danger, danger. He's pulling the psychologist act on me, I thought.

"Rick, I'm happy. Maybe a little torn. Maybe I'm bisexual. I don't know."

"I've counseled a few guys who are bisexual. They're pretty tortured."

Now I was really upset. "Rick, you can think whatever you want about whether or not I'll always be a homo. Please don't compare me with depressed college kids who come to you after trying to commit suicide or something. I'm dealing with this really well. A little confused, but pretty happy."

"Well, you sound somewhat conflicted. That's OK to admit."

Shit. Now I didn't know what to think. I was so mad. It wasn't just a phase I was going through, was it? I thought I had resolved something.

"—and whatever you do, I hope you're not thinking of telling Mom and Dad."

"Don't worry. I'm only telling you," I said "I thought you'd understand." I was getting snippy.

"Dave, I do. It's OK. I do understand. I love you whatever. I just want you to be happy. So be good to yourself, and take it one step at a time."

"I will."

We were no longer hugging, and looking down. We picked up the stuff Mom asked for.

Suddenly, a voice from on high: "Boys, Are you finding everything OK?" Mom called down from the kitchen.

"Oh yeah! More than we bargained for," Rick muttered.

I giggled. Rick started to laugh, too. Pretty soon we were laughing uncontrollably, goading each other on, like we'd done since we were kids.

"Yes, Mom. We're coming up," I hollered between squeals.

"Is this friend of yours a nice guy?" Rick whispered as we marched up the stairs.

"His name's Michael. He's really wonderful. Handsome."

"Great. If you like him, Dave, then I'll like him, too. I hope I get to meet him. Hang out, you know. I want to get to know him."

Now, that's more like it, I thought. Maybe Rick and I could still be friends. Maybe it wasn't so bad for me to be Rick's gay little brother after all.

By the time that eventful Passover Seder had progressed to the ritual breaking of the middle matzo—and the feigned hiding of the affikomen (which Dad had always taken care of, mysteriously, Dad-like, beforehand), Rick and I had exchanged a lot of knowing looks, and smiles. At one point, Dad asked us boys if we were dating anyone new, and Rick and I just had to laugh out loud. oon, we were in tears, again.

"What are you boys up to?" My Mom asked. "I like the laughter, but what's so funny ?"

"Nothing's funny, Mom," Rick answered. "Just brother stuff."

I loved my brother Rick so much.

Together there we were, gathered around the Seder table, the circle of our family made sacred by the motion of our hopes, our shared knowledge, our prayers. We were seeking God's blessing and each other's love. And there, then, together, we constructed our own unique sort of Christian-Jewish, Jewish-Christian architecture. We, together that night, as so often in our lives, built a private house of worship, linking ourselves with a chain of sanctified souls. Jewish, Christian, or otherwise. Some of whom, I had to believe then, and as I still do, were gay like me.

Two Women, One Man, and Me

Daniel M. Jaffe

In 1987, I was a securities lawyer on yet another Palm Springs booze-and-shmooze junket disguised as national conference: one part golfing (I didn't golf), one part drinking (I didn't drink), two parts kissing ass (I did kiss ass, but not in a way that would help my corporate career). For the benefit of any IRS agent who might happen actually to check the write-offs, conference organizers stirred a jigger of substantive lawyering into the mix, which really made the conference a bore. Instead of attending a Friday night cocktail party, I sought a venue offering genuine comfort—a gay bar.

Across the proverbial Some-Enchanted-Evening crowded room, I spotted a handsome bearded man with glasses, a receding hairline, and an overall post-college-nerd look to his face. Hot hot hot. He returned my smile, we chatted, tossed back a couple of Diet Cokes on the rocks, drove to my air-conditioned, pastel-colored Marriott (Hyatt? Sheraton?) hotel room, enjoyed each other on the king-sized bed before falling asleep, then while sleeping, then after waking up. Bob was cute, Bob was horny, Bob was sexy, Bob was horny, Bob was smart, Bob was horny, Bob was Jewish.

Bob invited me to extend my stay in Palm Springs and enjoy the rest of his vacation with him. I did—barefoot midnight walks on the golf course near his rented condo, hand-holding drives through the Coachella Valley desert, secret kisses behind this tree and that in Joshua Tree National Park. How appropriate for us to kiss behind trees named for the prophet Joshua, their prickly-fisted arms uplifted and outstretched as if in biblical supplication. The first time either of us had found a Jewish boyfriend.

Although raised somewhere between Conservative and Orthodox, I had distanced myself from tradition, feeling that, as a gay man, I was somehow beyond the Jewish Pale. But now I was finding acceptance and affection in a Jewish man's eyes and arms. Bob, a Reform Jew, was even an active member of his local B'nai B'rith and American Jewish Congress chapters. A real Jew.

A quick, tearless embrace at LAX—this was, after all, a beginning, not an ending—and Bob returned to St. Louis, I to Boston. Six months of bi-weekly telephone calls and my monthly weekend visits to St. Louis (Bob worked in television and was on call in case of weekend television emergencies [?], so he couldn't visit me). We longed for a stretch of time during which we could do more than become awkwardly reacquainted over a Shabbos chicken dinner, spend a passionate night in bed, hang out watching professional wrestling with Bob's one gay-Jewish friend, spend another (somewhat less) passionate second night, grab a deli sandwich, and say an all-too-soon goodbye.

Bob suggested we take a summer trip to Israel, one sponsored by the Reform movement for folks in their early 30's like us. I readily agreed. Bob's only caveat was that we could not acknowledge our relationship to others in the tour group.

Although I was "out" back then to friends and family, I was not out at work, so I acknowledged the importance of remaining closeted in certain contexts. Rather, the seeming importance of remaining closeted—the terror of disappointing and hurting friends or family, the terror of being rejected and finding oneself alone, the terror of losing love and career opportunity—terrors collectively seeming to outweigh all that could be gained by coming out: self-respect, dignity, inner peace, friendship, and love. Since Bob had not yet come out to parents and most friends, and since one of the Rules of Gay Brotherhood is to respect another's closet rights, I totally agreed to keep our true status secret during the trip. This, I admit, even added a titillating naughtiness to the venture.

For Bob's taste, "friends" was too simple an explanation of our relationship, so on the El Al flight between Kennedy and Lod Airports, we transformed into cousins related on our mothers' sides. (What was that sexy movie from the seventies? *Cousin, Cousine*?)

To my surprise, this lie was swallowed easily by the two dozen others on the tour. To my even greater surprise, and to my even greater dismay, others found our physical resemblance, Bob's and mine, so uncanny, that some could not tell us apart. "Are you the lawyer," I would hear more than once during the trip, "or are you the TV guy?" (Such resemblance had not entered my [conscious] thoughts. But now when I look at a photograph one of us took of the other from behind, in a narrow Safed alley, I can't discern which of our yarmulke-sized bald spots the camera captured. Oy gevalt, Freud! Vey iz mir, Narcissus!)

Perhaps one reason the group so readily accepted our cousinhood was that a rabbinical student named Amy happened to be rooming on the trip with her own cousin, Sheila. The possibility that they might be kissin' cousins like Bob and me never popped into my head. Even though I had gay and lesbian friends, even though I frequented gay and lesbian social venues, everyone was hetero until proven otherwise—innocent until proven guilty. In this particular case, my self-invisiblifying assumption would prove correct: if ever God had created heterosexual woman, He'd done so with Rabbi Amy.

Israel may be the Promised Land, but it wasn't the romantic paradise I'd been expecting. Because Bob was too tired from the flight, we didn't make love our first night, in Tel Aviv. We didn't make love the second night, in Haifa, because Bob was too tired from the bus ride. We didn't make love the third night, at a Galilee kibbutz, because I was pissed about the first and second nights.

Embraced by our respective passive-aggressive silences, we bounced beside each other on the tour bus to Jericho, where we experienced food poisoning and then, for two days running, gave explosive vent to the consequent fragrant putrefaction in our shared Jerusalem hotel bathroom. Not an atmosphere conducive to romance.

A bumpy bus-ride side-by-side to Eilat, by which time our silence had at last been broken—we now bickered at breakfasts of cucumbers and hard-boiled eggs ("I tripped over the sandals you tossed off in the bathroom!" "I was afraid they'd muddy the floor that was all wet since you don't know how to tuck a shower curtain

inside a bathtub!"); we bickered at lunches of hummus and tabouleh ("You didn't hold the door for me at the museum!" "Not my fault you can't keep up with the group!"); we bickered at the god-awful fried leather dinners deceptively called shnitzel ("Must you chew gum all day?" "You want my breath to stink like yours?"). Bob whined that the air-conditioner in our hotel room didn't work well, complained that the tour guide was way too arrogant, and responded to my last-ditch suggestion that we spend the day alone together, with: "I should miss snorkeling with everybody in the Gulf of Eilat? You've got to be kidding."

The group headed back to Jerusalem. At the Dead Sea, Bob and I floated on distant patches of oily brine. When we reached the summit of Massada and wandered from one precipice to the next, we glared at one another, each bearing in his eyes an obvious inclination to shove the other off.

Back at our shared Hyatt (Marriott? Sheraton?) hotel room in Jerusalem, I stated that, like the blood tie binding our unrelated mothers, our relationship was mere fiction.

"You're not kidding!" he agreed.

"Fine!"

"Fine!"

We sought the company of others. I'd already had a few pleasant conversations with Rabbi Amy, and now sought out her company. Rabbi Amy struck me as a typical Jewish beauty—dark hair flowing in curls, brown eyes offset by mascara, a lean yet curvaceous figure. And smart! And warm! Oh, how lucky the straight man who would find her.

One Shabbos, we spent hours together drifting around the hotel pool, discussing family and friends and upbringing. We discovered that Rabbi Amy had actually studied Jewish liturgical music with a distant cousin of mine, a cantor. Such a coincidence, our friendship was clearly *beshert*, meant to be.

As we tread water in the deep end of the pool, our legs gently peddling and our arms swaying from side to side yet never touching, I revealed to her something I'd never voiced to anyone, let alone to an almost-clergyperson: "I hope I don't offend you," I said, "but I'm not so sure that God exists."

"Interesting," she said without a flinch. "Where do you think the doubts come from?"

Her face hadn't twisted in horror at my remark, she hadn't breast-stroked away in revulsion. She wanted to understand me and, clearly, to help me better understand myself. I so wanted to tell her my reasoning: that according to the Torah, God regards homo me as an abomination, yet the Torah says I'm created in God's image. Doesn't that mean that God's an abomination, too? If so, then why the hell should we do what He says? If not, then something's wrong with the Torah's logic and I'm not an abomination, after all. And if the Torah's illogical or inconsistent on this point, then maybe it's a bunch of baloney altogether.

I wanted to say all this to a representative of the religion, and I wanted such a representative to have the chance to find the flaw in my reasoning so that I would no longer feel compelled to choose between God and logic, so that I could be gay and remain Jewish and a believer, so that I could be shown a consistent Jewish path toward self-respect. I wanted Rabbi Amy's help.

However, I reminded myself that even if I could no longer stand Bob, I'd agreed, for his sake, to remain closeted during the trip, and it wouldn't be fair for me now to out myself, and him by implication. So, in answer to Rabbi Amy's question about the source of my doubts, I simply said, "The Torah doesn't always seem logical to me."

"Ah. I know," she said, tilting her head, raising her eyebrows, adjusting the right strap of her two-piece bathing suit. "Frustrating, isn't it?"

She was agreeing with me? This near-rabbi was agreeing with my blasphemous questionings?

"Yeah," I continued. "I mean, if the Torah's not always logical, then how can you trust it?"

"I guess faith needs to be approached through spirit instead of logic. And you know, even if all the God stuff doesn't work for you, there's an awful lot in the Torah about how to be a good person. That's worth something, don't you think?" How progressive and non-controlling of her. Firm and principled in her own belief, but respectful of my doubts.

Brotherly warmth filled me. I gave Rabbi Amy a hug, right there in the deep end. She returned the embrace, then we swam to the pool's edge, toweled off on lounge chairs, and basked in Shabbos sunshine.

In the hotel room before dinner, Bob sneered and said, "Everyone's talking about the *shiddach* between you and Amy."

One hug and already she and I were being married off. Bob hummed Mendelssohn's "Wedding March." The twerp.

Rabbi Amy and I spent our remaining two Jerusalem days wandering through the narrow streets of the Arab souk and the renovated Jewish Quarter. We chatted about Israeli politics and our careers. We enjoyed cucumbers together, smilingly gnawed shnitzel side-by-side. But I didn't initiate any more hugs because I didn't want to risk misleading her.

Our last night in Israel, I went with the tour group to a night-club; Rabbi Amy chose not to attend. When the singers started in with a rousing chorus of "David, Melech Yisrael," a song I'd been singing since first grade, I decided that Rabbi Amy had realized how hokey this show would be. I announced to the group that I was returning to the hotel. Sheila, Rabbi Amy's cousin-roommate, asked me to stop by their hotel room and convey the message that Sheila would be out "unusually late."

"Sure."

What I didn't know at the time was that while I was riding back to the hotel in a taxi, the two cousins were conspiring on the telephone.

I followed the door numbers to Rabbi Amy's room, knocked. The door opened.

Rabbi Amy stood on the threshold in nothing but a beige towel. Nothing but a beige towel wrapped in such a way as to reveal the beginnings of cleavage. Her dark hair was fluffy and dry, her makeup tastefully in place. Didn't look to me like she'd just stepped out of a shower, but, hey, what did I know about a woman's toilette?

Staring me straight in the eye, Rabbi Amy asked, "Would you like to come in?"

Perhaps my lower jaw actually dropped as the true nature of her invitation hit me like a slap in the face, maybe I stammered

"uh uh uh" while ogling her up and down, this woman in a towel who had just placed us both in a cliché Hollywood moment. I can't remember exactly what I said or did, but I definitely recall flashing back to a set of experiences that had taken place years earlier, an instant replay of the only "relationship" I'd ever had with a woman.

<p style="text-align:center">***</p>

During the spring of my junior Princeton year—1977—while in the final throes of gay-consciousness resistance, I took to heart a popular tomato sauce commercial—"Try it, you'll like it." The woman I selected to try, Arlene, was perfect in every way. We'd known each other slightly since freshman year when we'd sometimes sit at the same table in Stevenson Hall, the kosher cafeteria. I had grown up in South Jersey, she had grown up across the Delaware River in a Philadelphia suburb. I was hoping to get into Harvard Law School, she was hoping to attend Yale Law School. She was brilliant—spoke Hebrew and Arabic; she was beautiful-curly blond hair, freckles, sparkly eyes when she smiled. Her body? I have little recollection—what sort of college man ever notices a woman's body? Most important of all, our mutual acquaintances all thought we were perfect for each other; so many Ivy Leaguers just couldn't be wrong.

After years of trying to wait patiently for hetero attraction to enter my life the way others wait patiently for the arrival of the Messiah, I decided to take the initiative and give dating a try. I stealthily returned to Firestone Library the microfilm reel of *Playgirl Magazine* I'd smuggled out a month earlier and had been holding up to my dorm room's fluorescent light three times daily while lying in bed and...well...whatever.

And I asked Arlene if she'd like to go with me to a play at McCarter Theater on campus the following Saturday night.

"Sure!"

I can't recall the play, I don't know that I knew what it was even as I sat in the dark theater beside Arlene, wondering whether I was supposed to touch her hand or not. I had no inner inclination, and didn't know the rules. Her hand lay unobtrusively on the armrest between us; long graceful fingers, short manicured nails catch-

ing an occasional glint of stage-lighting. Arlene then slid her hand forward so that it jutted off the armrest's end. Another few minutes, and she casually pivoted her elbow just a tad; now her hand dangled over my thigh. Ever the cool one, Arlene never shifted her eyes from the direction of the stage; I knew because I kept turning my head and staring to see where her eyes were, and that hand.

After a touchless Second Act, and Third, I walked her through campus.

"Did you like the play?" she asked.

Not having watched the play, I hadn't the slightest idea. "Very interesting. Great blocking. Really good characterizations."

"I especially liked Act Three."

"Oh yeah, for sure. Act Three. A real winner."

We walked a bit in silence.

"I've never seen sneakers like yours before," she said, looking at my purple Keds.

"Yeah, me neither. That's why I got them."

"I like a man who's willing to be an individual."

God, she was perfect.

We reached the entrance to Pine Hall, her dormitory. Arlene stood facing me with her head tilted slightly up, her eyes fixed on mine. She was obviously waiting for me to make a move. Even I recognized that. I suddenly felt sweat jet out under each arm. Okay, this was it: I leaned forward, boldly touched the wrist above her temptress of a hand, and kissed Arlene on the cheek. Wrist and cheek, two moves at once—damn, I better slow down or she'll have me arrested.

"I'll call you," I mumbled as I raced away, not even looking to see what expression might be filling her face.

I returned to my dorm room and thought about the men of Playgirl.

Two days later, after eating all my (vegetarian) meals in the main campus dining hall so as to avoid Arlene in the kosher one, I girded my loins and telephoned, suggested that we go to a movie the following Friday night. She readily agreed. Gee, we even followed the same mix of idiosyncratic religio-secular observances:

only kosher food, but electricity on Shabbos. Yes, she was the perfect woman.

On Friday night, when I stopped by Arlene's dorm room to pick her up, she invited me into the suite she shared with two others; she was about to light Shabbos candles. Had she waited for me? Yes, she was the perfect woman. I stood beside her as she covered her eyes, waved hands gently over flames, said the brachah. Then she asked if I'd ever tasted Ouzo, which one of her roommates, a Classics major, had brought from Athens after spring break. If Arlene, the perfect woman, could sanctify Shabbos with something other than Manishewitz Extra Heavy Malaga, I could too. At her request, I recited kiddush over the Ouzo, then took a sip of this Greek holy water. Disgusting. "Very nice," I said. She smiled. "We don't want to be late for the movie," I added, setting my barely touched glass on the dresser.

This time, according to plan, somewhere in the middle of whichever movie it was we were seeing, I reached up to the hand dangling over my thigh and set my hand atop hers. She intertwined our fingers. I sighed—not in ecstasy or comfort or excitement, but in relief that I'd finally done it. Each time I turned my head to see if Arlene was looking at me (she wasn't), I noticed the faintest of smiles on her lips. This woman liked holding my hand.

I was bursting with pride. Not only could I could perform heterosexual hand-holding, but I intuitively knew how to please the woman. What's more, I had enough stamina to keep up the hand-holding throughout the entire movie, throughout our entire walk afterward through campus, and throughout the slow climb up the narrow stairs to her second-floor room. I was one hot stud.

Arlene again invited me into her suite. Mysteriously, our glasses of Ouzo had been set on the coffee table in front of the couch. "I guess one of my roommates expected us to come back," she said innocently.

My stomach seized with suspicion.

As she sat on the sofa—where a yellow blanket covered up heaven-knows-what upholstery stains—she handed me one of the glasses, which I took, careful not to let our fingers touch. I walked away from the sofa and stood with my back against a wall, as if to

be shot. (How Arlene ever had enough compassion to keep a straight face, I'll never understand. What on earth did the woman see in me? A goofy innocence, perhaps, a sincere disinclination to paw her, a genuine attraction to her intellect and personality.) She stood, stepped over to me, clinked glasses. We both sipped. Dreck!

Arlene pressed her back to the wall beside me and slid down to the floor, knees up beneath her long black skirt. I slid down too. Sofa spelled kissing; hard-wood floor spelled talking. I talked about a paper I was writing, elaborated on theories of brinksmanship as applied to tensions between India and China (I was a Politics major). Arlene listened politely, then mentioned, "It's such a coincidence—both my roommates are spending the night with their boyfriends."

An exit cue if ever I heard one.

Another sip of the ghastly liqueur or whatever it was, a quick peck on her cheek. "Gotta hit the library first thing in the morning," I said. "India and China wait for no man." The wit of the panic-stricken. If the Indians are right and there is such a phenomenon as reincarnation, I will come back as a garden slug or snail.

As I was half-way out the door, Arlene asked, "How about dinner next Friday in your dorm's cafeteria?"

She wanted to see me again? Hmmm, I didn't know if I cared for this masochistic side of hers. "Uh, sure."

I lectured myself all week long: "You've nothing to fear but fear itself…A man's gotta do what a man's gotta do… Try it, you'll like it…There's no business like show business…."

For some reason I assumed that Arlene's willingness to dine with me implied a desire to make love with me. I suppose that living in constant terror of having my sexual orientation put to the test led me to the delirious assumption that all women wanted to have sex with all men all the time, and that if I ever gave a woman the chance, she'd jump my scrawny bones in a flash. Or maybe I was simply projecting my own frustrated desire of having sex with all men all the time, and my own fantasy of jumping any set of male bones that happened to rattle in my direction.

Whatever the source of my naively perverse conceptualizations, on Friday I bought condoms for the first time. I just walked into the pharmacy on Nassau Street, circled from aisle to aisle for half an hour until the old lady at the cash register took a break and was replaced by an old man, then I boldly grabbed a red Trojan box from the display stand by the register and paid without a word. Not even a blink from that obviously dirty old man.

Where in my dorm room to put the condoms? I needed a spot that would be convenient, yet not grossly presumptuous.

I hid the red box in my top dresser drawer beneath my innocently white socks.

No, no good. To get the condoms, I'd have to get out of bed and then socks would go flying—how unsexy was that!—and maybe I'd lose my erection in the process. Nightmare of nightmares.

So I stuck the red box between my mattress and box spring. No, too lumpy. I removed the strip of 10 attached condoms, crumpled the cardboard package in a white plastic bag, shoved it beneath crunched up papers in my waste basket, and slipped the strip of condoms beneath my pillow.

No, Arlene might see the entire strip, and I didn't want her to think I was a sex maniac.

Ah—I detached one condom and slipped it beneath my pillow.

A convenient solution that yelled "responsible" but not "maniacal." The rest of them went beneath the socks. If it turned out that I needed more than one, then we'd already have done it, would be comfortable with each other, and if my erection ebbed on my way to the sock drawer, the humiliation would, at that point, be bearable.

By the way, how does one use a condom? Sacrificing one of the remaining 9, I tried to rip open the packet. It wouldn't tear. I bit the wrapper between my front teeth and yanked. The wrapper tore; so did the condom. Feh, bitter.

I had more success with Number 8. And since the condom was already out in the open, and since it would be a shame to waste it, and since I needed the practice anyway, I slipped off my pants, lay down in bed, conjured up memories of good old Playgirl (man on beach, man in rowboat, man in truck, man on sofa), figured out how to unfurl the rubbery little guy and…well…whatever.

My dorm room that year was part of a complex known as Wilson College, a semi-community with its own dining hall. Arlene and I sat alone that Friday night over a meal of crunchy cod and gray broccoli, she her typically effervescent self, asking me probing questions about the Mahatma. She succeeded in distracting me.

After dinner, she mentioned that she'd never seen any of the dorm rooms in Wilson College.

I silently repeated my "Try it you'll like it" mantra, then asked if she'd like to see my room.

She grinned. I took her hand, and all during the two-minute walk to my building, I thought I would puke.

I unlocked my room's heavy wooden door, we stepped inside, the door slammed shut behind us like one of those prison cell doors in *The Count of Monte Cristo* or *The Man in the Iron Mask*. Arlene looked at my standard-issue bunker: dresser, bookshelves, wardrobe, desk with two chairs set catty-cornered, one at the front of the desk for me, and one beside the desk for guests. And, of course, The Bed, which, although only a narrow single, struck me at the moment as monstrously huge.

I gestured Arlene to the guest chair, she sat. I sat in my chair. We were facing each other in a diagonal sort of way, with the desk corner protruding between us. I knew what I had to do. I'd thought about it, envisioned it, planned it, practiced it in pantomime no fewer than a dozen times that week: I leaned forward over the desk corner, caressed Arlene's cheek with my thumb, waited for her to lean forward, and … our lips met. Then I felt a sudden moistness … her tongue? Yes, her tongue. Hmmm, interesting. I let her tongue into my mouth. A little wet, but okay.

Her hair smelled like peaches. I reminded myself that I liked peaches.

How long were we supposed to keep this kissing business going?

Arlene stretched her arm over the desk corner, reached her hand behind my head and diddled with the back of my neck. I leaned further forward, reached my arm around her shoulders, felt the desk corner—that symbol of study and knowledge—jab me in

the stomach. I kept kissing until the dull pain in my gut grew to unendurable proportions. I pulled away. We both sighed—she, presumably, in satisfaction; me in multi-layered relief.

I stood. She stood.

I embraced her. She returned my embrace.

We kissed and we kissed and we kissed. Then Arlene sat down on the bed, actually lay back on the bed.

I could do this I could do this I could do this. I joined her.

We lay side by side and kissed, tongues and all.

And then, with fortitude arising from a now-or-never desperation, I tugged her gray Shabbos suit-jacket off by the cuffs. No resistance from her.

More kissing.

I undid the flouncy bow of her beige blouse, unbuttoned, tugged the shirt tails out of her skirt, slipped the blouse off her shoulders. No resistance from her.

I removed my best blue shirt and starched undershirt.

More kissing.

She unzipped her skirt, I slipped it off her. She undid her bra and slipped it off. Gott in himmel—breasts!

We kissed, I caressed her soft breasts, disappointed that they weren't firm and muscular. I reached my fingers into the elastic waistband of her pantyhose, and as I slipped them off, became totally entangled in their taffy-like, endlessly stretching legs. She giggled. A bit of finger-magic and bunching, then I hurled the humiliating bundle of nylon to the floor.

I slid off my own slacks and underpants in one fell swoop, lay down beside her and threw myself into my task, kissing those mushy breasts, licking them, all the while reaching between Arlene's legs and sliding a finger into her moistness and moving and twirling until I heard her cheep, "Oh! Oh! Oh!"

Not sure if that meant what I thought it did, I kept sliding my finger in and out.

"You better stop," she said, "or you'll break something."

Then, sighing repeatedly, she covered my face with light kisses. I supposed I'd done something right.

Arlene caressed my erection.

An amazing thing, erections. There it was, working just fine, responding reflexively to the various stimulations. Firm in her hand, dissolving years of insecurity and fears of mortification. But my erection felt somehow disconnected from the rest of me at that moment, the way my leg does when the doctor hammers just below the knee and my foot kicks forward. I felt no inner desire whatsoever, no compulsion to place erection where finger had been, none of the urge to orgasm I experienced every time I merely fantasized about men.

This hetero dating experiment was over.

Arlene whispered that she was uncertain whether we should go further. Knowing that I would not date her again, I said there was no reason for us to rush.

She studied the consternation on my face, and took on a serious expression I had never seen in her before. What was Arlene thinking right then? That she'd made a mistake by not inviting me into her body even though she was unready? Or that she'd gone too far too fast for such a conservative nerd like me? Did she see in my eyes that I wouldn't call her again, that I wouldn't, in those pre-answering machine days, answer my ringing telephone for weeks, that I'd avoid her in the various dining halls by eating peanut butter sandwiches in my dorm room three times a day for a month? Could she sense that I did not want her? Was she feeling sudden hurt?

<center>***</center>

Those weeks of dating Arlene, those weeks from a decade earlier, and that night in bed all flashed through my head when Rabbi Amy, so lovely and seductive in beige towel, invited me into her Jerusalem hotel room. Not wishing to mislead her any more than I'd obviously misled her already, I mumbled something about being tired, then dashed down the hallway. Glancing back over my shoulder, I caught a glimpse of Rabbi Amy's down-turned eyes, her bare-shouldered shrug, the drop of chin to chest. Did she curl up in bed and cry that night? Stare at herself in the bathroom mirror and scold her own forwardness? Or did she cut a white yarmulke into a voodoo doll and curse me as a pussy-tease?

The next morning, in the dining room, Rabbi Amy sat at a long table with her cousin and other women. I, munching cucumber-and-pita sandwiches, sat at a small table by myself. Not once did she glance in my direction.

On the El Al flight to New York, Rabbi Amy sat two rows in front of me, beside Bob, of all people. They laughed a great deal, and six hours into the flight, after lifting the armrest separating their seats, they lay down together, spoonlike, and napped. (Apparently, Rabbi Amy's gaydar could rival that of any Castro Street clone.) Bob, the very one who had teased me for having spent too much time with Rabbi Amy in the hotel pool, was now lying with his crotch pressed against her ass? All remaining respect I had for Bob evaporated like fresh water from the Dead Sea.

One week later, I wrote Rabbi Amy a letter, explaining that I was gay and apologizing for having misled her. Her response expressed a mix of sadness at what might have been, embarrassment at her misunderstanding, and appreciation that I'd finally told her. So began a friendship that has lasted for years, an important one continuing to this day. Rabbi Amy and I can spend hours discussing seeming inconsistencies in the Torah, the conflict I feel between Jewish principles from my youth and my current sense of self. We have not yet found a flow of logic that satisfies my doubts, but how comforting to be able to share them with a rabbi who respects me in my entirety. Rabbi Amy has helped me stop feeling like an outsider on the fringes of my own community.

I have not heard from Bob in over a decade.

Upon graduation from Princeton, more than a year after I'd abruptly severed all interaction with Arlene, I wrote her a letter explaining that I was gay and apologizing for having misled her. Her reply was brief, and true to her ever-gracious nature: "I wish you had told me back then. We could have been good friends."

When bothered now by pangs of guilt at my experiences with these women, I defensively reason that the three weeks with Arlene and the few days with Rabbi Amy undoubtedly loom much greater in my memory than theirs. To them at the time, I was probably just another jerk. And I remind myself that all dating is inherently full of misunderstanding and risk, that all men and women sometimes

date so as to build self-esteem, to gain experience, to satisfy immediate needs for companionship, affection and sex, and not necessarily to find a life partner. Everyone who dates knows that, or should. We can't always discern our own dating motives, let alone someone else's. Hurt is inevitable.

On the other hand, I don't like the idea of having been the agent of hurt, no matter how inevitable its occasional infliction might be. And my argument feels a weak palliative because it assumes that all parties bear equal understanding of the dating process and, therefore, knowingly undertake the same risk. Arlene and Rabbi Amy lacked information suggesting that I might be gay. Perhaps today straight women know enough to include potential gayness on their list of why-won't-this-one-want-a-relationship? But back then, they did not. The situation was unfair to them.

True.

Yet on the other hand, hadn't the situation been somewhat unfair to me, as well? Despite others' gossip, I didn't truly grasp that Rabbi Amy's interest in me differed from my interest in her. As a gay man lacking straight-dar, I couldn't tell. Likewise, in college, before ever having taken a woman to bed, I was unable fully to recognize the extent of my sexual indifference to Arlene. I couldn't have defined my lack of feelings in advance, not given the world's pressure toward conformity, the natural human inclination to internalize prejudice, even against oneself. Especially against oneself?

Are the consequences of living in a closet and clutching the door shut for dear life, are the consequences of behaving out of desperation entirely the responsibility of the closeted gay man? Or should some of the blame be borne by the phenomenon of the societally imposed closet itself?

On the one hand, we neither construct our own closets, nor do we choose to place ourselves in them. On the other hand, only we have the power to open our closet doors and give others the opportunity to know us.

I think of the tension between Hillel's questions: "If I am not for myself, who is for me? And when I am for myself, what am I?"

Myself, My Parents, and the World

Julian Padilla

Part One: Myself

"Are you starting to notice girls?" my aunt asked me playfully at the entrance to her house. My mom was getting my little brother out of the car, and the Christmas lights twinkled above me. I just smiled. "Oh, you are!" she said jokingly. I was eleven and knew I was gay. I had figured it out that year.

I felt very suspicious and anxious from the pressure of keeping my feelings hidden away and one of my crazy thoughts was that everybody knew I was gay, but no one would tell me they knew. Being in the closet made me feel scared, upset, and different from other kids. As a method of coping, I developed a very angry and vengeful side. I would dismiss my hurtful actions with a blanket excuse that would allow me to do anything I wanted, because society and my family made me stay in the closet. I would hurt other people or I would be very bitter, and I would rationalize it all in my mind.

Being in the closet didn't seem that bad while I was in it, but it hurt. I spent half a year figuring out I was gay and accepting it. I was brought up knowing that gay people were okay and deserved rights. It was no big deal. They were just like women or black people or people with disabilities. My parents didn't have to sit me down and specifically explain this to me. At the time, I didn't know anyone who was out, but I remember sitting as a family to watch the coming-out episode of the television show *Ellen*. Basically, my family is very conventional. I have two working parents and a seven-year-old little brother.

My story really began in fifth grade when I was introduced to gender roles, heterosexuality, sex, and puberty. With puberty came many ideas and conversations I would never forget, along with the feelings that helped me discover my sexual orientation. I remember sitting at lunch and listening to a conversation between one of my friends and the rest of us at our table. "I tried this number, 1-800-BIG-TITS. This woman talks really sexy. It's funny," my friend said. I didn't know what phone sex was but was quickly grasping the concept! "I also tried 1-800-GAY-GUYS, and a guy answered!" he added. People thought we were so naive. It often upset me that adults thought we were incapable of understanding sexuality or ideas pertaining to the world outside our own school, or thoughts about God. I labeled all adults ignorant. It was like something from a *Rugrats* episode. All the adults seemed to think that kids were so innocent, but in reality we kids were much more aware than they realized.

As I got older, I better understood how it would be hard to believe that a ten-year-old could be debating the truth about Jesus or the idea of reincarnation versus heaven/hell. Still my friends and I did wonder about and discuss those things. That year, in fifth grade, I found out about a friend's father's porn collection and the meaning of cherry popping. I remember going to my friend's house and watching the Playboy channel through the static fuzz. (His television didn't have that channel, but we could pick up a little of it.) His mother was out volunteering—she was a very conservative stay-at-home mom.

I was beginning to have crushes on girls and guys. The ones on the girls were a bit forced and dramatized. The ones on the guys were secretive and almost subconscious. As I look back on it I'd had crushes on guys before I knew what crushes were. In third grade I went to an after-school program. The director, Danny, was nice, masculine, and well built. I remember being sad when I saw his wedding ring and not knowing why I felt that way.

Yet the idea that I was different didn't develop until later. I thought everyone shared my feelings so they must be typical—and my first kiss was with a girl in a swimming party. Still, there were definite signs of my orientation, like the way I watched my friend

in his bathing suit at the same party. I had become closer to some new friends in middle school. One boy was funny and smart. Our goals were a lot alike and we lived a few blocks from each other. We also had a certain chemistry between us; when we were together we couldn't stop laughing. In the fifth grade I also became good friends with a girl from the neighborhood. We instantly clicked and our friendship had been close since. At school I met a guy who hadn't gone to my elementary school, but we quickly became friends. We had all the same classes and sat next to each other in most of them. He was the cutest guy, the nicest guy, and he had more charisma then anyone I had ever met. His smile was big and his eyes twinkled. He made me laugh the whole year. I had a huge crush on him.

I slowly began to understand my feelings and put them into perspective. I progressively became depressed and angry and spent many nights just crying. Then one night after crying for at least an hour, I ran into the bathroom and laughed. I told myself, "This is not going away. It's always been here. I can still live normally." Then I looked at myself with confidence and exclaimed "I'm GAY!" and I smiled and went back in my room. After that I felt such a relief, as if a huge weight had been taken off my chest. As much as that sounds like a cliché, it describes my feelings perfectly. After that I no longer had to hide my feelings from myself, but there was still huge pressure not to share this news with my parents or peers. It wasn't some sort of secret for me as I would traditionally think of secrets. It was just something that was a part of me that other people seemed not to understand but seemed to disapprove of. I "carried my cross," so to speak.

Around this time I was having a parallel journey of self-discovery. The spiritual and religious side of me was searching for something more than the Catholicism that I was raised with. It had nothing to do with my sexuality. I wasn't looking for something to "rationalize" or "excuse" my sexuality. I didn't think any religion could do that. At age seven, I had already decided I didn't believe in Jesus, though my very deep belief in God never changed. I talked to him all the time. I say 'him' because I was taught to. I don't really believe God has a penis, or a vagina for that matter. I don't

believe God has a masculine or feminine mentality either. I believe God created all the opposites including gender identity. The verse in the Bible that says he created Adam and Eve in his image, I understand as him giving them power to be godly. I thought about such things constantly, searching for the answers that flowed around me so obviously.

Then I had a "revelation." After about a year of looking at every religion and faith and idea I could get a hold of and also going to different places of worship, trying different ways of praying and expanding my horizons, I picked up a small book that would have a huge impact on the rest of my life. I had been meditating and reading the Koran, but nothing prepared me for this. The book was about a Jewish holiday called Yom Kippur. Everything fit perfectly with my list of values: healing of the world, charity, tradition, general guidelines to life, a sacred book and beautiful philosophies. Judaism was the last religion I thought of. I had pictured it as a bunch of out-dated old bearded men with funny hats and odd curls. But after that book, I knew I had found truth.

Before I continue, I want to explain why I was looking for a different religion. I used to be Catholic. I was baptized and made my first communion. I was always very interested in my faith and in others' faiths. But I soon realized the things I was being taught didn't fit with my sense or my concept of God and what he wants. For example, I was taught in Sunday school that women were supposed to listen to what their husbands commanded and not think for themselves—that the wife is to the husband what the church is to God. My mother explained to me at home that God wanted wives and husbands to be equal. I knew that there were many Catholic teachings my parents didn't agree with either, big things. They were fine with gays, birth control, and many other such issues.

When I was seven I decided I didn't believe in Jesus. Some people think that is too early to make such an big decision, yet those same people have never even questioned the faith they were brought up in. I thought about it for a long time and felt that if Jesus was really the Messiah, why didn't everyone agree or even know about it, and why didn't I feel some sort of presence or un-

derstand the "simple" concept of Christ or born-again stuff. I'm not trying to offend anyone; it's just my point of view.

Later, as I searched, I found something called the Messianic Prophesies. They are the original prophecies that predicted that a messiah would come, how we would know, and what he would do. It stated a messiah would come, but it also said that he would only come when the world had reached perfection or destroyed itself beyond hope. Jesus' timing was way off! It went further to say that the messiah would be born to a young woman, not a virgin. After the messiah's death all people would know the truth of God's plan beyond certainty, including the mysteries of the universe. I don't think that happened when Jesus came. There was to be no more war, and heaven would reach earth.

Christians rationalize the prophesies not coming true with the second coming. That is fine, but I (personally) don't understand why such a detail would be left out in the prophesies.

I also didn't like the idea of Hell. If you weren't Christian you went to Hell, yet we can't be sure if Christianity is the correct religion. Then we must have faith, but if we are excellent people but have faith in Hinduism we are damned by God for making the wrong choice. It seems like a very large trick on God's part to me. Hell is for people who are bad, but I believe that God would much rather people atone for their sins (through reincarnation) than just burn in Hell. I think God created good and evil, but he gives us free will to choose between the two. I believe the Bible is divinely inspired, but is not to be taken literally. God gave people the power of intellect. The Bible should be read in a historical context and interpreted using our gift of thinking. All of these principles and many others fit like puzzle pieces into Reform Judaism. I felt so amazingly free and alive when I accepted Judaism as the faith I would follow for the rest of my life.

After studying many books and talking to many people, I told my mom of my deep interest and awe with the faith I had already secretly taken up. My family wasn't strict, but my parents had wanted our family to become more devout and religious. I told her what I knew about Jewish beliefs and the conversion process. She was happy that I was spiritually "searching" but didn't want me to

convert until I was 18 or in college. So I hit the books. I went through legal books to see if I could become a Jew without my parent's consent or even knowledge of my actions. As it turned out, I couldn't, so my only other option was to convince my parents. I involved myself in completing this task. It helped me avoid telling my parents I was gay.

Delaying coming out wasn't good, but if I had dwelt on being gay instead of immersing myself in Judaism, depression, even suicide might have followed. I found strength in Judaism, and that strength eventually helped me come out.

Part Two: My Parents
The Truth Shall Set You Free 12/31/98

I want to be Jewish. Mostly because I don't believe that Jesus was the messiah, I believe EVERYBODY goes to heaven, and also because there are things in the Bible I don't believe in. I want to become officially Jewish at the age of 13 so I won't have to go through a Ba Mitzvah. I will not have to become circumcised when I become Jewish. I will want to go through the other holidays and customs as that of a Jewish family once I become officially Jewish. This does not mean no Christmas, no Easter, or being Kosher; for you guys, it means respecting my religion and celebrating Passover and Hanukkah with me or at least letting me celebrate them.

I am Gay. I have known since I was 11. At first I thought it was just a phase, then I thought I was bisexual, and by 11 and a half I sucked it all up and admitted to myself I was simply homosexual. I realize my future will be full of discrimination. I realize if I want children I will have to adopt. I realize the health risks involved in this sexual orientation. I have tried to throw hints and warnings—I hope you got them. I am lucky that you two are understanding of homosexuality.

I love you two very much and will talk with you about both these things when I get home. This is the best way of telling you that I came up with.

I wrote this letter when I was 12 as a way of coming out (to my Catholic, straight parents). I had a lot of internalized homophobia

and confusion about Judaism and how I planned to practice it. I had many common misconceptions. For instance, I thought almost all gay people had AIDS and called it a "health risk" in my letter. I thought life would be miserable and full of homophobia. I also thought that I would have to fight everyone very hard so that I could live a normal life. This idea was the last obstacle in coming out to myself, which I did once I realized I could get married (even in just exchanging rings), could adopt kids, and could participate in every other "American" institution I dreamed of. Although there is some truth to all my stereotypes, they are not the extremes I once imagined them to be.

I was only beginning a long process of study about Judaism and so things like "Ba" mitzvahs seemed boring and reminiscent of catechism to me. As I grew and learned more, I decided not only to have a Bar Mitzvah (September 15, 2001) but also to go through a full conversion including circumcision! The next three years would bring unforeseen understanding into all areas of my life, especially my sexuality and religious beliefs.

Although my letter was not the way I came out, it was part of my original plan. As a naive child, my mind was not so receptive to my parent's feelings. In my mind I was sure I would be forced to never speak of my sexuality and to convert without my parents' blessing when I was older. But still I was being eaten away because I had to hide myself from the people I loved most. And my very spiritual and philosophical young soul was about to physically lash out if I had to go to church one more time. So I had devised a plan to come out to my parents both as gay and Jewish. I made a "treasure hunt" that would begin with a phone call by me from a friend's house. I would then instruct them to look under a table, where a note to look somewhere else would begin their "hunt" through a series of notes, eventually leading them to my computer with the coming out letter.

Luckily I had called a friend of the family who had studied law, Sonia, to find out if it was legal to convert as a minor without parental consent, and I had left a message on her answering machine. I was sitting in the dark after crying and feeling lonely and depressed, as I had done many times before in the past year. She

called right in the middle of me feeling sorry for myself. I was forced to pretend everything was all right and discuss the conversion plan in a happy tone. She asked if I had been allowed to have a girlfriend, because I had emphasized my parents' "no girlfriends 'til high school" rule the last time I had spoken to her. In an attempt to erase anyone's questioning of my sexuality, I would pretend to be interested in girls or would make sexist, heterosexist, and sometimes homophobic remarks. I said, "That is the other thing I wanted to tell you about." And I came out to her right then—the first adult I ever told. At first she thought I was joking, but she took it so well and practically congratulated me. Somehow I told her my "treasure hunt" plan. She saved me from continuing with my impersonal plan and told me to tell my parents in person.

That night me and my mom were going out for dessert, so already having been given motivation by Sonia, I decided to come out. On the way there, I said, "Remember how I was looking at all those books about religion...well, I want to become Jewish." This wasn't too big of a deal because both my parents already knew I didn't like being Catholic and that I have always been interested in topics like God and religion. But they didn't know I was searching to change religions. My mom must have thought it was a phase, because she told me to wait until I was 16 or 18. I was a little disappointed and had every intention of running off and just having a blessing said over me by a rabbi, as that is what I was told (by a misinformed Jewish friend) that conversion was—a quick blessing.

But this wasn't all I had to tell her. I didn't have a connection between what I believed and who I loved, but knew that both were secrets I couldn't hold in any longer, so they became intertwined. We sat down, and I said, "I have something else to tell you—" followed by "Man, this is harder than I thought it would be" (several times!). Finally, as my mom died in excited anticipation, I said, "I'm gay. I've known since I was 11 that I'm gay." My memory isn't as clear after that, but it wasn't followed by screaming or crying, which was great.

My mom blurted out three questions, which in retrospect uncover my mom's own misconceptions. She asked, "Are you sure it's not a phase?" I responded in the affirmative in an almost patroniz-

ing tone, partly because I had expected the question and also because I had been asking and re-asking myself the same question for over a year. I don't know if she was totally convinced. Then she asked "Does this mean you're going to have a lot of boyfriends?" My answer went along the lines that I was going to have as normal a life as I could. I think she was more worried about HIV than polygamy. Her last question was a little depressing and not one I wanted to discuss, because it made me feel helpless, or that she was trying to list the negatives to talk me out of my "decision."

Now I realize she was just concerned with my safety and well-being, like any good mother. She asked about discrimination, I don't remember the specific words but that was the topic. I told her I knew it would be a hard life, but that I would fight the laws and try to change people's ideas. (Thank God there was another generation before me, who had already begun and won a lot of important battles.) I also asked her not to tell my dad, because I wanted to tell him in my own time. The rest of the evening was spent discussing pretty expected ideas of my future and identity, which seem to have faded out of my memory. But I remember the car trip home and feeling relieved but anxious, too. As soon as we got home, I called Sonia to thank her for everything. It was almost midnight, but we talked forever about the previous events of the night. I slept very easily that night.

Years later, I found out that my mom told my dad, and not because she wanted to disrespect my wishes but because she loved my father and couldn't keep such a large secret to herself. I'm also sure she needed his support. I am glad she told him, but on the other hand, I waited two weeks before I came out to him, and it must have hurt him to think I didn't trust him. When I did come out to him, I left him my letter on the table, and as I got out of his truck to go to school, I told him to go read it. I think it might have hurt his feelings that I didn't tell him to his face, but I didn't know how he would react and I wanted to give him time to think of what to say and maybe call my mom and talk to her before he said anything. I guess I thought that being a man who lived in the South most of his life and being pretty "manly" he might have a few more issues than my mother, a professor of social work.

As it turned out, I was wrong. When I got home we went for a walk and talked first about my converting to Judaism. He asked questions like why and what it meant, but he was mostly concerned that I would be setting myself up for discrimination. Then we talked about my homo-ness, as I like to call it (homosexuality sounds like a science experiment) and how hard my life would be. My dad had been a Chicano activist and I think he hoped I would be spared from so much discrimination because of the changing times, and this must have thrown him back. No stereotypes or anger were displayed, only caring for me. Still, I already thought my life would be hell, and this reminder about the discrimination I could face didn't help. I honestly believed I was the first gay kid to ever want to lead a completely normal life with marriage and kids. It was only when I became a queer activist and came out to my peers that I realized times were changing for gays.

Part Three: The World

I told my best friend at his house before anyone else knew. He was more supportive than I imagined any straight person could be. Later, I found out that it was because he wasn't straight. Though he didn't tell me 'til a year later, he knew he was gay too. I called my good friend from the fifth grade and told her, after I had come out to my parents. I also told her mom, but she didn't quite believe me. I remember putting my mom on the phone with her and listening to what they said, very proud of my mom's supportiveness. It wasn't until months later that I told my other friends. We were sitting at lunch one day, when I said, "What would you say if I told you I was gay?" One friend responded pretty nonchalantly, "You're not, though, right?" followed by a quick and excited grin made by me and, "Yeah, I am." When I first began coming out, each time I said or did something to show or prove my gayness a huge surge of serotonin and adrenaline entered my system, which was pretty addictive. Though I barely remember the feeling now, at the time it was like a drug.

Between that week and the end of that semester, every student in every grade in my middle school knew I was gay, which

continues to blow my mind. People I didn't know would come up to me at lunch and ask if I was really gay, and in some classes people would point and giggle. I never denied that I was gay, and I would say it a few times a day. I had drifted apart from the new friend I had made in sixth grade because of our schedules, but we still talked and saw each other between classes. After I came out, it stopped in a heartbeat and he would look the other way when I walked by, as if he hadn't noticed I had ever existed. Another boy in my gym class said he didn't want to talk to me because there was a rumor I was gay. These two incidents hurt me, but not as much as one might expect.

I had a warped frame of mind that developed in the closet. I had expected to lose all my friends and get harassed all the time. Even though this didn't happen, thinking this way helped me cope with the harassment I would later have to deal with. It was better this way, because I was happily surprised by the reaction of my peers and not disappointed. I also had positive incidents to help balance out the negative ones. One girl told me she thought it was great that I knew myself so well and was so brave to come out. Another girl surprised me when she said she liked me for who I was, a "funny and nice guy," and that she didn't care who I liked. In a few classes people asked me everyday just to annoy me, and a few people thought I was doing it for attention or was in a phase, but all of those people now believe and accept me. A lot of people just adapted to my news and were interested in who I had a crush on.

My coming out was extremely well-handled and turned out to be the best thing I have ever done. I was harassed but only in two incidents worth noting, both at school. After I had first come out, a boy in middle school was offensive. He would say "faggot" a lot, and so I asked what he had against gay people. He responded with the question, "What do you care, are you gay or something?" And I, having decided never to lie about it again, said yes straight out. This surprised him, and he started to say that I was stupid for choosing to be gay and that it was against god and nature and other bullshit. Some other students defended me and the bell rang. I was mad and sad and also afraid because we shared a class later that day. In that class, he continued to verbally harass me, saying that

all gays should be taken up in a ship and blown up and that they shouldn't flaunt it. He got some other guy to back him up and laugh at me, all pretty discreetly in class. He mimicked flamboyant gay people and taunted me. This scared and annoyed me, so after class ended I walked straight to the office and asked how to make a formal verbal harassment complaint. The vice principal told me to "be more careful in whom I confided," and that I "didn't have to decide all my life choices in seventh grade." It was like I was talking to the adult version of the harasser.

In the end, the boy was told that he needed to stop because his behavior was inappropriate, and that if his behavior continued he would be suspended. The next day I was nervous about seeing him. He ignored me or behaved mildly human-like, though he told his friends that he had to be nice or I would sue him. Luckily, that summer he moved away.

By eighth grade, everyone had gotten completely used to my being gay, and it was not a big deal at all. I had kept all my friends and even made some more, my grades were fine, and my parents were becoming more involved in the gay community. I thought nothing could get better, plus I had met a boy. I helped him come out to his mom, though everyone at school knew he was gay. We decided to go out, which meant learning each other's favorite color, late-night conversations, and picking a song. We played footsy once in an auditorium of a local university during a guest speech by Barney Frank, but nothing else ever happened. He moved to another part of town and I went on to the neighborhood high school.

I had met new people and drifted from others—after all, it was my first year in high school. I adjusted well and was having fun. I even had a new huge crush! He was a really hot bass player in a local band with some other guys from school—and he was straight. I, naturally, told all my friends that I liked him, who in turn told their friends, and within a few weeks the whole school knew, including him. Soon, I heard rumors that he was going to beat me up. I became frightened when he and his friend followed me down a school hallway calling me faggot, which continued over several weeks. Finally, I spoke to the school counselor about my fears, and she met with him. A few days later, I heard that he was

mad and was going to beat me up. One day, between classes, he appeared out of no where in the hallway. I thought I was going to get killed, so I flexed my stomach waiting to get hit. And I was hit, all right, but not by a fist. He extended his hand to shake mine and apologized. He also said that if anyone ever insulted me again, he would beat them up! This set the tone for the rest of high school, unexpected but positive experiences, not only related to my sexual identity but extending to all areas of my life.

In my family life, things were also progressing for the better, as if it could get any better! My mom and I celebrated the anniversary of my coming out by going back to the coffeehouse where I had come out to her and re-creating the whole night. It was incredible to think that only two years ago that day I had been crying and feeling hopeless. Now my mother had joined several gay and lesbian advocacy organizations and had even become actively involved in gay and lesbian studies at the university where she teaches. My father had gotten many books for me, books about coming out and gay activism, and just stayed the same—he loved me no matter who I loved.

I, too, had become more involved with the gay community. I read a lot of queer history and activist books by authors who surprised, saddened, and inspired me. I marched to the capitol. I helped film a gay youth short for a film festival. I spoke at a press conference in support of gay nondiscrimination in schools. I testified in front of a legislative committee at the state capitol. I also attended a conclave of gay Jewish college students from around the United States. I even met a handsome Latino Jewish guy there (what are the chances!). Attending this conclave helped me feel more comfortable with myself and my decisions. It was the first time that I had the chance to be part of a group of gay Jews, whom I saw as my role models. It was probably the coolest thing I had ever been a part of—although my first three sexual encounters are fair competition! Just kidding, mom.

My religious life also improved. Within the year that I discovered Judaism, my mother picked up a book by Harold Kushner off my floor. She read it and began to attend services with me. She, like I had been, was completely taken by Judaism and decided to

convert with me. (She had broken with Catholicism when I came out.) I was so excited! My father was very supportive of us. After a year of study and many months of preparation, I became a Bar Mitzvah, but only after converting with my mom and little brother. I had a fun party on the lake with the help of my dad and my friends and relatives.

No other time has my sexuality been, not only anything but a burden, but a pleasure than right now. Recently I tied two of the most important aspects of myself together as I sat on a panel at my Temple. The subject was "Sexuality and Intimacy: What Do We Tell the Children?" I spoke about my coming out story and helped explain teenage feelings concerning sexuality to members of the congregation. Life has changed me from my angry and depressed self, with a distorted perception and an attitude tainted by the closet and the Church, into an active and productive member of society and my family. I am happy. All I need now is a boyfriend.

Choreographer

Edward M. Cohen

"I'm dying. I'm dying!" my father was bellowing into the phone at 9:30, not exactly the middle of the night but my folks are in their 70's and go to sleep at eight. I heard her crying behind him.

"I'm having a heart attack! Do you hear me? I'm dying!"

"Hold on a minute, Pop, hold on..."

"Don't tell me to hold on!"

"What are the symptoms? Tell me what you feel."

"All of a sudden you're a doctor? You're a choreographer! What the hell kind of job is that? How does a cockamamy choreographer know if someone is dying?"

When my father curses my career, it means he'd like to take potshots that hit closer to home, but I've warned him not to call me a faggot again. Since I've come out, the war between us has been conducted in code. Still, he gets his message across.

Of course, my father bellows constantly. In conversation, on the street, falling into rages at bank tellers. He is a retired attorney: son of immigrant parents, drove a cab during the day—went to law school at night. He started out representing poor Jewish families on the Lower East Side. Some of my earliest memories are of strolling with him down Delancey Street as ladies in babushkas called out from doorways, "Counselor Cohen! Counselor Cohen!" waving incomprehensible documents about citizenship, truant children, evictions from their Essex Street Market stalls, and he advised them then and there in Yiddish, a god on those streets.

Today, his practice is over but he is still involved in dozens of suits against insurance companies, manufacturers who have "defrauded" him, ex-employees who have "stolen" from him. He uses me to type his legal papers. Nobody knows how he gets from his

house to mine. He is half-blind and his driver's license has been revoked. He cannot get auto insurance and won't say how he is able to hang onto his car. He claims he hires drivers who owe him for past legal favors: an out-of-work bartender, a bookie. I think he is driving illegally.

All I know is that he arrives at my door whenever he has chaotic papers to be typed. He has never accepted the fact that I might be at rehearsal, might be working at home, making phone calls, meeting with composers. The whole thing infuriates me. But I have been choking on rage with him all of my life.

"You gotta come down! I'm dying, you hear?"

"Did you call an ambulance, Pop?"

"I don't want an ambulance. By the time they get here, you're dead. You'll drive me in the car. OWWW! The pains are awful!"

So I grabbed a cab, muttering that this was crazy. In fact, he did not look well; pale, perspiring, terrified. My mother was ready to pass out.

We left her at home and I drove him to the hospital, repeating that he would be fine. He kept bellowing that he was dying. When they wheeled him away to Emergency, I collapsed into a waiting room chair, suddenly afraid he was right.

They kept him all night without telling me a thing. I called my mother hourly with the non-news because she could not sleep, anyway. The time passed in panic.

He has always scared me. He clawed himself out of immigrant poverty, fighting his father who was furious he was going to law school instead of spending the time tending the counter of the family store. They had argued so much that when there was no longer a need—with me—he could not stop. So, I flew as far from him as possible, becoming a modern dance choreographer. Like he said, what the hell kind of job is that? Even at the top, they don't make any money. And I had been so wrapped up in rage and rebellion that I had never made it close to the top.

When I danced with my mother at my Bar Mitzvah, he had beamed but that had been as much a part of the tradition as my reading the Haf-Torah. As I grew older, dancing pulled me away.

He knew why and I knew that he knew but it was never discussed until he appeared at my door on a Sunday morning after my lover had slept over. We were cooking breakfast in our robes and I could see in Pop's eyes that he got the picture. So I followed my gut instinct and jumped right in. That's what choreographers do.

"Pop, this is Lewis... my lover..."

"I need these typed," he mumbled.

"You don't seem surprised," I said.

"Cooking, dancing, lovers," he shrugged. "It's all the same to me."

He handed over the papers and left me once more in a rage.

It was all so clear to me, sitting in that waiting room, half asleep, more alert than I had ever been, how much energy had been wasted, battling my father. Once, Lewis had video-taped me in rehearsal and it was my dad on Delancey Street: bellowing, giving orders, moving masses of people around, exuding authority, making quick decisions, energizing the room. I had defined myself as an artist to get away from him, but I had used what he had taught me to do it. Had I used those talents in another way, say, by becoming a lawyer, I would be helping people, would have an admired place in society, would be making lots of money. I would not be tied up in knots, working in crummy off-off Broadway theaters, trying to prove that I was different from him. It all made such sense in the dizzying fluorescent glare.

It turned out to be indigestion. They kept him for tests, but it was obvious in the morning that he was fine, perched on the side of his bed, spindly legs swinging out under the sheet, flirting with nurses, joking with attendants.

"This is my son! He's a big shot choreographer!" Then, snarling out of the side of his mouth, "She probably thinks that's some kind of chemist!"

I was astonished. He was putting a different spin on the word. It gave me the courage to respond calmly.

"Dad, I thought about that last night. I made a decision to take some time off from dance. What the hell, I'm not making any money."

"You can say that again!"

"I'm thinking of going back to school."

"What kind of school?"

"Law school, Dad. I'd like to become a lawyer."

He reflected for a second. Then he snapped back: "If I had it to do over, I'd never be a lawyer. I made all of my money in real estate!"

"Son of a bitch," I seethed to myself. "Nothing I do can please him."

I expected him to go off on a harangue about how the legal profession had cheated him. But, no, we both lapsed into a surprising silence. Usually, one or the other is complaining. I peeked up to find him glancing at me.

Finally, I had to get to rehearsal. Waiting for the elevator, I tried to figure out what had just happened. Through our lifelong fog of miscommunication, because of the terrifying night, not even knowing what I was saying, I had offered to be the son he wanted. And he had answered by saying, "Be who you are."

We announce that we are gay with a flourish. Our parents accept it in quieter ways. The truth rolls forward in waves until the family starts to float. Slowly, gently, we reconnect—with ourselves, with our pasts, as well as with them. The truth was that I was trying to tell him how much he meant to me and he was trying to say the same to me.

Maybe I was misreading the code. I don't think so. Maybe there were other interpretations. At another time, I might have leaned toward them.

Maybe I was putting words in his mouth, but they were better words than I used to put there. Glad he was alive, I raced to rehearsal, light-hearted.

My Father's Tattoos or, Family Outing

Lawrence Schimel

When I at last published in 2000 an anthology of explicit memoir and fiction concerning Jewish identity and gay sexuality, after a long gestation that included various previous contracts for the book to gay presses that were each in turn canceled, I had hoped to create a sort of "virtual" community or family of gay Jews, bringing together a Minyan of our stories which I hoped would serve as a visible public document that might help and inspire others to reconcile the often problematic identities of being both Jewish and gay.

What I didn't anticipate was how publishing that book, *Kosher Meat*, would heal various ruptures in my own extended family and bring us all closer together.

Coming out is a continual process and one which must be repeated with each new acquaintance or relationship. I had been publishing openly gay books under my own name since 1996 and had been out to my entire immediate family for a few years before then. A search on my name in the internet, or asking for titles by me at any bookstore—it was generally known if not necessarily much discussed that I wrote things, which for years was akin to being "outed" as not having a "real" job in the eyes of the family— would've "outed" me (in the more traditional sense) to anyone who hadn't already known my sexual orientation.

But evidently none of these events occurred, and it was *Kosher Meat* that finally hit the radar of the extended family: all those relatives whose surnames were different than my own.

And it was the publication of that book that outed my family as having a gay son, a gay grandson, a gay brother, etc. The sort of second-wave "outing" that comes from being related to an openly

gay public figure. Because, like it or not, the issues surrounding the acceptance of homosexuality in today's society are suddenly thrust upon one. (Look at Ellen DeGeneres' mom as perhaps one of the most visible, recent examples of this.)

In coming out to my immediate family, I was asking them to accept my homosexuality and inviting them to remain involved with my personal life: to know and care who I was romantically involved with, and so forth. In publishing books with queer content under the family surname, I was asking them to respect my need to write about my life and/or issues which were important to me. In turn, I respected their decisions to tell whom among their own friends and relationships they wanted to, or didn't, at their own rate. I wouldn't lie if asked a direct question, but I also didn't need to bring up the issue if they were not prepared for it to be raised with certain people.

I didn't make it easy on my family, in that I "came out" pretty badly, all things considered. My mother had been asking me if I was gay for long before I even began to be aware of sexuality, so of course by the time I began to recognize in myself my attraction for other boys I was in deep denial. When I did finally come out to them, I wasn't definitive enough, either to myself or to them, and almost immediately found a girlfriend as what is commonly called a "beard," and claimed to be "bisexual." I also came out to them before I was personally ready to broach the subject, one afternoon when my mother asked me point-blank if I was sexually involved with my then-boyfriend; while I had been selectively omitting certain details about my life for some time, I didn't want to actually lie, and I confessed that, yes, we were lovers. And it took us all some time to dig free of all the backpedaling and denial and the years not-talking that had gone on, to arrive at the point we're at today, where I'm sometimes almost embarrassed by how often they bring the subject up in public, in relation to my latest book, or trying to fix me up with the gay son of a friend of theirs, or however.

Over the past decade, it's been easier for my family to get used to various aspects of my life—including the fact that I'm a writer. They've gotten used to the fact that I am able to support myself—some years more marginally than others—from my writings.

They've watched as I've published book after book, and how these titles have often gone on to be nominated for or win awards, and otherwise receive acclaim. (If their son had to be a homosexual, at least he was an award-winning homosexual....) Eventually, they began comparing me to the children of their friends and peers in that time-honored parental tradition, and realized that I was not the only one (either in terms of my homosexuality or my writing), which of course made it easier for them to feel more comfortable with the idea of those identities. Further acceptance came when the offspring of many of their friends and acquaintances boomeranged home, for various reasons, a number of whom were trying to publish their first book and finding it difficult. I not only didn't move home, but I've left the country—a decision they at first were opposed to, although having now visited and seen the quality of life I'm enjoying here, they've come to accept it—and have published over fifty different books, in a diverse array of genres and modes of writing.

I keep moving back and forth between my writing and my homosexuality; while not exclusively linked, they're both important components of my personal identity. And combined they have very often provided a strong sense of meaning to my life.

I began writing before I began having sex. I should clarify that I not only began writing before becoming sexual with another person, of any gender, but I also began selling and publishing my writing before sex occurred. As a result, I did not write about my sexuality for the first few years of my career. But once I began writing about being gay—and often, about gay sex—I discovered a personal sense of worth that I had lacked before. Because I began to meet people who had read these pieces, and who remembered them, and were altered by them in a way that hadn't occurred with my previous works. If earlier I had written simply to entertain, suddenly I was writing to also have an impact on the world, to change how people thought, to put certain concepts into the marketplace of ideas... hopefully while at the same time also entertaining the reader. (I've never been an especially highbrow writer, even when I've published work in respectable mainstream venues; instead, I quite often embrace the more "vulgar," or popular, genres, such as pornography or science fiction.)

Suddenly, my "activism"—that desire to make the world a better place that is so much a part of the Jewish ethic I was raised with—had an outlet via my writings. And over the years, it is how I have come to define myself, not just as gay or as a writer, but as a gay writer and, especially of late, as a Jewish gay writer.

Because so much of my personal identity and my interaction with the world is tied up with language, it is unsurprising that my relationship to Judaism is also heavily influenced by language. As a fairly typical Diaspora Jew growing up in the U.S., I learned to recite many prayers in Hebrew without ever learning what they meant. I went Sunday School and Youth Group events at our temple, but my Hebrew vocabulary was never very large. As I studied for my bar mitzvah, I simply memorized the Torah passage—which, in the end, I never even got to recite.

For my bar mitzvah, my family took a trip to Jerusalem, where an uncle of mine who is a rabbi performed the service at the Wailing Wall. Despite the fact that my mother, grandmother, and sister were exiled to the women's section, it was a very moving experience for me—especially the morning after. I spent the night with my uncle's family, so that we could be up before sunrise to go to the Wall and pray—the first time I would no longer be considered a child, but now counted as a "man." I still recall how overwhelming it felt when, just as the first syllables of the morning prayers rolled off our collective tongues, the sun poked above the horizon, its rays striking the wall and awakening all the birds who roosted in its nooks and crannies. It seemed as if our prayer had brought forth light, as the birds leaped into the sky and soared overhead.

I no longer recall who told me, but I learned, shortly after this momentous personal experience, what the words of those morning prayers meant in English. While I was not yet consciously aware of my homosexuality, nor conscientious enough to be offended for its misogyny, when I learned that I had been thanking G-d for not having been born a woman without knowing what I was saying, I felt betrayed with the innocent fury of early adolescence, which prompted a complete break with any active participation of Jewish ritual or religious life. I attended temple only on High Holidays when the entire family went, and of course I still had to be present

for the Jewish holidays when they were celebrated at home, but I was an unwilling, sullen participant.

Over the years, I came to distinguish my religious practice or lack thereof from my Jewish cultural background and was able to embrace my Jewish roots. Once again, language helped play an important role, especially when I moved to Spain a little over three years ago. Suddenly, I was immersed in a culture where Jews hadn't existed for five centuries; and I was speaking, as my daily language, a tongue that was commonly referred to as "cristiano" instead of Castillian or Spanish.

Culturally, it was a tremendous shock. Often, I was the first Jew that many Spaniards had met, which is still something that I find incredulous (not to mention alarming) every time it occurs. Occasionally, there have been moments of anti-semitism due largely to ignorance, such as a woman who earnestly asked me what it felt like to belong to the people who had murdered Jesus Christ as her immediate response to learning that I was Jewish. For many Spaniards, being Jewish is something exotic; over the centuries, it's lost a lot of the stigma, since only the memory and the history of the important contributions of Sephardic culture to Spanish culture remain in the absence of actual Jews.

And there is a constant friction of being Jewish in such an intensely Catholic country that doesn't even realize how homogenous it is, nor how pervasive religion is in its society. In addition to one's birthday, often there is a celebration of one's Saint's Day (the day whose patron saint you share a name with) and every official holiday is associated with a particular Saint or Christian holiday. These quasi-religious festivals, often with elaborate processions and folkloric rituals, are sometimes national and sometimes unique to a particular town or region; if one does business in various regions of Spain, one is required to learn the patron saints of each city, to know if bank holidays coincide.

And so much of my own cultural background simply doesn't exist over here; a non-Jewish friend in New York always jokes that everyone who lives in New York becomes a little Jewish, citing for example a Pakistani taxi cab driver he once had, who leaned out the window and started cursing in Yiddish when another driver cut

in front of him. But if a Yiddish expression—let's say the word "schlepp" or "mensch"—slips out as I'm talking in Spanish, I am met with blank stares. If anyone visits from New York, I beg for bagels, or rye bread, or pickles. Spanish doesn't even have a word for pickle.

Even on a daily linguistic level there are reminders of my difference from the local cultural norm, such as when anyone sneezes and the immediate response in Spain is to say "Jesús." Every time I or someone in my presence sneezes, I'm reminded of my Jewishness. Speaking in "cristiano" has brought me back to an active identity as a Jew.

I first began to have a serious adult relationship with my father through my books. My father is not a strong reader—music is more of a passion for him than text—but he is the child of restaurateurs, a good cook, and a collector of cookbooks. In 1996 I published a benefit cookbook titled *Food for Life*, featuring recipes and anecdotes about food from gay and lesbian celebrities such as Martina Navratilova, RuPaul, Dorothy Allison, Tony Kushner, and many others, whose royalties were donated to meals-on-wheels programs across the U.S. serving the needs of people with AIDS. From the moment my father heard about the project, he began coming up with tongue-in-cheek recipes (such as: "Chicken à la Queen" 1. First you take a *coq*...) that were so campy one had to wonder.... But while his exuberant enthusiasm for the project as I was compiling it was appreciated, it was what happened after the book was published that is most meaningful to me: after reading the introduction, in which I talk about what compelled me to create the cookbook, he said that it was "not right" that he had to learn about my thoughts and feelings—things we had never really spoken of before—from a book instead of from me directly.

And from that moment on we began to talk to one another, as adults. He took an active interest, not just in what I was doing, but why I was doing it. He respects that the books I publish are important to me and the communities for which I write or compile them. He is actively supportive every time I sell or publish a new book, whether its content is gay or more "mainstream," explicit or not.

I respect that he has no interest in reading erotic stories about gay sex.

I am very grateful that he can be so proud of me when things go well—if a book of mine is nominated for or wins an award, if it gets a good review, whatever—and is supportive and optimistic for the future when things go wrong (which, in the current publishing climate, is happening oftener and oftener).

I get a kick out of the fact that he loves coming up with titles for possible projects; he's "responsible" for the title of my forthcoming anthology *The Burning Bush: Jewish Women Write About Sexuality*. For all that my father delights in bringing his sense of humor to my various literary projects, and despite the fact that we are both avid book buyers who can happily go off to a bookstore together and spend hours, each of us browsing separately, showing one another the curiosities we turn up, etc., he is, in general, more apt to prefer a conversation, or a game of chess, than to sit down and read.

I am especially grateful, therefore, when he does sit down to read something of mine, as was the case with the afterword to *Kosher Meat*, "Diaspora, Sweet Diaspora," which talks about some of the parallels and differences between gay and Jewish identities. Not only did he read it, but he then began to give out copies of the book to acquaintances of his—for instance, to the circle of friends who all make the same commute into Manhattan each morning, not to mention my dentist, who is an Iranian Jew—so he could discuss it with them.

For me this was a major step; not only was he publicly acknowledging me as his gay son, but he was actively kvelling about exactly that!

And he went one step further, by making for me, as a surprise, a huge batch of temporary tattoos that said *Kosher Meat* in the same typeface as the title, as a give-away to promote the book.

As pleased as I am with the book itself, I was much prouder of the fact that my father was so proud of me for doing it!

I always remember my mother as an avid reader, when I was growing up, although her interests have since gone off in other areas. My mother's support of me, as a result, often shows up more

in the personal arena, concerning itself largely with questions of health and relationships, rather than with my books and the often "political" motivations behind them. While my mother is not especially religious, I recall the first time she invited a boyfriend of mine to visit the house: it was the first time I was dating a Jewish boy, and of her own initiative she called me up and offered an invitation to bring him to a Passover seder. While it turns out that he and I broke up before Passover, it marked an important change in my relationship with my mother, and her attitudes toward my homosexuality.

Over the years, as friends in her own social circles have come out of the closet to her, and other parents have come out about their own homosexual children, it's become easier and easier for her to be open about being the mother of a gay child. Since coming out is a continual process, as mentioned toward the beginning of this essay, it sometimes happens that one gets so used to being "out' that one forgets who one hasn't yet talked to about the issue. (Usually, because it has stopped being an issue.)

Thus it was that shortly after the publication of *Kosher Meat*, my mother got a call from one of her college roommates, who she hadn't talked to in a few years (for no reason in particular, simply the way one sometimes drifts away from friends). The roommate in question had read an interview with me about *Kosher Meat* that appeared in *The Jewish Week*, and called my mother as a result, renewing their friendship.

My extended family had not been especially close in the past. With the handy "excuse" of all the positive publicity *Kosher Meat* was getting in the Jewish media, the decision was made to finally break the ice and tell them. Not only did my family get "points" for honesty, but my coming out came across as "good news" because of the critical interest in the book. And what a relief it was, for all of us, to no longer feel pressure to "hide" anything about my life, that worry whenever the Holidays came around that someone might ask personal questions about why I wasn't dating anyone...

Because of *Kosher Meat*, the issue of my homosexuality was suddenly made more "accessible" in the context of many relationships and friendships, through the common bond of our Jewishness.

One relative came out to me about some homosexual experiences he had had in his youth, before his current, monogamous relationship.

A cousin, who defines herself as heterosexual and is in a relationship, used the book in one of her college courses.

And, in general, the extended family has all been accepting and interested.

Because of this "family outing," we resumed, as a family, a lot of relationships that had fallen by the wayside.

In particular, for over fifteen years, we had had almost no contact with my maternal grandfather's children from his second wife—who were my mother's half brother and half-sister and my own aunt and uncle—ever since my grandfather passed away. We had seen them—Jonathan and Julie—on visits to Florida to see him, but once that link was gone they disappeared from our lives—especially since my maternal grandmother is and remains an active and integral part of my immediate family.

But as a result of publishing *Kosher Meat* I was invited to give a talk in Miami as a fund raiser for NUJLS, the National Union of Jewish LGBT Students. Julie, who is a year younger than I am even though she is my aunt, was still living in Miami, and my mother's full-sister, Suzen, wrote to her, telling her about the book and that I was coming to town and giving her my contact info. We arranged to get together while I was in Florida, and I got to meet her husband and baby son; not only were we finally able to heal that rift in the extended family tree, but already it had begun to put out new branches!

These are just some of the happy repercussions that publishing a book about gay Jews had on my own family, and how we interact with each other and the larger outside world.

The book has had its impact on other men—both other contributors and readers—and their families, as well. But that is a subject for another essay.

When I think of the personal impact that *Kosher Meat* has had, I always go back to my father's tattoos. For while the tattoos themselves might be temporary, the acceptance and love expressed in that gesture are anything but ephemeral, and that parental support is an important foundation in my life.

A Scout Is...

David Ian Cavill

I never wear a yarmulke in gay bars. Actually, I don't wear a yarmulke in straight bars either, but I try to avoid straight bars. I find them boring and annoying. Of course, after a while even the most fabulous gay bar becomes tired. When asking why I don't wear a yarmulke people are very surprised to hear that I don't wear one because I'm religious. If I were wearing a yarmulke in a bar and some religious Jew were wandering along and saw me sitting there wearing a yarmulke he might assume that everything the bar served was kosher. While many things one can order at a bar are in fact kosher (I usually drink whisky or vodka) many are not. Heaven forbid a Jew should come into sin because something I had done misled him.

Besides, do you know what kind of freaks hit on the guy in the yarmulke? Who has a Jew fetish anyway? Actually, I do know someone with a Jew fetish. He's a Protestant minister. Thankfully, though, he never seemed to have much interest in me. Maybe it's because I don't look Jewish. I have blond hair and blue eyes. You really can't tell that I'm Jewish unless I'm wearing a yarmulke. I don't wear hats in bars either. People assume that you're bald.

"So what do you do?" I hate that question.

"I'm a student."

"What do you study?"

"Religion."

"Oh. Do you want to be a minister or a priest or something?"

"No. Actually, I'm Jewish."

"Oh."

"I'm a student at the Jewish Theological Seminary."

"Oh, so you're studying to be a rabbi."

It's amazing how many different ways people will continue the conversation. For example...

"I grew up Catholic. Hated every minute of it. My parents sent me to this Catholic school where the nuns used to (insert horrible and emotionally scarring thing here)."

"I'm sorry to hear that. It sounds horrible and emotionally scarring."

"Yeah. After I gave up religion, embraced my sexuality, and stopped speaking to my family, I became much happier."

"I grew up German Lutheran."

"Really."

"Yeah. My grandfather was a member of the third Reich."

"Seriously?"

"Yeah. We used to have barbecues to celebrate the Führer's birthday. My father kept a picture of Hitler on his desk."

"You're kidding."

"No. Really he used to."

"He doesn't anymore?"

"No. I'm pretty sure he gave it up."

"What does he do now?"

"He's a boy scout leader."

Oye vay.

"Are you still a Lutheran?"

"No. I have an altar dedicated to the Egyptian god Amun in my living room."

"Oh. I think spirituality is important."

"How so?"

"Well like after my last lover died in bed with me..."

Oh my God!

A lot of the time people express their resentment toward religion. Individual clergy people, churches and synagogues, outdated theology, and anger are all things I've talked about in gay bars. Sometimes it seems that people think I'm a traveling preacher come

to save their soul from whatever Dante-inspired hell they've created for themselves and they proceed to pour out their souls onto the bar. Usually, I'm just taking a break from trying to save my own soul but I listen none the less. It never ceases to amaze me how much of themselves people are willing to share after only five minutes.

Ultimately, it's these conversations that drew and continue to draw me to a religious vocation. I do get a great deal of meaning from the experiences of others. I try to appreciate that everyone has his own unique personal spirituality. But sometimes religion is the last thing I want to talk about. It's not that I try to conceal being Jewish or religious or anything, but when you do something religious professionally, it can be nice, just like having any job, to talk about something else when you go out for a drink. But religion isn't like any other job. Everyone has an opinion, an encounter, and some individual mysticism that renders himself the prophet of his own religious experience.

A lot of people ask why I am religious. I think people are waiting to hear all about some revelatory moment when the Creator of Heaven and Earth sent angels and messengers and the like. It was nothing like that. When I first began Divinity School everyone had a calling. God never called to me. When people asked if I'd had a calling I used to joke that I hadn't had my phone turned on yet.

I was never oppressed by God or by religion, so I don't think my spirituality tries to reclaim anything in my past or overcome some long forgotten trauma. My parents aren't any more oppressive than anyone else's parents. My interest in religion all seems to have started when I was a Boy Scout. In 1984 I entered the Cub Scouts. At the time, I was eight years old. I earned the Arrow of Light and "bridged" into the Boy Scouts (a monumental achievement for a ten year-old). The Scout Law says, "A scout is trustworthy, loyal, helpful, friendly, courteous, kind, obedient, cheerful, thrifty, brave, clean, and reverent." The first eleven points of this law were simple enough. I understood what each meant and how I was supposed to practice each one. The final point, "a Scout is Reverent," puzzled me. In many ways it still does. The scout oath

states that a scout must do his duty to God and his Country. I think I became religious to be a better Boy Scout.

Shortly before Thanksgiving in 1991 my Scoutmaster made an announcement at a troop meeting about our town's annual ecumenical Thanksgiving Service, which was being held at the local synagogue that year. He knew that I was trying to find an outlet for religious expression and spoke to me personally about the service. He invited me to go with him. When I arrived he immediately introduced me to his next-door neighbor, who was quite active in the synagogue. That happened on a Wednesday night. That Friday night I went to the synagogue for the first time and have been attending ever since. My Scoutmaster still brags about being the only Roman Catholic to "convert" someone to Judaism.

Technically I didn't "convert." I grew up in what I like to consider an "unconventionally" Jewish home. That is to say, the home was conventional, but our Judaism was our own. My family's religion involved telling stories from the past and gossiping about the present. Food was always present and always Jewish. Sometimes I think we used holidays to celebrate food and not food to celebrate holidays. My family's religion was one based on togetherness and conversation. Some prayed. Some lit candles. Some even read Jewish books or spoke in Yiddish. But mostly we ate.

The summer I turned sixteen, after a year of study with a rabbi culminating in a Bar Mitzvah, I went to Boy Scout camp as a member of the staff. Among my many responsibilities at camp, I acted as chaplain. I was now able to teach everything I had just learned. When I returned from camp I started working towards the Ner Tamid award. In Scouting, there are awards and programs designed to teach each scout about his own religious tradition. The completion of this award was more difficult than I had initially thought, not because of the requirements, but rather because the discussions that my new rabbi and I had always seemed to digress into other greater theological issues than the award demanded. I never did finish the award. But I did continue working as a member of the staff. I worked at a new camp, a camp with the unique status of being the only Kosher scout camp in the world, which gave me new

unexplored outlets for Jewish religion and expression. I spent two summers working there.

When the time came to apply to college, I found myself interviewing at the Jewish Theological Seminary. I read up on a number of subjects so that I would sound like an intelligent person and walked into the Office of the Dean confident that I knew absolutely nothing and that I would have to rely on my stunning good looks to get me through the interview. The Dean looked over my application and noticed one thing above everything else. "Eagle Scout." For the 30 minutes of my interview at the Seminary, I spoke about the Boy Scouts. I walked out somewhat confused, but relieved. I can't help but believe that I was admitted to the Seminary because I am an Eagle Scout.

In the fall of 1994 I started the Jewish Theological Seminary's Joint Program with Columbia University. Students in this program study for two bachelor's degrees simultaneously. I was busy in college. During my second semester of college I took two courses in early Christian history, a subject that had always interested me, and enjoyed it so much that I decided to major in Religion. Briefly I thought I would make mathematics my course of study, but exponential functions are far more transcendent than religious truth and consequently I did quite poorly in Calculus II. So instead of math, I studied Religion at Columbia, on top of my seminary studies. I learned about Christianity, Hinduism, Indo-Tibetan Buddhism, Sikhism, and the theory of religion. That's a lot of religion. For five years my mind raced with the potential for enlightenment. I regret to tell you that it remains only potential, but hopefully not for long.

By the end of my first year of college I was a Gabbai in the Seminary's synagogue. I held this position on and off in one form or another for the duration of my studies. I used to blow the shofar there at the New Year. It is with exuberant pride that I look back on the Rosh HaShanah when a very prominent rabbi walked up to me to tell me "David, you blow very well."

I used to lead services all the time. I was even offered a pulpit position at a synagogue on Long Island, and I spent the high holidays officiating there one year. It just seems that I've always been

in charge of something religious. By far the most rewarding experience returned me quite unexpectedly to the Boy Scouts of America.

When I started college I thought that my time with Scouting had ended. While a scout I earned 42 merit badges. I was a Den Chief, a Patrol Leader, a Senior Patrol Leader, and a Junior Assistant Scoutmaster for my troop. I attended Junior Leader training where I was elected patrol leader. I have served on camp staffs in three Boy Scout camps. I am a member of the Order of the Arrow and I performed as a member of a ceremonial dance team. I am certified by the BSA National Camping Schools as a Chaplain. I spent six years as an Assistant Scoutmaster. I am an Eagle Scout. I thought that the rigors of college combined with BSA's policy about gay people would exclude me from Scouting.

Technically the BSA doesn't have a written policy excluding gay people from membership. The BSA says that being gay conflicts with the eleventh point of the Scout Law, which states that a Scout is clean. They also believe that it conflicts with the part of the Scout Law that says a scout will be "morally straight." The BSA throws out scouts and leaders it learns are gay.

I was content to let that part of my life end. Or so I thought.

In February during my fourth year of college the synagogue in my hometown hosted something called Boy Scout Shabbat. I called my rabbi to find out what was going on. We talked for a while and agreed that I would give the sermon that morning and recount some of my Jewish Scouting experiences. After the service a gentleman from the synagogue asked if I would like to act as the Jewish chaplain for a scout camp I had attended as a child. Without hesitation I said yes. When I was a scout, even before that first Thanksgiving service in 1991, I made every attempt to attend religious services when I was in scout camp. I have no idea what motivated me to go but I did. The first religious service I ever attended on my own was in that camp. I could not turn down the opportunity to return as a chaplain. The time I spent that summer as a camp chaplain remains among the best times I've ever had. I had become a religious leader in the very place that had inspired

the beginning of my own spirituality; I came full circle. Never before in my life had I felt so in tune with Divine purpose. The exquisite natural beauty of the place is enough to draw a person back again and again. Despite the years of theological and religious studies, Boy Scout camp is about the only place where I've had a truly religious experience.

I'm not sure how to describe what it's like to be a gay scout let alone what it's like to be a gay Jewish scout. At first there were some uncomfortable moments. It usually involved mealtime. Boy Scout camp was the first time I said grace before meals.

> Tireless Guardian on our way
> Thou has kept us well this day
> While we thank thee we request
> Care continued, pardon, rest.

Everyone always uncovered his head to say grace. I don't remember when I made a point of keeping my hat on my head, or if I ever removed it at all. I do remember when I started replacing my hat with a yarmulke. The camp director during my first summer on a camp staff was a Roman Catholic priest. Whether by accident or design, religion was brought to the front of everyone's mind. I remember being asked to remove my hat in the dining hall. I explained that I was Jewish and that I'd prefer not to. "Oh. Well could you wear a yarmulke instead?" I guess I could, so I did. If I ever meet the Pope I'm going to ask him why so many Catholics keep trying to make me a religious Jew.

It was two summers later at the Kosher camp that I started wearing a yarmulke and tzitis all of the time. Who would ever have thought a talis could be part of a Boy Scout uniform?

Christians started Scouting. The fleur-de-lis worn by every scout in the world was originally a Christian symbol. Everywhere one looks in Scouting one can see the trappings of Christianity. Officially, Scouting has no religious affiliation. Individual troops may be sponsored by a church or synagogue, but the organization does not affiliate. The Roman Catholic Church and the Mormons sponsor more units between them than anyone else. I suspect that

may be a part of why the BSA has been very slow to change their policy on gay Scouts and Scouters.

Looking back it seems that someone in Scouting always knew that I'm gay. No one ever really seemed to care. But that is not to say that I was out in Scouting. Being a religious Jew in a Catholic troop always made me just a little different but never alienated or estranged. I took more ribbing for my vegetarianism than anything, but it was always good natured. I guess all my little quirks put together made being gay seem much less an issue. It was just one more thing that made me who I was. Scouting taught me to embrace my individuality, including and especially my sexuality.

In 2000 the Supreme Court returned a decision in the case of James Dale v. the Boy Scouts of America. James Dale grew up as a Boy Scout and become a leader after he was eighteen. After learning that Dale was gay the BSA threw him out. Dale sued and continued to win appeals until the case was brought before the US Supreme Court. The court voted 5-4 in favor of Scouting. After the court returned its decision I decided to resign from Scouting, marking 2000 as my last summer with Scouting.

At the beginning of camp that year I announced my resignation from Scouting. During camp I spoke to hundreds of people who offered their support for my convictions but their regrets at my leaving. I learned quickly about the gay friends and family of so many Scouts and Scouters. I have even been able to meet many more gays in Scouting, some of whom I have known for years. I came out to as many people in Scouting as I could. I was met with acceptance and the affection of my friends. This was especially true during my last week at camp.

"What kind of a chaplain would I be if I didn't stand up for what I thought was right."

"I guess you're right. You know what the problem is with you spiritual types?"

"What's that?"

"You think too much. Why can't you just have fun like everyone else?"

"Are you sure you really want to do this?"

"Yes. I've been thinking about this for a long time."

"Couldn't you make more of a difference from the inside?"

"I don't think so. It really can't be my fight any more."

"Why can't you wait until they throw you out?"

"Because I may never be able to come back."

"I disagree with your decision, but I respect you for doing this."

"I kinda thought you were."

"Really?"

"Yeah. After you spoke the other day I figured you might be."

"I see."

"I think it's wonderful that you're able to do everything you do and still be yourself."

"Thanks. It's nice to hear that."

"My pleasure. You're one of the special ones and you should know it. I think it makes you a better chaplain."

"All right then, I guess it's time for me to get going."

"Thanks again for everything. It wouldn't have been the same without you."

"Thank you, I appreciate hearing that."

"David."

"Yes?"

"David, we're not National. We're your friends. Please don't leave. We need you. Scouting needs you."

"Thanks."

"A man should be judged by the difference he makes, not by who he sleeps with."

"Thanks."

He hugged me.

On my way out of the reservation at the end of camp I looked out over the lake and sat down to take in a few last moments for myself. A scout that I once spoke to about God wandered by on his own way out of camp. He too was one of the staff members who

asked me to stay. As he passed by me he called out "Keep it in your heart." One day my heart will stop beating. I think I'll keep it with my soul instead.

Not long a after camp that summer I took someone I was dating out to dinner with a whole bunch of people from camp. No one batted an eye. I thought one guy was having a little bit of a problem with my companion. He called me from camp the following year to tell me that everyone missed me and that I belonged with them. Scouting brought me to religion and religion back to Scouting. No one thinks about Scouting or even the religious world as welcoming places to come out. They can be. They were for me. With courage and determination the human spirit can flourish anywhere.

Every so often you can hear someone say that Scouting is his religion. Perhaps it is mine. Before I first wrapped myself in a talis I wore a scout's uniform. I knew the scout oath before the Shema. My Judaism was the Judaism of a scout. Perhaps one day God will call me. Maybe I will be called back to the woods. I hope to be prepared for it. I would again like to camp with my friends. Besides, I look good in my uniform.

Name and Memory

Gabriel Lampert

For Mani Lucas and Rabbi Joseph Klein

The worst curse in Hebrew is "Yemach shemo!" May his name be erased! It seems to me now, looking back over the past twenty-three years, that all that time has been bound up in the terror of that curse, in preventing it from happening, or undoing it.

In 1978 I was working in Tucson and painfully taking baby steps out of the closet. I was not yet out to my family or my colleagues at work, but I had begun to participate in gay social and political life, albeit as a self-convinced outsider.

The whole time I was growing up back east in Philadelphia, I couldn't have kept my Jewishness a secret—it was as plain as, well, the nose on my face. My looks, voice, and stance told everyone I was Jewish. When I first moved to Las Cruces, where Jews were indeed very few, I was suddenly free in a new way; no one seemed to know. I started hearing the things that people don't say when they know you're Jewish. I remember one older woman telling me, "His eyes lit up like a Jew church," a phrase I've never heard before or since.

My training was eclectic. I could *lehn* Torah but I could also parse it; for one class we had to count parts of speech in Psalm 23 (there are *no* adjectives, which is part of its beauty in Hebrew). Though I had learned Hebrew both out of the Bible and on the Israeli street, it had been years since I had made any connections with other Jews.

My gayness I kept a secret, though, even from me. I dated women, and even tried to force imaginary women into my nightly masturbation sessions, but the men always charged into my fantasies before I was done. Through college at Penn, and during grad

school in Chicago, I hid. I kept both my Jewishness and my queerness under wraps when I moved out west.

All that changed when Mani Lucas died. Mani and I attended an ongoing poetry workshop in Tucson, but he was a dancer as well. One night he led us in reciting poetry in dance, and it was thrilling. It was also surprising, because Mani was round, like many Papagos. But his dancing was airy, light, he moved easily, with grace I could barely imagine, and it was easy for me to "get" how the dance read the words of his poem.

We flirted. Once while we were waiting to go on at a reading, sitting up where everyone could see us, he kept squeezing my thigh under the table—to make me laugh and squirm (which I did) and to see if I would go to bed with him (I didn't). Sometime, I thought, I would find myself in his arms.

It didn't happen. Mani moved to Phoenix in the summer of 1978 because there was no future in dance in Tucson, and was shot dead one month later as he stepped out of Club 307, a gay bar. The police never found the killer, whoever had waited in ambush in the parking lot to shoot someone he didn't even know, someone gay. Mani was the unlucky one to exit next.

I felt both fear and anger. It seemed that Mani's folks were so traumatized by discovering he was gay that they didn't have the strength to put pressure on the police, pressure that I was convinced would force them to find the murderer. It looked like Mani was disappearing like a stone in the ocean. That's how I saw it. Later, it became clear that the bar had been the scene of other violence that summer; so why weren't the police ready? I liked Mani. Why didn't he matter?

In later weeks, I would feel the hackles rise on my neck when I walked to the gay bar I knew in Tucson, even though it was a hundred miles from the murder. Sometimes I didn't go in. Meanwhile, Mani disappeared from the conversations I heard.

I began to believe that Mani's closet made the difference. Perhaps I couldn't stop a killer, but I was not willing to disappear so easily. The answer had to lie in remaking the connections I had myself broken, with family and with Judaism.

I called my brother and came out to him—not too bad!—and then wrote to my parents in Philadelphia. I came out to my parents in a letter—a nice, safe method but, as my mother let me know, not a very Jewish one. Then I made my usual weekly call, the call I'd been making ever since getting back from Israel. We chatted in the usual way, with no hint on my folks' part of having received the letter, so I asked them outright, "Did you read the letter I sent?"

Well, yes, they had. My father could care less ("It's your life"), but I could hear that my mom was working hard not to tell me how she felt.

The bottom line, the one she never admitted as long as she lived, was not that I was sinning or sick or criminal, but that she wouldn't get any grandchildren from me. When I told her I didn't want her to be ashamed of me if someone should kill me for being gay, she said nothing. At first, I was disappointed, and then I realized that she couldn't speak. So, the weekly calls continued, and from time to time I talked about gay things, and my mom became more at ease. She made it clear that she still loved me and she didn't bar me from talking about my gayness, but she herself never mentioned it. My father's stance was entirely hands-off. The result was that the need I felt wasn't being satisfied; I had to have some other grounding in addition to the family.

Living in Tucson became impossible. I moved back to Las Cruces, New Mexico, where I had gone to grad school in the late sixties and seventies. It was a far smaller town, then only forty thousand. I had been heavily involved in the anti-war movement then, and had gotten to know well a large enough group of friends to create my safe place.

But that safe place seemed to need my Jewishness, too. In the weeks before moving from Tucson back to Las Cruces, I suddenly decided to abandon the cover name my family gave me at birth, Gary, and be known by my Hebrew name, Gabriel. At a new-age dance, we were each asked to dance our names, and "Gary" had no meaning for me, while "Gabriel," warrior of God, had some heft to it. That quickly, I changed my name: Social Security, birth certificate, everything. At the time, I could not even have told you

why it was so important to do it. Was it the old superstition of cheating the Angel of Death by changing my name?

When I arrived in Las Cruces in 1979, I began attending shul again. The congregation had shunned me ten years earlier when I was a peacenik, but there were enough new faces now to at least give it a chance. Each time I attended services, I walked out in the middle. Sometimes I walked back in again, and sometimes not. Again, I could not have told you why then; now I know that I wasn't yet sure the congregation was safe in the way I wanted it to be. Eventually, I realized that I had to come out to the rabbi, or it would be just like Mani and his family. If the congregation didn't know, then I was still at risk of sinking like a stone in the ocean. I made the appointment. I had to tell the rabbi I was gay. If he didn't like it, I'd leave. Given that as a possible outcome, I should have been afraid, but I didn't feel the fear until the summer day I had to cycle up to his home.

The way I know I must have been afraid is that I don't remember any of what we talked about. I'm sure his wife, Rose, invited me in and brought something to eat, and then I was alone with him in his study. The rabbi had been brought up Orthodox and was already seventy, not an age I trusted for open-mindedness. He knew to keep up a pleasant chatter until I worked up the nerve to say whatever was on my mind, or (as it turns out) until I couldn't stand *not* saying it. So I gave him the one sentence version: "I'm gay."

His response floored me. I still well up when I remember it. "Well, I don't know anything about homosexuality, but I do know that you belong here in the Temple." He also put me in touch with a rabbi who did know quite a bit about homosexuality, Janet Marder in Los Angeles. She was rabbi at Beth Chayim Chadashim, the gay congregation there. But it is his comment that has meant the most. Why? Because lots of people know nothing about homosexuality, but he was willing to say so, and not to act as if he did know something. Later, I remembered that among the qualifications of a *hacham* listed in Pirke Avot, one was "and about what he doesn't know, he says, 'I don't know'" (Avot 5:9).

Rabbi Klein knew I liked calligraphy, so he asked me to do the calligraphy for a new design for the doors to the ark. I designed

it, arranged to have the brasswork done, and helped fit the letters onto the doors. The congregation became my home, my family. The board of trustees sent letters to the governor and state legislators backing gay-rights initiatives. When I brought my roommate-best friend to the communal seder, he was automatically treated as family. I began to serve on committees, give sermons, lead services, chanting, reading Torah for the first time in years. I have spoken openly about being gay with probably most of the congregation—we are only two hundred adults or so. I sing Kol Nidre every Yom Kippur. I was asked to help in selecting later rabbis, and ultimately was elected president of the congregation. I kept the post two years, giving it up at last due to pressures of work.

I still lead services from time to time, *lehn* Torah, tutor bar- and bat-mitzvah students. My participation has centered more and more on the creative side of my Judaism. Calligraphy was the first bond I made with our synagogue; since then chant and literary interpretation have become my focus. I get to try out my own new melodies for some of the liturgy; some are now the accepted ones. In addition to giving a sermon on, say, the horrors of the closet, I also have the chance to do a *drash* on the literary aspect of the Torah portion, or some point about how the Torah or Haftarah chant in a particular verse amplifies the point of the story. So, when in Numbers we have two episodes on Tzelophechad's daughters, I point out how in the dispute between the daughters and the elders of the tribe, each group has its signature "trope," an *azla-geresh* for the daughters and a *gershayim* for the men. I have given talks about how the trope—the cantillation—in the text can mirror the dramatic action, for example in Genesis 44-45, where Joseph is about to come out to his brothers, or in I Kings 18, where the repetitive chant underscores the humor in Elijah's sarcastic response to Obadiah.

It was because of Rabbi Klein's steadfastness that the synagogue became a home for me, the place of security that gave me the sure-footedness both to explore my Jewishness and to become active in gay politics locally. Las Cruces is a very closeted town, and activism is difficult and not always well received. Still, I belonged to every ad hoc or ongoing group I could. I got out the let-

ters to state legislators and, especially, I worked on setting up connections with the police, where I could at last attend to anti-gay violence. If Mani has a direct legacy, it is in my constant prodding to do more about violence, in town and at New Mexico State University.

Las Cruces is still a difficult town to be gay in. Just two years ago, a gay man was beaten up in his home, to the point of needing surgery on his skull. This can happen anywhere, of course, but here the police and D.A. were so negligent, or perhaps uncaring, that they let the assailant slip out of the country not once but twice. This is all the more frustrating because I have been active for the past seven years in organizing a "gay awareness" segment of each police academy.

Last summer (2001), two gay men were beaten up in the New Mexico State University dorms. This time, I was able to help organize a group, town and gown, gay and not, to pressure the District Attorney's office to attend to the crime. We got supporting letters from the University President, the Temple, the Unitarian Church, PFLAG, and others. When the assailants were sentenced, in February of 2002, we had put on the D.A.'s desk clear options for the probationary part of the sentence, and a demand for at least some jail time, counseling, and diversity-oriented classwork.

In fact, the judge required all of that. I have since begun a documentation project where NMSU students can come in and report any anti-gay incidents they've encountered, and our project has the blessing of the university.

I sometimes remind myself that a bigger city would have given me more like minds to draw on, more like hearts. But I doubt that I would have pushed myself as hard as I have, creatively, spiritually, and in my activism, if I had landed elsewhere. And I know it would not have happened without Rabbi Klein's easy open-heartedness.

As for Mani, the memory of his death still comes back to me at times. I always call up a picture of him dancing his poems; it's a better memory.

Two Truths: Living as a Religious Gay Jew

Gabriel Blau

for my grandma who I never had a chance to tell
for my savta who always says she loves me even though she
doesn't understand

Shabbat services had ended, and the kiddush had begun, shmoozing and all. This was what I had waited for. I had very much wanted to speak to my Rabbi the night before, with my best friend at my side, but the Rabbi was busy.

Now I walked up to him, looked up into his eyes, and said "Rabbi, there is something I need to speak to you about." He pulled me over to the wall and said "sure Gabe, what is it?" This was the moment. I was nervous, excited, and relieved all at once.

Trying to be as casual as possible, I leaned against the wall and began to say what I had practiced so hard.

"As you might have already guessed, I'm gay. Actually I'm bi, but that's not important for what I want to talk to you about." Being gay, or bi, couldn't be the focus, I had to shift it to something else. I told him very briefly about a boy I had met online who is also Jewish and gay and with whom I shared the idea that we need a support group for Jewish LGBT youth.

He acted as if I said it as smoothly as I imagined. Then he said he supported me one thousand percent. I will never forget it. It was as if the entire world around us had disappeared, leaving my Rabbi, HaShem, and me standing there alone. There I stood, realizing that I would be able to be a Jewish bisexual, and at the time I believed I was bisexual. For a moment I truly felt that everything would be just fine.

But the moment quickly ended when he looked me straight in the eyes and said, "It's going to be hard." I knew that he was serious but I felt prepared. There was nothing anyone could say that would make me believe that my search for understanding my position in Judaism as a non-heterosexual was not important.

But now I am far from that shul, far from those halls and the support of my Rabbi. My mind flashes to one of the most simple and telling conversations of my life.

The place is Jerusalem, 2000. The poster in front of me is for the third discussion in a series I was giving at the Jerusalem Open House, Jerusalem's Gay and Lesbian center. The man standing next to me is *Charedi*, an ultra-orthodox Jew, and is apparently doing some shopping in the area.

He was reading the various posters on the billboard when I hung mine. He looked at the poster and then at me and said, in Hebrew, "It's a problem." I asked what was. And he just pointed to the poster. "You're right, it is a problem. That's why we're having the meeting." I said.

"What do you think we should do?" After a shrug he said, very calmly, "What can we do? We can't just get rid of them." I added something about that not being an answer and if he is interested he should join us. He said he would think about it. We never looked at each other, just stared at the flier. The whole conversation was very quiet, cordial, even pleasant. He didn't show up at the meeting.

Coming out is not something you do in one day. That much is obvious enough. But there are moments in the coming out process that stand out, moments that let someone say "Now I'm out, now I'm free."

My coming out experience, like that of most people I know, was an experience that played out on many stages. Over and over again I would tell someone of my true sexuality, and again and again I would wonder when and how was appropriate. Who do I tell first? Can I tell him without telling her? If I tell her will it get back to my parents? If he knows, will he tell those guys, and will anyone care? Is this dangerous? None of these questions, I discovered,

could be answered until I came out where it mattered, in my soul, to God.

Since the earliest stages of puberty I had known I was attracted to men. I certainly didn't think I was gay. Naming the feelings didn't come up until much later. I thought it was a phase. One day I would surely find myself attracted to women and I would marry.

But I was worried that others might find out my secret feelings. I tried for a long time to suppress them. I remember walking home from the bus stop and almost every day I was trying to talk to God, trying to find some truth. Was this really me? Could it be that I'm one of "them"? Would God forgive me? Would God help me change?

I started coming out when I was fourteen. People always ask me when I decided that I was gay, and I explain that I never decided, but that at a certain point I just acknowledged it. The next question, usually with a nervous eye to my kippa, is about my being religious and gay. I explain that I never decided to be both, I just am.

Some people say I didn't come out, but that it was something more along the lines of an explosion. The truth is that I only burst out in the religious arena and in Israel. By the time I had moved to Israel to study in a yeshiva for a year I had been so out in the U.S. that going back in to the closet was not an option. In fact, just before making the decision to live and study in Israel I was almost fired from a Jewish camp where I was teaching because I was out to campers. It took a rabbi's intercession to resolve the situation. Similarly, two years earlier, my job at a non-Jewish camp was threatened because I had a gay magazine in the staff area. In short, after all the work I had gone through to be out I was not going to go back in to the closet.

There was another reason I refused to be quiet in Israel. I was there to be a student of Torah and there to be in the Jewish state. Being gay, I had realized, was part of my own being as a Jew. I had done enough studying and soul searching to be confident that I didn't have to live a lie. I was no longer fighting God. Instead, we were together on this journey.

Coming out to God was about as difficult as coming out to my mother, perhaps even more. It has certainly lasted longer than the process of coming out to anyone else I told. When you come out to a person in many ways it comes down to saying "I'm Gay." When you come out to God, as countless religious people can attest, it involves much more.

One afternoon while no one was in the sanctuary at the suburban synagogue my family once belonged to, I walked in and stood in one of the pews near the center. I looked up at the 1950s ark and at the eternal light above it. I was sixteen or so and had struggled with the issues of being gay, but was now grappling with the issues of being gay and Jewish, spending countless walks agonizing over what love, life, and God were for me. I was not going to go through this alone. If God was an integral part of everything else I did, why should this be any different? I needed to make sure God and I were on the same page. I raised my eyes to the ark that was supposed to represent our connection to God. I said it once quietly, "I am Gay." I said it again "God, I'm Gay." And when I got no response I screamed "I'm Gay! You hear me? I'm gay! And if You have a problem with that, screw You!"

I don't suggest screaming such things to God or most people. But it was the heat of the moment; it was a matter of being sure I was heard. In my experience, then and now, God's responses can be hard to discern. This was a moment of invitation to God to love me, a literal cry for help.

I sat there in that sanctuary and cried. Had I been heard? Would God help? Had I done the right thing? How would I ever find peace? I had come to Israel to continue nurturing my relationship with God. If there was ever a time I needed to be out it was now. If there was ever a place in which I needed to be visible, it was here.

When I was growing up my mother was traditionally observant. For a time she studied with Rabbi Meir Fund. For years she kept the lucky dollar the Lubavitcher Rebbe gave her in her wallet. My parents sent my two siblings and me to day school and we belonged to an Orthodox synagogue. My sister went to yeshiva for high school. When I was nine we moved to Israel for a year where

we became less religious. By the time I was ready to come out to my mother in my third year of high school she was about as secular as could be.

I, however, had again become religious and observant almost two years earlier. When I came out I hadn't anticipated her initial reaction to include asking how I could call myself religious and whether the rabbi knew.

When she came to visit me in Israel we decided to take advantage of my choice to live in Jerusalem—we took a walk to the Old City. For the first time, walking through the Armenian quarter that evening, we spoke openly about my life as a gay man and hers as a single woman. We broke personal ground. Today my mother is my biggest supporter. She continues to teach me about engaging Judaism and finding your own space in it.

What was happening on the outside was often different from what was going on inside me. When I had started coming out I questioned myself every day. Coming out to my mother and my rabbi in my third year of high school may sound early to some but in reality it was about eight years after I had begun to realize I was attracted to men, and already it had been a couple of years since I had become shomer mitzvot, one who follows the commandments. As I got more and more involved in the religious world, much of it online where I would talk and study with other Jews, often studying the weekly Torah portion, I began realizing that I was living in two worlds. Although they were struggling to come together, it hadn't happened quite yet. I was feeling more and more torn, not comforted.

Whereas in the U.S. the two worlds were somewhat theoretical, when I temporarily moved to Israel they became very real. In the egalitarian yeshiva I attended I met some discomfort among several of the faculty but found support among most of the student body. This was a minor discomfort, one I was used to. Outside of my yeshiva I found a little more resistance.

On one of my first nights in Israel that year I was sitting at a café in Hertzelia Pituach with a group of gay men, a lesbian, and one straight man. They were all older than me, none of them religious. These were successful people, some of them well known,

living in Tel Aviv. If Jerusalem is the religious center of Israel, Tel Aviv is its secular counterpart. All of them had the same reaction to my feelings about being out in Jerusalem. "Don't," they told me. "You'll get hurt."

I had begun to understand that for many being gay was something you could do in the secular world, world number one. Strongly identifying with Judaism and its traditions and observances was something for the religious world. Neither was so thrilled to have the other intrude. Gay friends were often more upset with my being religious than my straight religious friends were with my being gay. Still, being closeted was not an option. Now I had to be sure not to be closeted about my religiousness as well.

Almost daily I would face some challenge to being myself. Sometimes the experiences were subtle, other times I faced blatant opposition. More often than not, though, as long as I stayed strong and calm, the interactions became important moments for everyone involved, chances for growth.

I left class one afternoon to grab a book from the beit-midrash. I went to my table and fished the book out of a small but messy pile. Sitting one table over was my Gomorrah teacher. I can't quite recall what prompted the question, but my teacher looked up from his books and asked how I knew I was gay. Would it really be impossible to marry and live happily with a woman?

"How would you feel," I said, "if I told you that you that you had to live and sleep with a man for the rest of your life, pleasing him sexually at least once a week, and being his emotional partner?"

A moment of silence followed, and we had come to a new understanding. I went back to class, more out and more free.

When I was still running the online forum for frum gay Jews I was amazed at the incredibly different backgrounds we each had, the tremendously varied coming out stories, concerns and relationships. But there was one clear and unifying notion among us: we had two undeniable truths. Our biggest fear was having to live each of these truths in a separate world.

* * * * * * * * * *

I'm standing in the middle of a gay club in Manhattan. I am here, for the first time, with six or seven guys from strong Jewish backgrounds, all of us at some point in our lives having identified as Orthodox, many of us still *frum*, some of us out. Standing here I think about one of the first pieces of Mishnah I ever learned. At the very beginning of tractate Brachot a story is told. Rabbi Gamliel's sons came home from the tavern after midnight and asked whether or not they could still read the Shema. When we left, would we too think about Torah? And at that very moment one friend lifts a beer bottle to his lips, momentarily pausing to say the bracha.

Gayness and God

Rabbi Steve Greenberg

I am an Orthodox rabbi and I am gay. For a long while I denied, rejected, railed against this truth. The life story that I had wanted—wife, kids, and a family that modeled Torah and *hesed*—turned out to be an impossible fantasy. I have begun to shape a new life story. This essay is part of that life story, and thus remains unfinished, part of a stream of consciousness rather than a systematic treatise.

It is hard to say how or when I came to know myself as a gay man. In the beginning, it was just an array of bodily sensations. Sweaty palms, warm face, and that excited sort of nervousness in your chest that you get when in the company of certain people occurred without understanding. The arrival of the hormonal hurricane left me completely dumbfounded. Just when my body should have fulfilled social expectations, it began to transgress them. I had no physical response to girls. But I was physically pulled, eyes and body, toward guys. I remember my head turning sharply once in the locker room for an athletic boy whom I admired. At the time, I must have noticed my body's involuntary movement, but it meant nothing to me. I understood nothing. How could I? I had no idea what it meant to be homosexual. *Faggot* or *homo* were words reserved for the boys hounded for being passive, or unathletic. None of this said anything about sexual attraction. There were no categories for this experience, no way to explain the strange muscle spasms, the warm sensation on my face, or the flutter in my chest. Not until years later, after countless repetitions of such events, did it slowly, terrifyingly, breathe through to my consciousness.

When other boys were becoming enraptured by girls, I found my rapture in learning Torah. I was thrilled by the sprawling rabbinic

arguments, the imaginative plays on words, and the demand for meaning everywhere. *Negiah*, the prohibition to embrace, kiss, or even touch girls until marriage, was my saving grace. The premarital sexual restraint of the Halacha was a perfect mask, not only to the world, but to myself.

My years in yeshiva were spectacular, in some measure because they were so intensely fueled by a totally denied sexuality. There were so many *bachurim* (students) in the yeshiva whose intense and passionate learning was energized with repressed sexual energy. For me, the environment deflected sexual energy and generated it as well. The male spirit and energy I felt in yeshiva was both nourishing and frustrating. I do not know if I was alone among my companions or not. From those early years, I remember no signs by which I could have clearly read my gayness or anyone else's. I only know that I was plagued with stomachaches almost every morning.

Later, on one desperate occasion, beset with an increased awareness of my attraction to a fellow yeshiva student, I visited a sage, Rav Eliashuv, who lives in one of the most secluded right-wing Orthodox communities in Jerusalem. He was old and in failing health but still taking visitors who daily waited in an anteroom for hours for the privilege of speaking with him for a few minutes. Speaking in Hebrew, I told him what, at the time, I felt was the truth. "Master, I am attracted to both men and women. What shall I do?" He responded, "My dear one, then you have twice the power of love. Use it carefully." I was stunned. I sat in silence for a moment, waiting for more. "Is that all?" I asked. He smiled and said, "That is all. There is nothing more to say."

Rav Eliashuv's words calmed me, permitting me to forget temporarily the awful tensions that would eventually overtake me. His trust and support buoyed me above my fears. I thought that as a bisexual I could have a wider and richer emotional life and perhaps even a deeper spiritual life than is common—and still marry and have a family.

For a long while I felt a self-acceptance that carried me confidently into rabbinical school. I began rabbinical training with great excitement and a sense of promise. At the center of my moti-

vations were those powerful rabbinic traditions that had bowled me over in my early adolescence. I wanted more than anything else to learn and to teach Torah in its full depth and breadth. I finished rabbinical school, still dating and carefully avoiding any physical expression, and took my first jobs as a rabbi. There were many failed relationships with wonderful women who could not understand why things just didn't work out. Only after knocking my shins countless times into the hard wood of this truth was I able fully to acknowledge that I am gay.

It has taken a number of years to sift through the wreckage of "my life as I wanted it" to discover "my life as it is." It has taken more time to exorcise the self-hatred that feeds on shattered hopes and ugly stereotypes. I am still engaged in that struggle. I have yet to receive the new tablets, the whole ones, that will take their place in the Ark beside the broken ones. Rav Nachman of Bratzlav teaches that there is nothing so whole as a broken heart. It is in his spirit that I continue to try to make sense of my life.

Although much has changed in the past few years as I have accepted my gayness, much remains the same. I am still a rabbi, and I am still deeply committed to God, Torah, and Israel. My religious life had always been directed by the desire to be a servant of the Lord. None of that has changed. The question is an old one, merely posed anew as I strive to integrate being gay into my life. Given that I am gay, what is it that the God of Israel wants of me?

Of course, many will hear this as an illegitimate question—fallacious in thinking that the God of Israel can somehow accept and move beyond my gayness. Leviticus 18:22 instructs: "Do not lie with a male as one lies with a woman, it is an abhorrence." I do not propose to reject this or any text. For the present, I have no plausible halachic method of interpreting this text in a manner that permits homosexual sex.

As a traditionalist, I hesitate to overturn cultural norms in a flurry of revolutionary zeal. I am committed to a slower and more cautious process of change, which must always begin internally. Halacha, the translation of sacred text into norm, as an activity, is not designed to effect social revolution. It is a society-building enterprise that maintains internal balance by reorganizing itself in

response to changing social realities. When social conditions shift, we experience the halachic reapplication as the proper commitment to the Torah's original purposes. That shift in social consciousness in regard to homosexuality is a long way off.

If I have any argument, it is not to press for a resolution, but for a deeper understanding of homosexuality. Within the living Halacha are voices in tension, divergent strands in an imaginative legal tradition that are brought to bear on the real lives of Jews. In order to know how to shape a halachic response to any living question, what is most demanded of us is a deep understanding of the Torah and an attentive ear to the people who struggle with the living question. Confronting new questions can often tease out of the tradition a *hiddush*, a new balancing of the voices and values that have always been there. There is no conclusive *psak halacha* (legal ruling) without the hearing of personal testimonies, and so far gay people have not been asked to testify to their experience. How can halachists possibly rule responsibly on a matter so complex and so deeply foreign, without a sustained effort at understanding? Whatever the halachic argument will be, we will need to know much more about homosexuality to ensure that people are treated not merely as alien objects of a system but as persons within it. Halachists will need to include in their deliberations the testimony of gay people who wish to remain faith to the Torah. Unimagined strategies, I believe, will appear under different conditions. We cannot know in advance the outcome of such an investigation. Still, one wonders what the impact might be if Orthodox rabbis had to face the questions posed by traditional Jews, persons they respect and to whom they feel responsible, who are gay.

There is one quasi-halachic issue I must address—that of choice. One of the mitigating factors in halachic discourse is the presence of free will in matters of law. A command is only meaningful in the context of our freedom to obey or disobey. Thus the degree of choice involved in homosexuality is central to the shaping of a halachic response. There is indeed a certain percentage of gay people who claim to exercise some volition in their sexual choices. But for the vast majority of gay people, there is no "choice" in the ordinary sense of the word. Gay feelings are hardwired into

our bodies, minds, and hearts. The strangeness and mystery of sexuality is universal. What we share, gay or straight, is the surprising "queerness" of all sexual desire. The experience of heterosexuals may seem less outlandish for its being more common, but all sexual feeling is deeply mysterious, beyond explanation or a simple notion of choice.

The Halacha addresses activities, however, not sexual identities; thus, in halachic Judaism there is no such thing as a gay identity—there are only sexual impulses to control. The tradition describes all sexual desire as *yetzer ha'ra* (evil impulse), rife with chaotic and destructive possibilities. Heterosexual desire is redeemed and integrated back into the system through a series of prescriptions and prohibitions that channel sexuality and limit its range of expression. Confined within marriage, giving and receiving sexual pleasure, even in non-procreative ways, is raised to the level of mitzvah.

Homosexual desire, in contrast, is not seen as redeemable and thus remains an implacable *yetzer ha'ra* that needs to be defeated rather than channeled. In this argument, gay people are treated as people with a dangerous and destructive sexual desire which must be repressed. The spiritual task of a gay person is to overcome that *yetzer ha'ra* which prods one to have erotic relations with members of the same sex.

The unfairness of this argument begins with the recasting of homosexuals as heterosexuals with perverse desires. The Torah is employed to support the idea that there is only one sexuality, heterosexuality. God confirms heterosexual desire, giving heterosexuals the opportunity to enjoy love and companionship. With the impossibility of another sexuality comes the implicit assumption that gay people can "become" straight and marry and indeed should do so.

This has in fact been the ordinary state of affairs of many, if not most, gay men and women throughout history. I know a number of gay (or bisexual) men who have married and sustain relationships with their wives. Of course, most have had an affair at some point which did not end their marriage. Two gay rabbis I know were married and are now divorced, and a third remains happily married, surviving recurrent bouts of depression and emotional

exhaustion. What disturbs me most in this sometimes heroic attempt at approximating the traditional ideal is the cost to the heterosexual spouse. While in my first rabbinical post, I decided to come out to an older rabbi and seek his advice. He counseled me to find a woman and marry. I asked him if I was duty-bound to tell her about my attractions to men and my general sexual disinterest in women. He said no. I was shocked to hear that it was all right to deceive a woman who could very easily be damaged by such a marriage. It made no sense to me. Surely some heterosexual women might be willing to marry a gay friend who could provide children and be a wonderful father. There have been rare instance of gay women and men who have worked out marriages where the "uninterest" was mutual. I struggled for a number of years to find such a woman, gay or straight, with whom to begin a family. Sometimes I still torment myself to think that this is all possible—when it is not. I still feel ripped apart by these feelings—wanting a woman at the Shabbat table and a man in my bed. If I am judged for some failure, perhaps it will be that I could not choose the Shabbat table over the bed, either for myself, or for the forlorn woman, who, after dinner wants the comfort of a man who wants her back.

Having rejected this option, the standard Orthodox position is to require celibacy. Many recent articles and responsa regard gay sex as indistinguishable from adultery, incest, or bestiality. The heterosexual is asked to limit sexuality in the marital bed, to non-relatives, to human beings; the homosexual is asked to live a loveless life. I have lived portions of my adult life as a celibate clergyman. While it can have spiritual potency for a Moses or a Ben Azzai, who abandoned sexual life for God or Torah, it is not a Jewish way to live. Always sleeping alone, in a cold bed, without touch, without the daily physical interplay of lives morning and night—this celibate scenario is life-denying and, for me, has always led to a shrinking of spirit. What sort of Torah, what voice of God would demand celibacy from all gay people? Such a reading of divine intent is nothing short of cruel.

Many gay people now and in the past have been forced to purchase social acceptance and God's love through a denial of affection and comfort and, worse, a denial of self. Today many simply

leave Judaism behind in order to salvage a sense of dignity and to build a life. This understanding of homosexuality leaves no legitimized wholesome context for sexuality; no possibility of *kedusha* or *kedushin*.

I have come to understand my gayness as akin to my Jewishness: It is integral to my sense of self. Others may misunderstand and even wish me harm, but from myself I cannot hide. I did not choose it, and yet now that it is mine, I do. It is neither a mental illness nor a moral failing, but a contour of my soul. To deny it would be self-defeating. There is nothing left to do but celebrate it. Whether in or out of the given halachic rubric, I affirm my desire for a full life, for love, and for sexual expression. Given that I am gay and cannot be otherwise, and given that I do not believe that God would demand that I remain loveless and celibate, I have chosen to seek a committed love, a man with whom to share my life.

But so little of life is carried on in the bedroom. When I indeed find a partner, what sort of life do we build together? What is it that the God of Israel wants of me in regard to family and community? Struggling with God and with Torah as a gay person was just the beginning. To be Jewish is to be grounded in the continuity of the Jewish people as a witness—a holy people, a light amongst the nations—a blessing to all the families of the earth. How does a gay person help to shape the continuity of the Jewish people? The carrying forth of the Jewish people is accomplished by marriage and procreation. It is both a tool of the Abrahamic covenant and its most profound meaning statement.

We are a people on the side of life—new life, more life, fuller life. The creation story invited the rabbis to read God's blessing of "be fruitful and multiply" as a command to have two children, a male and a female. Every Jewish child makes the possibility of the Torah's promise of a perfected world more real, more attainable. Abraham and Sarah transmit the vision by having children. Often the portrayal of blessing includes being surrounded with many children. Childlessness is a punishment and curse in the tradition, barrenness a calamity.

Gay life does not prevent the possibility of producing or rais-
ing Jewish children, but it makes those options very complicated.
Being gay means that the ordinary relationship between making
love and having children is severed. There is a deep challenge to
the structure of Judaism, since its very transmission is dependent
on both relationship and reproduction. For Jews who feel bound by
mitzvot, bound by the duty to ensure that life conquers death, the
infertility of our loving is at the core of our struggle to understand
ourselves in the light of the Torah.

This problem, among others, lies at the root of much of the
Jewish community's discomfort with gay people. To a people that
was nearly destroyed fifty years ago, gay love seems irresponsible.
Jews see the work of their lives in light of the shaping of a world for
their children. By contrast, gay people appear narcissistic and self-
indulgent. Gay people's sexuality is thus a diversion from the tasks
of Jewish family and the survival that it symbolizes, and is per-
ceived as marginal to the Jewish community because we are shirk-
ers of this most central and sacred of communal tasks.

This challenge also has a moral chord which strikes deep into
the problems of gay subculture. The tradition understood parenting
as one of the major moral crucibles for human development. No
judge could serve without first being a parent for fear that without
the experience of parenting one could grasp neither human vul-
nerability nor responsibility. Being heterosexual carries one down
a path that demands years of selfless loving in the rearing of chil-
dren. While not all straight couples have children, and some gay
couples become surrogate or adoptive parents, the norm is shaped
less by choice and more by biology. Given that gay people do not
fall into childbearing as an ordinary outcome of coupling, how do
we find our place in the covenant? And what of the moral training
that caring for children provides, how do we make up for that? Is
there another job to be done that requires our service to God and to
the Jewish people? Of all the problems entailed in gay sexuality,
this one looms for me, both spiritually and emotionally.

Although there is no obvious biblical resource for this di-
lemma, there are biblical writers who struggled to address God's
will in very new social circumstances. Isaiah was one such writer

who bridged the worlds before and after the Exile. Some familiar passages have become charged for me with new meaning. In these verses Isaiah is speaking to his ancient Israelite community and trying to convince them that God's covenantal plan for Israel is larger than they think. The covenant begins with Abraham and Sarah but has become much more than a family affair. He speaks to two obvious outsider groups in chapter 56, the *b'nai ha'nechar*, the foreigners of non-Israelite birth, and the *sarisim*, the eunuchs:

> Let not the foreigner say,
> Who has attached himself to the Lord,
> "The Lord will keep me separate from His people";
> And let not the eunuch say,
> "I am a withered tree."

In the Talmud, a eunuch is not necessarily a castrated male, but a male who is not going to reproduce for various reasons (*Yevamot* 80b). Why does Isaiah turn his attention here to the foreigners and the eunuchs? In the chain of the covenantal family, the foreigner has no past and the eunuch no future. They both seem excluded from the covenantal frame of reference. It is this "exclusion" that the prophet addresses:

> For thus said the Lord:
> "As for the eunuchs who keep my sabbaths,
> Who have chosen what I desire
> And hold fast to My covenant—
> I will give them, in My House
> And within my walls,
> A monument and a name
> Better than sons or daughters.
> I will give them an everlasting name
> Which shall not perish."

The prophet comforts the pain of eunuchs with the claim that there are other ways in which to observe, fulfill, and sustain the covenant. There is something more permanent than the continuity

of children. In God's House, the achievement of each individual soul has account. A name in the Bible is the path toward the essence, the heart of being. It is passed on to progeny. But there is another sort of a name, a name better than the one sons or daughters carry. The covenant is carried forward by those who live it out, in the present. Loyalty to the covenant is measured in God's House in such a way that even if one's name is not passed on through children, an eternal name will nonetheless be etched into the walls. Isaiah offers a place to the placeless, an alternative service to the person who cannot be part of the family in other ways:

> As for foreigners
> Who attach themselves to the Lord,
> to be His servants—
> All who keep the sabbath and do not profane it,
> And who hold fast to my covenant—
> I will bring them to my sacred mount
> And let them rejoice in my house of prayer.
> Their burnt offerings and sacrifices
> Shall be welcome on My altar;
> For My House shall be called
> A House of prayer for all peoples.
> Thus declares the Lord God,
> Who gathers the dispersed of Israel:
> "I will gather still more to those already gathered."

So inclusive is God's plan for the Israel in the word that any foreigner can join. The notion of conversion, so obvious to us now, was a striking innovation for the generation of Isaiah. Conversion is about rewriting the past. Like adoption, conversion redefines the meaning of parents and family. Birth and lineage are not discarded. The central metaphor for Israel is still family. But Isaiah and later tradition open up another avenue into the covenant. Those with no future are promised a future in the House of the Lord; those with no past are nevertheless included in Israel's destiny.

God can only require the doable. A foreigner cannot choose a different birth or the eunuch a different procreative possibility. Gay

people cannot be asked to be straight, but they can be asked to "hold fast to the covenant." God will work the story out and link the loose ends as long as we hold fast to the covenant.

Holding fast to the covenant demands that I fulfill the *mitzvot* that are in my power to fulfill. I cannot marry and bear children, but there are other ways to build a family. Surrogacy and adoption are options. I have a number of friends, gay and lesbian, who have found ways to build wonderfully loving families. If these prove infeasible, the tradition considers a teacher similar to a parent in life-giving and thus frames a way that the *mitzvah* of procreation can be symbolically fulfilled.

A special obligation may fall upon those who do not have children to attend charitably to the needs and the protection of children in distress. However, childlessness offers more than a call to activism and philanthropy in the defense of children. It can be received as a way to live with unusually open doors. I have always felt that the open tent of Sarah and Abraham was loving and generous in the extreme because they were, for the bulk of their lives, childless. With no children upon whom to focus their affection, the parents par excellence of the covenant spent lifetimes parenting other people's grown children.

Holding fast to the covenant demands that I seek a path towards sanctity in gay sexual life. The Torah has much to say about the way people create *kedusha* in their sexual relationships. The values of marriage, monogamy, modesty, and faithfulness which are central to the tradition's view of holiness need to be applied in ways that shape choices and life styles.

Holding fast to the covenant means that being gay does not free one from the fulfillment of *mitzvot*. The complexities generated by a verse in Leviticus need not unravel my commitment to the whole of the Torah. There are myriad Jewish concerns, moral, social, intellectual, and spiritual, that I cannot abandon. Being gay need not overwhelm the rest of Jewish life. Single-issue communities are political rather than religious. Religious communities tend to be comprehensive of the human condition. The richness of Jewish living derives in part from its diversity of attention, its fullness.

For gay Orthodox Jews, this imagination of engagement between ourselves and the tradition is both terribly exciting and depressing. Regretfully, the communities that embrace us, both gay and Jewish, also reject us. The Jewish community wishes that we remain invisible. The gay community is largely unsympathetic and often hostile to Judaism. There are some in the gay community who portray Judaism as the original cultural source of homophobia. More often, the lack of sympathy toward Jewish observance derives from the single-mindedness of gay activism. Liberation communities rarely have room for competing loyalties.

Gay synagogues have filled a void for many, providing a place of dignity in a Jewish community. This work is part of a movement toward a fuller integration in the larger Jewish community for which most gay Jews long. Gay-friendly synagogues may well point the way, modeling a community of families and singles, young and old, straight and gay that is in spirit much closer to my hopeful future imagination than anything yet.

Gay Jews who wish to be part of an Orthodox community will find very few synagogues in which there is some level of understanding and tolerance. Some gay Jews attend Orthodox services and remain closeted in their communities. It is crucial that Orthodox rabbis express a loving acceptance for known gays in their synagogues even if public legitimation is now impossible. Attacks on homosexuality from the pulpit are particularly painful to those who have remained connected to the traditional synagogue, despite the hardships.

For the present, in regard to sexual behavior, I personally have chosen to accept a certain risk and violate the Halacha as it is presently articulated, in the hope of a subsequent, more accepting halachic expression. I realize that this is "civil disobedience." It is not the system itself which I challenge but its application to an issue that has particular meaning for me and for those like me. There is always a possibility that I am wrong. Ultimately, the halachic risks that I take are rooted in my personal relationship with God, Whom I will face in the end. It is this faith which makes me both confidant and suspicious of myself.

I have, admittedly, a rather privatized form of community. I am closeted and have chosen to write this essay in anonymity to preserve what is still most precious to me: the teaching of Torah and caring for my community of Jews. What concerns me most is neither rejection by the Orthodox community, nor the loss of my particular pulpit. Were I to come out, I suspect that the controversy would collapse my life, my commitments, my identity as a teacher of Torah, into my gayness. Still, the secrecy and the shadowy existence of the closet are morally repugnant and emotionally draining. I cannot remain forever in darkness. I thank God that, for the time being, the Torah still sheds ample light.

I have a small circle of friends, gay and straight, men and women, with whom I share a sense of community. We are looking for other tradition-centered Jews who can help build a place that embraces both the Torah and gay people. Not a synagogue, not a building, but a place for all the dispersed who are in search of community with Israel and communion with God. In this place, this House of the Lord, now somewhat hypothetical and private, and soon, I pray, to be concrete and public, those of us who have withered in the darkness, or in the light of day have been banished, will discover our names etched upon the walls.

Postscript

I wrote "Gayness and God" only four years ago, and while it may appear insignificant to those who live in more open societies, much has changed in the Orthodox world in that short span of time. Four years ago the closet was darker and the door shut tighter for most traditional Jews. Social attitudes in the Orthodox community toward homosexuality have moved in two opposing directions due to the greater social acceptance in the larger society. The most important change is that in the past four years the topic has been raised repeatedly in articles, conferences, and newsletters. In short, as homosexuality, as an issue, has come out of the closet, things are worse and better.

Antihomosexual rhetoric in the Orthodox community has become more shrill over the last few years, with various leaders and

writers using gay liberation as a symbol of social and familial dis-
integration and expressing shock and horror at Reform Judaism
for its acceptance of gay commitment ceremonies and gay rabbis.
But the effect of the rhetoric has often been to the advantage of
those pressing for gay inclusion. A gay and lesbian student organi-
zation established by a few graduate students in a professional
school associated with Yeshiva University drew public outrage from
religious authorities, university students, and community members.
The president of the university, Norman Lamm, chose to put the
issue to bed by claiming that public funds necessary for the uni-
versity depended upon a liberal policy in regard to student asso-
ciations. The public debate has invited Orthodox rabbis to speak
from the pulpit on the issue, mostly in unaccepting ways, and be
confronted later by parents of gay children and by gay Jews them-
selves who take the opportunity to come out to their rabbis.

Gay traditional Jews have not come out en masse, but they
have begun in larger numbers to make themselves present to each
other. Today there is a Gay and Lesbian Yeshiva Day School Alumni
group that meets monthly in New York City, has a membership of
nearly a hundred people, and even has a web site. Until recently, it
was impossible to speak about AIDS prevention in the Orthodox
community for fear that any talk was an incitement to promiscuous
gay sex. Now there is an AIDS hotline for Orthodox Jews which
especially targets the Haredi neighborhoods of Brooklyn and
Queens. Until recently it was common for Jewish hospital groups
in religious communities to actively avoid visiting Jewish AIDS
patients. Today there are Orthodox synagogues in Manhattan and
Queens that have special *Bikkur Holim* groups that deliver meals
and visit Jewish AIDS patients.

Fifteen years ago the boundary issue was feminism. Ortho-
doxy surely constructed its difference in a number of ways, but
anti-feminism was a difference that proved evocative both theo-
retically and pragmatically for its constituents. Until the line was
drawn openly, it could not be contested. Once the conversations
about women's roles were engaged, everyone was led into consid-
eration and dialogue. This past February one thousand people gath-
ered for a conference on Orthodoxy and Feminism. It used to be an

oxymoron to say that one was an Orthodox feminist. It no longer is. Today the line in the sand for many, the boundary case that distinguishes the halachic Jew from the rest, is homosexuality. While the issues are potentially more explosive and the concerned parties much less numerically significant, still engagement begins with a conversation. Public formulation actually works to problematize the issues and raise to consciousness the human concerns that expand the possibilities.

After I wrote "Gayness and God" I received many letters, mostly from Orthodox or once-Orthodox gay men and lesbians grateful for the attempt to make sense of their experience. I met Jews who had been self-accepting homosexuals in their college years and in their thirties were turning toward observance and Torah study as much deeper resources of humanity and identity than those which they had found elsewhere. I received letters from a number of Orthodox rabbis, all but one sincerely engaging if not supportive. I was showered with support from family and friends.

Recently, one Orthodox rabbi was asked by a group of young leaders about his stance on homosexuality. In the public forum he said that only a few years before he knew exactly what he thought about homosexuality and would easily articulate his halachic position. He now admits that he is humble before a profound human dilemma and prefers less rhetoric and more understanding. He doesn't know what he thinks, nor is he quite sure what to say, and that is how he responds when asked.

It takes great faith to stand at the threshold of another human being and really listen. It takes great courage to do so before a person whose inner life is terribly alien, whose experience touches dark fears, or whose commitments seem to shape a threatening ideological frame to thousands of years of tradition. It is much easier, safer, to have the procrustean bed already made. It is true that in most settings those beds are ready made with all the proper arrangements for stretching our legs or cutting off our feet. Most Orthodox rabbis are not like my rabbi-friends or the rabbi mentioned above.

Often over the past twenty years I have wanted to storm the heavens, to demand of God an explanation, a reconciliation, a response. In the language of Judith Plaskow, I am standing again at Sinai, insisting to be heard and to hear anew. One of my dearest colleagues is an Orthodox rabbi schooled in black-hat yeshivot and a psychologist. A few years ago he accosted me as we walked in New York City to a kosher diner. He told me that he'd had enough of my self-doubt and that he didn't even see how I could make do with mere self-acceptance. "You have no choice," he said, "but to celebrate your gayness." I began to cry on Thirty-seventh Street not knowing what had burst in me. Later I understood my response as surprise. For years my Orthodox compatriots, friends, and family had accompanied me to this Sinai not by the force of a rational argument or a textural proof but by having come to share my demand for sense, my longing for wholeness. I had just not thought to look behind me.

Notes of an Adopted Son

Jesse G. Monteagudo

The search for family and community takes us in different directions. In my case the search took me to an alien faith and to a people I had no direct connection with, neither ethnic or cultural. At the age of twenty-three, after growing up in a Latino Catholic culture, I became a Jew. My conversion to Judaism was part of an ongoing process of redefining and rediscovering myself, both as a gay man and as a human being.

In 1492 Spain's Catholic monarchs, Ferdinand and Isabella, expelled the Jews from their country. The Edict of Expulsion left Sephardic (Spanish) Jews with no choice but to leave their country or convert to Christianity. Many who converted, called *conversos* (converts) by the authorities and *marranos* (pigs) by the masses, were closet Jews who practiced their ancestral faith in secret. Others married into the general population, including the nobility, and merged into the Spanish bloodline. Because of this mixture it is estimated that most of us who are of Spanish descent have Jewish (and Moorish) ancestry. Though I have no proof of Jewish ancestry, I like to think that I do, and that my conversion is a return to my Jewish roots. But this is speculation. My ethnic background, as much as I can tell, is Spanish, French, German and North African (from the Canary Islands), but not directly Jewish.

My introduction to Judaism and to the Jewish people was a gradual process. As a boy in pre-Castro Cuba, I did not know any Jews, though the island had a small but vital population of both Sephardic and Ashkenazic (Eastern European) Jews. Cuban Jews flourished in spite of an atmosphere of anti-semitism that the Cuban people, an explosive mix of Spanish and African (with everything else thrown in for good measure), inherited from our Spanish

ancestors. Jews were not legally allowed in Cuba until its independence in 1902, and those who came afterwards were hated as alien immigrants or as agents of U.S. Imperialism. The Spanish term *Judia* (Jew) had such negative connotations that Cubans who did not want to seem prejudiced often used the term *Hebreo* (Hebrew) to describe a Jewish friend or Jews in general.

The Cuban Catholic Church, until 1959 predominantly Spanish, was anti-semitic. It was also, before the Revolution, in charge of much of Cuba's educational system. My second grade class was run by a notorious (though not atypical) clerical bigot who taught his students that the Jews were Christ-killers who were expelled from their homeland as punishment for their crime. Having learned about the State of Israel in another class, I quickly noted that the Jews *have* a homeland. The monk, not used to feedback from impertinent seven-year-olds, tartly noted that Jews were still scattered about and went on with his lecture.

Not untill I came to the United States in 1962 did I meet any Jews. My father, like many immigrants to South Florida, got a job at a Miami Beach hotel that was largely frequented by Jews. During the sixties the Jews in my life were tourists whom I encountered in the hotel where my father worked and where later I held a series of summer jobs. To the adolescent me, the Jews were strange but interesting people, often immigrants like myself—mostly elderly people who spoke a different second language (Yiddish), had different tastes in food, liked books and movies and the theater (as did I), and practiced a religion that circumcised their sons but managed to survive without Jesus, Mary, the saints, the Pope, priests and nuns and with only half a Bible. I also learned about the State of Israel, as dear to them as fighting Communism was to us Cubans, and about the Nazis who murdered six million Jews during World War Two. Like Jews, middle-class Cubans, called throughout the hemisphere as the "Jews of Latin America," prized education, hard work, family and community, values that I inherited from my parents and my surroundings. Like the Jews of Miami Beach, the men and women of the Cuban *diaspora* were then creating a dynamic community in exile—across Biscayne Bay in Little Ha-

vana—which, like Jewish-American communities everywhere, combined our ancestral traditions with American values and ideals.

Little Havana too had its Jews, men and women and children who like the rest of us fled Cuba to escape the rigors of Communism. Many flourished in *El Exilio*, a term which, like the Hebrew *diaspora*, is full of meaning for those who speak the language. To those of us who grew up in Little Havana during the sixties, Cuban Jews were not Jews but Cubans, so much like us that they did not impress me the way their distant cousins on the Beach impressed me. In fact, Jews and Judaism were not priorities with me during my crucial decade. These were the years when I discovered my essential difference: the fact that I, like a Jew in an anti-semitic society, was something that everyone around me despised.

Coming out as a gay man in a homophobic society is a story that has been told before. Though homophobia is not unique to Roman Catholicism—it is a trait that is shared by other faiths, including traditional Judaism—it seemed to be especially hypocritical in an institution where so many of its spiritual leaders were gay. One of my uncles, now deceased, was a closeted gay man who joined a religious order in order to avoid dealing with his homosexuality. It was obvious to me, as a student in a Catholic school in Miami, that many of the priests, nuns and monks were gay. In fact the Catholic tradition of clerical celibacy encouraged men and women who were homosexually oriented to enter the religious life, where marriage and children were not expected of them.

The sixties were uncertain times, when my emerging sexuality and my developing intellect clashed with established beliefs. I began to question a Church that condemned all its masses to impoverishing overpopulation, its women to second-class citizenship, and its sexual and intellectual dissidents to excommunication and hell. Though I continued to believe in a God, I gradually lost faith in the Trinity, the Virgin Mary, the saints, a supposedly infallible Pope, and a priesthood that claimed supernatural powers. Though I continued to think well of Jesus, he seemed to be no more than a man—a devout Jew who wanted to reform his people but not start a universal faith, and certainly not the Messiah. By the time I graduated from Catholic high school in 1972, I had ceased to be a Catho-

lic, though I continued to be a nominal Christian, albeit a non-believing one, for some time.

All this turmoil might have made me, like so many other "lip-service Catholics," an unbeliever who continues to pay lip service to his Church, if only as a place to be married and buried in. But I was not satisfied with a "solution" that to me was no solution at all. My college years, the years in which I came to terms with my sexual orientation, were also years of spiritual searching, when I explored several spiritual options, from atheism to Holy Roller. I even dabbled in Scientology, perhaps the worst mistake of my life, for the Church of Scientology was not only homophobic but also centralized and regimented to a degree unheard of even in the Catholic Church.

Now I realize that my spiritual road, through many detours, was taking me towards Judaism. My admiration for the State of Israel translated into deep affection for the people who made the Zionist dream a reality. The Jewish ability to survive for centuries among hostile Christian or Muslim populations struck a chord in a man whose sexual affinities made him something of an outcast. I found in the Jewish traditions of justice, as expounded by generations of prophets and rabbis, an ethic by which I could live. Like King Bulan of the Khazars, a Russian prince who converted to Judaism in the middle ages, I compared Judaism with Christianity and Islam and found Judaism to be first, not only in age, but in its beliefs, traditions, and rituals. Judaism gave humanity the Torah, the Sabbath, a strong moral code, and a one-to-one relationship with a unitary God whose uniqueness was diluted by trinitarian Christianity. While other religions stress the afterlife, Judaism is oriented toward the here and now; study and good works are honored for their own sakes and not as conduits to heaven.

And Judaism was more than a religion. It was a way of life, practiced through the ages by a "chosen people"—more precisely a *choosing* people—who, though not quite a "race," were an extended (if quarrelsome) family that went back in time to Abraham and Sarah and forward into the untold future. Life cycle events, daily rituals, and annual holidays alike served to bring the Jewish

family, whether in Israel or in the Diaspora, together with one another and with our ancestors. All this struck a chord in me.

My affinity for Judaism and for all things Jewish might have never carried me over the threshold to conversion had I been heterosexual. As a straight man, I would have almost certainly married a Cuban woman, or at least a Latina, and raised our children in our parents' faith. As a gay man, and thus a rebel against society's sexual and gender mores, I had less of a reason to remain rooted to my religious and cultural heritage. I am not alone in this regard. In my twenty years in the lesbian and gay community I have known many women and men who have changed their faith, not only to Judaism (or Christianity) but also to Unitarianism, Islam, Buddhism, Santeria, Wicca, and other cults.

There was another reason why being gay influenced my decision to choose Judaism. That was my need to find a family and community that would take the place of a Cuban-Catholic culture that I was no longer quite comfortable with and which would not accept me on my own terms. The gay bar scene, as I experienced it, left me empty, and the Metropolitan Community Church would have me believe in a theology that I could not accept. Judaism, on the other hand, represented a community that I could accept, admire, and emulate. Though traditional Judaism was too sexist and homophobic for my taste, I was attracted to Reform Judaism, a forward-thinking and progressive branch of Judaism that, at its best, combined Jewish traditions and ideals with modern realities. Reform Judaism's stand on lesbian and gay rights is more progressive than that of any branch of Judaism except Reconstructionism and any Christian sect except the Unitarians and the MCC.

During this formative period (1973-76) I developed friendships with many Jews, both gay and straight. Steve was an attorney and singer who I met in a Miami bar and who became my lover for several years. It was early 1976, a memorable year for several reasons, not the least of which being the start of my involvement in lesbian/gay politics. Steve, as it turned out, was active in Congregation Etz Chaim, Miami's lesbian and gay synagogue, where he served as a cantorial soloist. Though I heard about Etz Chaim, I

had never been there, so I accepted Steve's invitation to go with him to *shul*. The rest is history.

Congregation Etz Chaim, then the Metropolitan Community Synagogue, was founded in 1974 by gay and lesbian Jews who were not comfortable with the Metropolitan Community Church. In the Spring of 1976, services were held at the YWCA building in downtown Miami. The Synagogue was run by the lay leadership, then for the most part consisting of the Synagogue's founders. Since congregants came from all branches of Judaism, service leaders tried for a mix of Conservative and Reform. Etz Chaim did not have a rabbi at that time, nor a permanent home or any of the accoutrements one expects to find in a temple.

Though organized as a Synagogue, Congregation Etz Chaim drew lesbian and gay Jews who were not religious but who had strong ethnic and cultural links to the people Israel. Some came to Etz Chaim for the services; others came for the social events—Etz Chaim's annual drag shows, featuring the "Fabulous Yentettes," were already notorious; and virtually everyone looked to Etz Chaim as a place where those who are "twice blessed" could be out of their double closets, free to be gay and Jewish in a world that was often anti-semitic and mostly homophobic.

Though I have been to synagogues before, this was the first time I attended a "gay" synagogue. I remember being greeted at the door by David, a lovable old bear who took me by the hand and introduced me to everyone there. A stranger in a strange land, I was fortunate to already know some of the people there, including Steve and Jay, one of the Synagogue's founders and then its president. Someone put a prayer book in my hand and a *yarmulke* on my head and I sat down, looking at the incomprehensible Hebrew script in front of me (fortunately for me, the prayers were also transliterated into English script). I sat (and stood) through the services, led by Jay, Steve and Howie (another founder), following the time-honored prayers of the Sabbath Service. Services were followed by the *Oneg Shabbat*, literally "joy of the Sabbath" and actually an after-service social with plenty of food, coffee and *shmoozing* (conversation). For many congregants, an Etz Chaim *oneg* was the social highlight of the week.

All the roads that I traveled in my life, whether they were sexual, social, religious, or communal, came together that night. Though I could not explain it to myself, I knew that this was where I belonged. Etz Chaim was different from other synagogues, not only because it was gay but because its friendly and informal nature encouraged participation from the congregation. It was clear that the members of Etz Chaim, joined by shared ethnic, religious, and sexual identities, cared for each other and looked to each other for support, assistance and camaraderie. Here was the family I was looking for and the community I never had!

I was not the first gentile to be active in Congregation Etz Chaim, nor was I to be the last. But I wanted to do more than sit in the sidelines, as a clever *shaygetz* (gentile partner) in a nominally interfaith partnership. Howie, a devout man who was a member of both Etz Chaim and Miami's largest Conservative synagogues, noted my interest almost before I did. He came up to me one night and asked me if I was interested in pursuing a conversion. Without hesitation, I said yes.

Judaism does not proselytize. Christian and Muslim leaders forbade their coreligionists from converting to Judaism under pain of death. Traditional Judaism discouraged conversion, though it might have accepted the conversion of a non-Jewish partner as an alternative to an interfaith marriage. As a faith that is intimately tied to an ethnic group, conversion to Judaism is problematic to many people, both Jew and gentile. I could never become a Jew, they would say, no more than I could become a Black or an Eskimo. Not being the son of a Jewish mother, I had no automatic membership in the covenant of Abraham. Nor could I claim to be a part of the Jewish "race." How could I, who did not have the bloodline, the parentage and the education of a born Jew, claim to be part of the people Israel?

I did not let those qualms stop me, any more than I let my Cuban birth keep me from becoming an American. Though I was not a native son, I begged to be adopted by the family of Israel. I knew that Judaism brought about commitments and obligations as well as pleasures and blessings, that the Jews are disliked by many,

that the time would come where I would have to prove myself, that my Jewish identity would always be in doubt. But I proceeded.

It was not easy. Some Reform rabbis perform "quicky" conversions that are convenient for the convert but are not recognized by the vast majority of Jews. An Orthodox conversion would have been ideal, for it would be one recognized by all branches of Judaism. However, the issue of my sexuality impeded such a move. Instead, Howie referred me to the rabbi of his Conservative congregation, a learned and affable man who was not fazed by my gayness (though we would later part company over his opposition to Dade County's gay rights law). The rabbi had done his share of conversions, so he was able to tell a sincere commitment from a convenient sham. Having satisfied him as to the sincerity of my quest, the rabbi put me through a rigorous course of study in Jewish doctrine, history, rituals and law.

Today the Reform movement conducts regular "Introduction to Judaism" classes for would-be converts. This was a service that the Conservative movement did not provide in 1976. Though Steve and my Etz Chaim friends helped, I was basically on my own. The conversion process took six months of hard work, from May to November 1976, a time in which I was also occupied with my secular studies at Florida International University. By the end of that period, the rabbi decided that I was ready to convert.

Of course I had to be circumcised. As the living symbol of God's covenant with His Chosen People, it was a ritual that no male convert could do without. (In the case of an already circumcised male, a symbolic pinprick to the penis was performed.) In Judaism, ritual circumcision, the *brit millah*, occurs when the boy is eight days old. But I was a 23-year-old man, with an adult male's normal-sized penis. How would a *mohel*, used to clipping eight-day old babies, deal with me? The solution, as it was, was worthy of King Solomon. I was checked into a Jewish hospital, where the *mohel* made the first cut and said the blessings while a Jewish surgeon finished the job. Needless to say, I was knocked out through the entire ordeal, though I (ouch!) felt the effects of the *brit* for several weeks after. I was even able to get my health insurance to

cover most of my "surgical" circumcision, for reasons of health, of course.

Having been circumcised, I was instructed to pick a Hebrew name. I chose Yeshuah ben Abraham, the Hebrew translation of my birth name plus "son of Abraham," the surname that is traditionally given to converts who don't have a Jewish father. Since then I have added "ben Sarah" to my name, in honor of our first Matriarch. I also appeared before a *bet din*, a rabbinical court that examined me, asked questions and formally granted my conversion. Last, but not least on my agenda, was a dip in the *mikveh*, a ritual bath that is taken by Orthodox Jewish women after menstruation or childbirth and by everyone upon conversion. The temple's *mikveh* was closed for repairs, so I had to take my ritual bath *al fresco* at what turned out to be the local gay beach. Though it was not the first or last time I skinny dipped in Virginia Key, it was the only time I did so in full view of two of our most revered rabbis and cantors. Fortunately for the course of my conversion, there were no police officers or former tricks around to witness my ritual bath.

Now formally a Jew, I (Yeshuah ben Abraham) proceeded to arrange my life accordingly. I became more active in Etz Chaim's congregational life. Having achieved an Etz Chaim first with my conversion, I went on to become this Synagogue's first *bar mitzvah* (1979). I also served on the Synagogue's board, on and off, for the past fifteen years, most notably as President from 1989 to 1991. Though my political, social, and literary interests have taken me elsewhere, Congregation Etz Chaim continues to be my second home and the Jewish family that I never had. It was there that I met my lover Michael, a teacher, musician, and lovable bear of a man who combines all the qualities that have attracted me to Jewish men for so many years.

All in all, and in spite of lingering doubts (in myself and others), my search for family and community has been a successful one. But it is not the end of the story. To choose Judaism is to devote a lifetime to becoming a Jew, a process that is never complete. Each day I learn something new about my adopted people and the Jewish community, gay and nongay, which is now part of

my life. Nor have I ignored other aspects of my life. I've reconciled myself to my ethnic and cultural background, even as I realized that I will never be the nice Cuban boy my parents wanted me to be. And though I shall never have Jewish children in a physical sense, I trust that through my work and my example I shall be able to touch a new generation of lesbian and gay youth, Jewish or otherwise. Nothing would please me more than the knowledge that I will leave this world a little better than it was when I got here. That is what family and community are all about.

Twice Blessed

Philip Ritari

When I came out, a 40-ish married Jew-by-choice, a friend surprised me by asking if I had converted to Judaism during my college years instead of coming out. At first her comment seemed out of left field, but over time I gave more thought to it. While I have not decided what the true answer to the question is, my musings have given me a lot insight into myself as well as into the naturally intertwining identities of being gay and being Jewish. There are times when I wonder how I managed to end up as a member of two minority groups with challenging experiences to offer, but most of the time I truly see these parts of my identity as making me twice blessed.

One event in particular brought many of the parallels and contradictions to the surface. Last summer my son became a bar mitzvah, in the davenning room of Havurat Shalom in Somerville, Massachusetts. I have been associated in various ways with Havurat Shalom for a good 20 years, watching it transform from a post-hippie Jewish Catalog oriented group into a curious hybrid of straight and gay members, both those with families and single people. In this same room I've had some of the most powerful spiritual experiences of my life—*the aufruf* before my wedding, leading *Musaf* prayers on Yom Kippur, mourning the suicide of a friend, my son's *brit milah*. And now my son was entering the adult Jewish community in the same room, in a gathering of old friends, new friends, family, and ex-friends. In preparing my little speech for my son, I had anticipated somewhat the crazy zigzag nature that my life, in retrospect, has followed. Though I find it frustrating at times that I have never walked directly towards my ultimate goals, in other ways I find it comforting that I am more like Alice managing her literal growth in Wonderland with "Eat Me" and "Drink

Me." Her two potions are like the advice in the Talmud: each person should keep two pieces of paper, one in the right pocket, one in the left pocket. One reads, "I am but dust and ashes, and to the ground I must return, a passing breath"; and the other, "The whole world was created for my sake; the whole world was made that I might live." In many areas of my life, religious and secular, gay, Jewish and other, I find this balance to be a necessary way to live.

I thought back also to my college days and my struggles with sexual and spiritual identity. As a closeted young gay man in the insecurity of college, brought up in rural Ohio as a Christian Scientist with few religious traditions, my first exposure to Judaism in the form of my roommate, on whom I undeniably developed a crush, might easily have been predicted as a direction my unconscious would guide me towards. But it was actually one little story my roommate told me that I think made all the difference. He told me of talking with a family friend, an older man who had lived during his life many kinds of Judaism, from atheism to secular Zionism to orthodoxy. But always, he told my roommate, he stayed a Jew, no matter what kind of Jew he was. Instinctively, I was drawn to both the freedom and the security that vision of life and spirit represented. I, also, after my conversion, have wandered between the extremes. But that identity, once absorbed, was unshakable.

In my life as a gay person I've wandered back and forth too. And while I once acted as though being gay was also a choice, one that I could deny, I've discovered that to be the opposite. And how do we really know what a free choice would be like? Looking back, I remember my boyfriend during my high school years (with whom I shared an intense but completely undiscussed relationship) telling me that I looked Jewish before either of us had any real idea of what Jews or Judaism were. Perhaps even the things we believe are choices are determined at some deeper level. In any case, the distinction is irrelevant once something has become real to one's soul.

While I was giving my speech to my son at his bar mitzvah, I looked around the room and noticed the variety of people there. There were old friends with whom I had shared many of the same

events in that room as well as new friends for whom a Jewish service was a complete novelty. I also spotted a few friends who had pointedly ignored me after I came out. Somehow, converting to Judaism, while causing a few strains in relationships with friends and family, didn't permanently rupture any of them. While coming out as a gay person, even in liberal Massachusetts, had more such consequences than I had anticipated.

Later that summer I happened to see a small invitation on my ex-wife's refrigerator door when I picked my son up for our midweek dinner together. It invited the recipient to attend the Vermont civil union ceremony a few weeks earlier of a lesbian couple that, I had thought, were friends with both my ex-wife and myself. However, this was the first I had heard of this event having taken place, despite having talked to the said couple in a very friendly fashion at the bar mitzvah. I had asked them then about how it felt to be living in Vermont now that civil unions were legal. "Oh, it's wonderful," they said, "We're planning on having one ourselves." But evidently they'd had no intention of inviting me.

It isn't that hard to come up with hypotheses as to why friends reacted the way they did. My wife's feelings when she outed me to them were strong and angry, and though we are now on fairly cordial terms, perhaps she forgot to tell them it was OK to be friendly once again. And by this time, it's a little late. Most people seemed to assume my emotional needs were immediately picked up and met by that mysterious cadre of "the gay community," the same people, presumably, in charge of handing out the toaster ovens. But the reality is it takes time and effort to build new social connections, and those first couple of years were fairly lonely. Other people seemed nervous that my gayness might somehow rub off on their husbands and children, however reluctant they would have been to admit it. Or perhaps their children would worry that Daddy would suddenly change the way Jake's Daddy appeared to change.

Ironically, having come out, I was much more able to be friends with those around me, more open and confident. But the process has been a lot like picking up and moving to another country, where one has to make new friends and become accustomed to a new language and customs, and contact with friends in the old country is limited to the occasional postcard. "Having a fabulous time. Wish

you were here." Well almost. My partner says I should just forget about the slights and omissions, and concentrate on the present and the future. But as I get older I also appreciate the continuity of relationships, and it's the loss of so much of that continuity that disturbs me.

Sitting in the Havurat Shalom davenning room for the bar mitzvah was also something I have been doing much less frequently than at other periods of my life. Again, like my roommate's family friend, I don't feel any less Jewish, but I have had fewer experiences like that one in recent years. The combination of comfort and strangeness is so much the same for being gay and visiting Provincetown as it is for being Jewish and visiting Crown Heights. Again, for me it's so important to maintain a balance between the extremes without staying in exactly the same groove. I often quote E.M. Forster's description of this in *Howards End*, and I returned to the same theme in my speech to Jake that day.

I ended by quoting the familiar Shaker hymn to him that is a beautiful image of finding as you go the place you are meant to be, and subtly Jewish with its references to turning, or *tshuvah*.

'Tis a gift to be simple, 'tis a gift to be free,
'Tis a gift to come round where we ought to be.
And when we find ourselves in the place just right,
'Twill be in the valley of love and delight.

When true simplicity is gained,
To bow and to bend we shan't be ashamed.
To turn, turn, will be our delight,
'Til by turning, and turning, we come round right.

That also brought back memories of my friend Leora quoting one of my favorite poems along the same lines, in her inspired leading of Rosh HaShanah services in previous years at the Havurah, Theodore Roethke's "The Waking":

I wake to sleep, and take my waking slow.
I learn by going where I have to go.

I felt great satisfaction in sending my son off into a world where his turnings will be guided much more by his internal needs than by society's expectations. In fact I think he is lucky to have a father who is both gay and Jewish, because in coming to accept both these parts of myself, however they came to be, I have a much greater understanding of that process for others. We all have our own paths to follow, and while some help and advice can come in handy along the way, it must always be offered with respect and humility.

I'm certainly not finished with my own journey either. I don't offer any predictions about how big my internal Alice will be in five years, but I have confidence that if I listen carefully to God's voice inside, she will always grow or shrink to a perfect size.

To Be a Jew

Lev Raphael

I was relieved in my late teens when our Washington Heights synagogue, victim of a "changing neighborhood," became some sort of church. I'd only been inside once, for a campaign speech of John Lindsay's, but my father's small dry cleaning store was on the same block, and when I worked there on Saturday mornings while the synagogue was still open, I felt uncomfortable and ashamed. I wished we were closed. Even though we weren't remotely observant, it didn't seem right.

My father, whose childhood and adolescence resembled the devout Eastern European life Elie Wiesel has described in many of his books, had abandoned his religious belief during the war—maybe in Bergen-Belsen, where his father died three days before the Liberation, or earlier, as a slave laborer for the Hungarian Army. Asking him to close the store on *shabbos* would have been foolish.

As I watched from behind the scarred linoleum-covered counter, watched the men and boys in suits, the women lovely and correct, the girls trying to be, I felt alien. I had no idea what they did inside the high-fronted, vaguely Moorish-looking building, only that they did it without me. I had not been bar mitzvahed, and neither had my brother. I suppose I didn't believe it mattered.

Although Yiddish newspapers and books filled our home, and my parents' only close friends were other ghetto and concentration camp survivors, I did not identify with them. I did not want to be a Jew.

I wanted to escape.

My earliest intense awareness of myself as a Jew had come in first grade, when an older child told me that "Germans threw Jewish babies in the air and caught them on bayonets." She acted it

out while she spoke. This may have been around the time of the Eichmann trial. So, like the lesbian Jewish poet Irene Klefpisz (also a child of Holocaust survivors), "my first conscious feeling about being Jewish was that it was dangerous, something to be hidden."

I can't recall now if I mentioned the incident at home, but I know that afterward, I began to learn at least partial answers to questions that must have been troubling me: Why didn't I have grandparents? Why did my father have terrible nightmares? Where was our family?

As with many families of Holocaust survivors, in my home there was a vast and deafening silence about the Holocaust. Details emerged piecemeal, unexpectedly, painfully. Amid the silence, I was always stepping on mines. Like the time when I was eight or nine, making a hand puppet from an old white sock I'd given a crayoned face. He'd be a superhero because I'd tied a handkerchief around his "neck" to make the cape. But he needed an emblem, which I drew with gold glitter glue: a bolt of lightning. It looked so good I drew a second one and showed it to my mother, expecting praise and smiles.

"That's like the S.S. insignia." She turned away and I felt crushed.

My mother told me only fragments of her ordeals, and my father said next to nothing. I don't think I ever completely understood a very simple truth: People had wanted to *kill* my mother, *kill* my father—and hadn't quite succeeded.

Until I was well into my twenties, I had no Jewish pride at all; I was *ashamed* of being Jewish. I was mortified by my parents' accents when they spoke English (though they spoke a dozen languages between them) and by their use of Yiddish in public because it seemed to stamp us as alien, different, inferior. When I was young I even imagined having a non-Jewish name. Like Tom Danbury, a name I had heard in an Abbott and Costello movie. Think of it: Tom Sawyer crossed with the name of a New England town—what could be more American?

When friends or acquaintances in junior high or high school made anti-Semitic jokes or remarks, I never challenged them. A

fierce admirer of Martin Luther King from fourth grade on, I didn't have the courage to speak up for my own people in my own voice. I rarely identified with Jewish causes, except for a visceral support of Israel, and felt a terrible embarrassment when I read something disgraceful about a Jew in the newspapers.

My Jewishness in part consisted of a sensitivity to any threat to American Jews. I had more than a vague idea of the Jewish past, but Torah, prayer, and religious observance of the holidays were all another world, one I didn't even know enough about to truly ignore. It didn't exist. I had no close Jewish friends even though my neighborhood was heavily Jewish, and so were my schools. When I read about Jewish history, I felt both attracted and repelled.

My parents themselves were deeply ambivalent about being Jewish. When I asked them why they'd come to America rather than Israel after World War II, my mother was sharp: "Live with all those Jews? I had enough of them in the ghetto and the camps!" And when I was in first grade and a fire broke out one Friday night in the apartment of Orthodox neighbors, my parents both seemed to blame our neighbors' shabbat candles, nodding as if to say, "See, that's what happens...."

They didn't know that the neighbor's son and I had once traded views of our nascent penises. One afternoon in my bedroom, we agreed to the exchange, and laughing with nervousness, I stripped completely. I waited for him to do the same, but he only pulled his pants and shorts away from his waist and let me look briefly down. I felt humiliated. With my girl friend Vicky, our genital displays and exploration were completely mutual, which might explain why I felt so cheated and ashamed.

There were other sources for my mother's rage, and other reasons for coming to America. Simply put, "In Brussels, we couldn't stand being so close."

I knew she meant so close to *Germany*. And I knew they missed Belgium. It was obvious in their joyful recollections of the bakery in the first floor of their building whose early morning breads wafted them awake; the squeaky tram line on their street; the delicious fresh vegetables they couldn't seem to find in New York; the elegant and beautiful neighbor who told them "*Je fais les boulevards,*"

which they didn't understand meant she was a streetwalker; the oddities and humor of living in a bicultural and bilingual country. Their five years there after the war were to me like some colorful but cloudy ideal to strive after.

My parents had a small battered briefcase filled with tiny black and white photos of monuments, streets, parks, zoo animals—all Belgian. It never occurred to me to ask why they hadn't been neatly hinged into a set of albums. There was to my young imagination something mysterious in the disordered, rustling bulk that shifted when I picked up the peeling butterscotch case with rusty locks and set it onto the floor. Something alive.

Maybe fixing each photograph into a permanent position would have stifled that life for them, crushed the memories. Perhaps what they wanted was the opposite: randomness as a snapshot of a strutting peacock at the zoo slid across a snapshot of a windy beach, scalloped edges catching, bringing the photos into surprising conjunction.

They had very little money in Belgium, moved into an apartment so filthy the black wooden mantel turned out to be white marble after repeated washing. She said they couldn't afford to have children and aborted their first child. Was Belgium truly home? Perhaps it was simply being alive and living in relative comfort after living in hell for so long that had made Brussels wonderful.

"America wasn't our first choice," I heard more than once. My parents had wanted to go to Australia, where friends had emigrated, and made it rich. Australia, of course, was the opposite of Belgium—it was as far away from Germany as you could get.

But America claimed them because of empty promises.

Betrayal was my family's narrative. The great betrayal by the world that murdered their families, destroyed their homes, their culture, and ripped them out of life. That was central in our family, like the atrium of an ancient Roman home, a place where all can meet and stare above at mystery.

But there were other more intimate betrayals connected to family, and to other Jews.

In Brussels, my mother worked as a teacher in a school that did what we now call "reprogramming." Her students were Jewish

children who had been hidden by priests and nuns during the war, and though none of them had been baptized, their minds had been poisoned against Jews and Jewishness. My mother taught Yiddish literature and drama, and at one of the children's performances, New York teachers of Yiddish raved about her work and urged her to come there, promising a job.

Her uncle in New York likewise promised her a new life, and his continued blandishments lured her away.

What did she find in New York? The wonderful apartment her uncle promised her was run down and at the southern shabby end of Washington Heights, more than thirty blocks away from where he lived. My fifth grade teacher said where I lived was Harlem; that street is certainly Harlem now.

Her uncle wouldn't help my mother go back to school ("What'd'ya need college for?"), even though she had done her first year at the university in Kaunus, Lithuania. And his wife made a remark that was often repeated to me as proof that she was a miserable human being: "You think you had it bad in the war? Here, we had *rationing*. I had to stand in line for sugar!"

This anecdote would be followed by my parents' withering Yiddish assessment: *"Azah shtick baheymah!"* (What a horrible creature).

And the job my mother had been promised didn't exist. The Jewish educators so impressed by her work in Brussels didn't care that she was in New York in 1950, and had nothing to offer her but excuses. Some of these people, fleeing Warsaw in 1939, had wound up sheltering with her family in Vilno. "They slept on our floor!"

Apparently they had forgotten the favor.

So. American Jews in general didn't help my parents, didn't care about their uprooted lives, and the Jews who should have been most concerned—family—didn't seem to care either.

These were the main charges in the indictment my mother had handed down before I was born.

But despite my parents' contempt for the American-born teachers there, my parents made me go to a Workmen's Circle Sunday school into my early teens, where I was exposed to Yiddish-language lessons in Jewish history and literature. I was happy when-

ever I fell ill or overslept and didn't have to go to that school. Almost nothing made an impression on me there, except for one older boy—dark, sexy, slim—whom I sometimes annoyed because that was the only way to make him interested in me.

What I remember best of all about my Workmen's Circle classes happened one day in our excruciatingly dull Torah class, where the ratio of Hebrew to Yiddish on the page intrigued me. The thick square of Hebrew words, surrounded by the long Yiddish translation, seemed so dark and dense, impenetrable. We were studying *Koheleth* (Ecclesiastes), which is still vivid to me because of the "vanity of vanities" refrain, *"nishtikeit"* in Yiddish. It seemed powerful to consider this cynicism and despair in three languages.

I was culturally Jewish, or more accurately, the *son* of parents who were culturally Jewish. So I could feel superior, with my father, to the Reform rabbi of the synagogue down the street, who drove to services in a Cadillac, and laugh with my mother at the women's "Easter" hats she found so appalling. I know I once wanted to go to *shabbat* services with a junior high school friend, was excited and nervous, wondering what to wear, how to act, but the plans fell through somehow and I never passed beyond contempt and distances, never prayed or even watched others pray in the synagogue only two blocks from our apartment building. Perhaps not coincidentally, this same friend was one of the first teenage boys I showed my penis to, hoping he would reciprocate, but he didn't. This experience left me feeling stupid, weird, and worried that other kids would find out.

What *did* we observe in my family? We lit Chanukah candles (except on the days we forgot), and if my father did it, he said a prayer under his breath. My brother and I got the traditional Chanukah coins made out of chocolate. My parents each lit a *yorzeit licht*, a memorial candle, on Yom Kippur and on the anniversary of their parents' deaths. We ate "holiday dinners" somewhat fancier than the usual fare—to which dinners my father was invariably late from the store. But we never had a Passover Seder. I resisted the huge Workmen's Circle Seders because I knew I wouldn't feel at home there, and never went to a real one until I was twenty-six.

Passover always embarrassed me, especially when friends asked what I did, where I'd gone.

I had no sense of Jewish holidays marking spiritual as well as historical time.

Partly because of my parents' very mixed feelings about being Jewish, and their professed superiority over observant Jews, I came to feel both estranged from more religious Jews and better than them, more rational and realistic, as if true observance were nonsense.

None of this seemed to matter until college, when I met and fell in love with Beverly Sheila Douglas, a tall, blonde, kind, lovely New Zealander. She was not Jewish.

I had dated girls erratically in junior high and high school, partly out of pressure to do so because everyone else was. I was attracted to these girls not as incarnations of femaleness, but as individuals. Each seemed ambivalent and maybe even frightened about dating and sex. Though we were physically affectionate, nothing seriously sexual every happened between us.

In college I was pursued by "Bonnie," a smoldering theater major who had keys to the backstage dressing rooms. We met in one of a series of exciting winter afternoons in my sophomore year at Fordham University's Lincoln Center campus. We used my air force surplus coat as a blanket on the cold tile floor and it all seemed dreamlike to me, intensely pleasurable and confusing. How could this feel so natural when I was attracted to men?

I was nineteen then, and my brother had been asking me if I was still a virgin. I was determined not to be. And determined not to go to bed with a man, though I don't think I had the courage or insight to even articulate that taboo.

I met Beverly around the same time I was screwing with Bonnie, and broke off the relationship (if you could call it that) as Beverly and I started dating. We fell in love our junior year.

I had chosen a Catholic college because the campus was very small, my brother's Jewish girlfriend raved about her creative writing teacher there, and because it was Catholic. I'm sure of that now. I wasn't interest in converting, just hiding form Jewish iden-

tity, even though, as one of the very few Jews there, I actually stood out. This turned out to be the first place I'd ever heard the phrase "Jew him down" as a habitual part of people's conversation.

Beverly intrigued me because she was so different from American girls—softer, quieter. A Masterpiece Theatre junkie, I reveled in her anecdotes about England and New Zealand, her sophistication, her kindness. It never felt to me that I was faking our relationship, that I was Odysseus bound to the mast of his ship to keep from answering the sirens' call. I had never had any kind of sex with a boy or man; it was all so out of the realm of possibility. Yet I was always aware of attractive men in the street, and my secret must have been visible in my eyes because men occasionally tried to pick me up. As James Baldwin writes in *Another Country*, like all people with secret fantasies, my secret lived in my eyes "with all the brilliance and beauty and terror of desire."

The fact that Beverly wasn't Jewish didn't matter in the beginning. There was no conflict until we neared graduation and her visa was running out. It was time for couples to get married, or at least to become serious. Friends told us that Beverly and I were fun to watch and be with, and I suppose we did shine with the delicate snobbery of first love.

Friends bombarded me with what they thought about me and Beverly, what others thought, what I should think; a chorus, a babble deciding my life for me, or trying to help. Beverly, very English, could not talk about the future or her feelings; I, very scared and conflicted, could only stumble. I wanted to marry her, or maybe wanted not to lose her. Most of all, I wanted not to feel split and afraid of myself, afraid now of the feelings for men that lay coiled inside me like a snake ready to strike.

If my parents were aware of my struggle about marrying Beverly, they never brought it up, and I never raised it myself.

Several of our friends at Fordham were ostentatiously gay, bragging about their wild nights in the Village, at the bars, the docks, the trucks. These men who camped and dished with us must have known about me, but they loved Beverly and insisted we get married. They rooted for us.

I began feeling that Beverly's being a Christian did make a difference, and I was drawn to the Judaica section at Brentano's on Fifth Avenue. I bought books about Judaism and read them with more hunger than understanding, searching, I now realize, to find what being Jewish meant for me. I didn't know enough to decide. Just as I hesitantly bought gay books in junior and senior year, burying them in a stack of other paperbacks as if sheathing kryptonite with lead.

Christmas 1974 brought deeper discomfort. At a friend's house with Beverly, the tree decorating was fun, but hearing the host read from the New Testament seemed unnatural to me, embarrassing. The carols at the piano drove me down the hallway to another room. I didn't belong there; I knew it, felt it, believed it. This was not my holiday or my place. I had always been somewhat uncomfortable during New York's Christmas madness, but never so intensely. I told Beverly that. The presents under the tree I'd helped string lights and popcorn on were gifts of love, but ultimately not appropriate to whoever I suspected I was. The hostess and I had once disagreed about the possibilities of Jews being conscientious objectors. "Look at the Bible," she'd said, "It's full of violence." And I had then only secondhand words for reply, none of my own.

Beverly and I did not get married. I knew more and more clearly that I could not marry a non-Jew, no matter how much I loved her. What pushed me over the edge? Imagining Christmas, so profoundly a part of Beverly's life, in "our" house. I couldn't do it, nor could I ask her to give it up. I couldn't confuse myself or any children we might have. I wanted a Jewish home. No—it wasn't that affirmative. I realized I couldn't have a *non*-Jewish home; that was as far as I got, and it meant much more to me than my subterranean attraction to men. When I told Beverly I couldn't marry a non-Jew—painfully, reluctant to hurt her, but forced to the truth by her coming departure, I closed that religious door forever.

But I made a claim on part of my future.

When I returned from seeing Beverly off at Kennedy Airport (she was returning to New Zealand forever), I found a package on my desk at home. My first selection from the Jewish Book Club

had come: a heavy one-volume encyclopedia of Judaica. I was too bitter to laugh, too stunned to cry.

My brother decided to marry the second-generation Polish Catholic he'd been dating for years, the woman he had said he would never marry, the woman my parents undoubtedly saw as "the enemy." Up at graduate school in Massachusetts, I received a phone call from him asking for help. Mom was "getting hysterical," crying. Dad was upset for her, for himself. My brother was stubborn, angry, and his girlfriend understandably incensed. If she was good enough to come to dinner and to live with him, then why—?

I made phone calls, wrote a frantic letter, said anything to keep what little family we had from destroying itself in bitterness and regret. It sounded like a catastrophe. I could imagine them getting married, my parents not coming, and me in the middle. I'm not sure how much I helped, but my parents calmed down because they had to. My brother would marry whomever he wanted, we all knew that, but the shock and resentment on all sides were inevitable. Later, I felt strangely betrayed. I had not married Beverly; how could my brother marry the woman he'd said he never would? I wish my brother hadn't taken something away from the family by marrying a non-Jew, but now I believe he had nothing to give. My brother was a Jewish Almanac Jew, the kind who like knowing which movie stars changed their names.

I also felt bested by him, out-maneuvered in our unspoken rivalry. I couldn't count on marrying even a Jewish woman, and so even though my brother had dropped out of college, he was normal, and had just proven it in the most obvious way.

He'd told me about his wedding plans before my parents, and the impending crisis sent me to Yom Kippur services in Amherst, Massachusetts, to a steepleless white clapboard ex-church, unused to being a scene of Jewish prayer, where I sat in a crowded balcony, hardly comprehending the English of the *Mahzor* (holiday prayer book), but crying unexpectedly, moved by the cantor's hall-filling eloquence, even by the children trampiing on the stairs, moved by the fact that I was there, suffused by the beauty, the solemnity of group prayer for forgiveness, a publicly shared intimacy and hope.

I was roused and transfixed without understanding how or why, or what it all meant. I called home that night, to share my wonderment. My parents approved, just as they did next Passover when I didn't eat bread even though my matzo ran out. My parents might have been proud, but like those who have stepped off a path, they could not fathom that I had felt the presence of a new possibility in my life.

It was my first synagogue service, my first Yom Kippur not listening to Kol Nidre on the radio or on a Jan Peerce album. I was twenty-three.

My brother's wedding, which took place in the United Nations chapel, was performed by a half-Jewish priest and a rabbi who looked Episcopalian. I held one pole of the *chupa*, the wedding canopy, and was thrilled by the ceremony, by the Hebrew that I did not understand. But the experience was odd for me. I was too uncertain in my own Jewish identity to condemn what my brother was doing—or to feel comfortable with it.

That year was traumatic for other reasons besides my brother's wedding. When I published my first short story, the event was overshadowed by my parents' severe reaction to it. This story had burst from me in a day and a half the year before, nursed by Kris, my writing teacher in college, who later became my closest friend. I read Kris the various sections over the phone as soon as they were finished, as if together we were tending a patient that might not recover. Her vigilance helped me being to heal my own split from Judaism, because this story was about a child of Holocaust survivors who felt crushed by what he knew of his parents' terrible past. It won a prize and was published in *Redbook*.

It scared me.

When my parents read it, they felt betrayed and outraged at the way I'd woven in autobiographical elements. Even worse, my mother had weeks of insomnia, as well as gruesome nightmares about the war, feeling, no doubt, violated by the son she had hoped to protect from the brutal realities of her past—a son who had unwittingly led her back. When I tried talking about the story—which I stupidly withheld from them until it was published—she berated

me as though I were not just her son but her persecutor, and she sneeringly tore the story apart. My father had little to say.

But the story led me to confronting my legacy as a child of survivors, and I started to read furiously about the Holocaust, steeping myself now in what had for years merely been bits of narrative gleaned from my parents, conquering my own nausea and fear of entering that Kingdom of Death. It was 1978, and Helen Epstein had made headlines with her book *Children of the Holocaust;* Holocaust curricula were being introduced all over the country; and Gerald Green's *Holocaust* had filled America's TV screens.

I was experiencing profound chaos in other ways. The night of my brother's bachelor party, I had left the Playboy Club, assaulted by its almost surreal heterosexuality to find a bar and get picked up.

That night was the fourth time I'd had sex with a man, and like the other times, it was colored by desperation, fear, and too much alcohol.

I ended up in a gay bar Beverly and I had visited twice to hear a comic singer who had mocked all the straight couples in the bar. "The guys always show up with a girlfriend first! Then they ditch her and come back alone." He was right about me. I had sat there with Beverly each time in a strange half-state, connected to her, in love, but hungering for the men around me and trying not to show it.

So, while my brother announced his marriage, I was enmeshed in a murkier, less public drama. At the University of Massachusetts, where I was doing an M.F.A. in creative writing, I was in love —or something—with one of my roommates in the house I shared at the edge of Amherst. "Scorpio" was of Italian descent, short, dark, heavy-shouldered, heavy-cocked, cynical. I had cast him in a dual role: he was my beloved; he was my tormentor. Always there, always out of reach. It was the kind of obsessive, confused, and unreal relationship you have with another man when you don't respect or understand your own homosexuality.

We never truly connected, we collided—with me usually feeling alternately bruised and elated. I would spend hours on the phone with friends trying to figure out what it all meant, as though I were struggling to turn lugubrious Derrida into crystalline and witty Jane

Austen. My parents and my brother knew none of this, and I felt stranded. Unable to ask for what I wanted, unable to comprehend just what that was, I stumbled through a year of living in the same house with him, my changing moods a puzzle to our other housemates. Scorpio didn't really desire me at all but wanted to put me in my place because I was the star writer in our creative writing program. An occasional fuck could do just that. At one party where my drunken dancing and enthusiasm galvanized the entire crowd, and attracted more than one woman, Scorpio got me away as soon as he could to prove in bed who was boss. These episodes sometimes seemed to occur in a parallel universe that we were only vaguely connected to.

The situation become even more tortuous and melodramatic when I wound up in bed with "Monica," a feisty, sharp-tongued and grandly multiorgasmic woman who disliked Scorpio and had been actively pursuing me, promising me the love he could never offer. I tried to keep our affair secret from him, Monica was only the third woman I'd slept with, but our lovemaking was incredible and liberating. For the first time in my life, I felt relaxed in bed, free of inhibitions, criticism, fear. We made love by a waterfall out in the woods. We made love in the back of her Volkswagen station wagon, parked on the side of the road at night where headlights raked across us.

Because she had also slept with women (and considered herself an "ex-lesbian"), I never felt judged. But I felt trapped in what was almost a menage à trois, and the lying, the frustration, the tension all seemed to burst after the semester was over and I was back in New York. Away from Amherst, the situation seemed even more bizarre and confusing. Every phone conversation about it with Kris was like watching a wounded animal trying to drag itself to its feet: It stumbles, falls, stumbles again.

Wisely, Kris said I had to cut through everything, that we couldn't spend the rest of the summer this way, but I had to pull myself out, to go as far away as possible. This was the same friend who advised me in college that although I'd probably never meet a woman as kind as Beverly again (and she was right), it would not

have made sense to marry her when I felt uneasy about marrying a non-Jew and wondered if I was gay.

Now, in the summer of 1978, Kris asked, "Don't you have relatives in Israel?"

Hysterically eager to drop everything and run from my confusion, I announced to my parents that I would spend the coming year on a Kibbutz. Alarmed by my vehemence, my parents suggested a few weeks just to see if I'd like it there, and I agreed. I called my Uncle Wolf in Tel Aviv to let him know I was coming, and little more than a week later, I was gone—without telling Scorpio in advance, although Monica knew.

But the delight in leaving Scorpio behind me faded quickly. In my dark time, Israel was a bath of light, several rich, dense weeks of escape from a home that I hated to one I didn't know. Israel: stifling heat, long political discussions, bus rides, the unforgettable first vision of glowing Jerusalem, exploring Masada, surprising people with how much Hebrew I picked up, meeting my mother's brother Wolf for the first time, speaking Yiddish to his wife because her English was minimal. Israel: seeing a photo of my mother's other brother, the man whose name, Lev, I bore as Lewis, the man lost in the Battle of Stalingrad. Israel: a dream more real than the dream of America, older in the mind of God.

Yet even there I ran right into what I had fled. On a bright noisy hot street, I'd pass a truck whose driver was more beautiful than any man I'd ever seen. And spending a few days on a heartbreakingly scenic kibbutz on the Mediterranean, I ended up having sex with a Brazilian Jew who was even more withholding and uncommunicative than the man I'd left in Massachusetts. Despite the smooth skin and soft voice, he was not a kind man.

One night there, he fucked me and went off to shower, just assuming I'd come. Another night, after blowing and rimming him, I pushed up his heavy bronze-brown legs, but he shoved me away as soon as I entered him, claiming he was tired. Enraged, perplexed, I was unable to respond. In the morning while he was gone, I contemplated ripping his clothes to shreds and destroying his few possessions.

Once more I was fleeing, this time back to Tel Aviv, where my puzzled uncle and aunt listened to my vague reasons for not staying at the Kibbutz as long as I'd originally planned.

I returned to New York determined to change my name to Lev. Erica Jong writes in *Fear of Fifty*, "A name should be taken as an act of liberation, of celebration, of intention. A name should be a magical invocation to the muse. A name should be a self-blessing."

I did all of that when I changed my name to Lev, liberating it from its Anglo-Saxon prison of "Lewis." Rocking one afternoon at my uncle's house, face-to-face with a picture of my mother, Wolf, and Lev, it had seemed dishonest to me to be named after Lev, yet not have his actual name. And the name Lev was a deepening of the link with my people and my history, because it had meanings in Yiddish (lion) and Hebrew (heart). Those languages even appear in the lives of Jews who don't speak or read them. Our religious and ritual terms are interchangeable, like *shabbos* (Yiddish) and *shabbat* (Hebrew).

I returned from Israel determined to speak Yiddish with my parents, to reclaim something of the past, and with a knowledge, undeveloped, unrefined, of the possibility of a deeper meaning to my life. Israel was another way, a different, difficult path, but far more rewarding, I thought, than graduate school. It was a life that could quench my thirst for meaning.

But I didn't take it. I had not even become a Jew—how could I become an Israeli?

The feelings of the Yom Kippur service in Amherst lay dormant for another two years. I was busy with finishing my degree, getting a part-time teaching job in New York at Fordham, my alma mater, writing and trying to get published, starting another degree, living at home again, and reexperiencing why I'd wanted to leave: the coldness, the constriction. But I started subscribing to *Commentary*, which may seem laughable to some. For me, it was a big step to read *any* Jewish magazine. I chose it because it was the one I had heard most about. I learned a lot in its pages and felt, however tenuously, more Jewish. I also felt repudiated for wanting men the day I read there Midge Decter's notorious homo-bashing essay

"The Boys on the Beach," a colorful diatribe about gay life on Fire Island and its threat to the American way of life.

I was so closeted at the time, and still relatively devoid of actual homosexual experience outside of reading, that the essay fascinated and excited me. It was like reading the foolish book review that convinces you to rush out and buy the book it's condemning. Despite the invective, you're dead sure that the reviewer is shortsighted and wrong. Midge Dector made me *long* for the life on Fire Island she found so disgusting. I'd had a similar reaction to *The Boys in the Band* when I saw it at fifteen. While as an adult I'm most struck by the self-hatred in that play, as a teenager I was flabbergasted at seeing gay men together—and encouraged. The movie told me that gay men were out there, real, alive; I wasn't alone.

Teaching at Fordham from 1978 to 1980 as an adjunct instructor, I had the opportunity of giving a "January Project," a course different from regular semester offerings. One fall night in 1979, it hit me: I would teach Holocaust literature. All that I'd read previously came back to me in a rush. I made a book list and syllabus, and plunged into three months of intensive research, reading even more than I had before, without stop: history, fiction, psychology, sociology, theology (I came across very few references to the situation of gays in the Holocaust). I was certain that literature had to be grounded in the reality it attempted to deal with, and in interpretations of that reality.

Children of Holocaust survivors tend to feel they know a lot about those nightmare years in Europe, given the way the Holocaust has left its imprint on their parents. But like many others, I actually knew little in the way of facts before I began reading, and came to see that I had wanted to know less because the Holocaust had stolen my parents' past not just from them but from me, and had made reminiscing a dangerous and bleak prospect. This drive to learn and teach was intimately bound up with my search for Jewishness.

The course—a difficult and intense month of readings, films, reports—surpassed any I'd ever done. Two-thirds Jewish, the students ventured along with me bravely, confused, awed, horrified,

searching too. What did it mean? we all wondered. How could we think of it?

Midway, we read Tadeus Borowski's scorching collection *This Way for the Gas, Ladies and Gentlemen* and several of us had nightmares. Some students talked about dropping the class. One Catholic man said, "It hurts to read this—but why should it be easy?"

The most memorable student was a short hostile Jewish woman, initially contemptuous of what she called the Jews' "collaboration" in their death, who underwent a challenge of those beliefs and emerged so changed, so much more sensitive and tentative, that we could all read the transportation in the very lines of her face. Another student, an older Polish man who had left Poland long before World War II, wrote in his journal about the troubling question of physical resistance: "It's very easy, sitting in a comfortable West End Avenue apartment, to talk about courage."

If anything, we all learned the extremity of conditions in the ghettos and camps, and found that New York standards of behavior did not, could not apply. And I emerged wondering if perhaps, as a son of Holocaust survivors, I hadn't found a *mission*. Traditional Jews observe 613 commandments; the philosopher Emil Fackenheim argues for a 614th after the Holocaust; to keep the memory alive. Perhaps that was what I could do. Teach others, give them from my own special experience, transmit and interpret the past.

In that spirit, I wrote the first draft of the somewhat autobiographical novel that would be published twelve years later as *Winter Eyes*. The intense privacy and immersion, the sense of deepening my craft made me contemplate the role of my writing differently. It could serve a larger social purpose, as opposed to being my individual path to success. But neither writing nor teaching about the Holocaust would make me a Jew. One year later, I found out what could.

After seeing an advertisement in *Commentary*, I ordered a pamphlet from the American Jewish Committee about "ethnotherapy" for Jews, group therapy to help those who had absorbed cultural stereotypes about themselves. This little pamphlet

unexpectedly ripped me open. The ugliness inside finally came to light: I realized that I had not one Jewish friend, that I hadn't seriously dated one Jewish girl, that I didn't particularly *like* Jews.

It was a revolution. I tore unread books from my shelves and plunged into them that week, submerged in discovery: Irving Howe's *The World of Our Fathers*, Cynthia Ozick's *The Pagan Rabbi*, Adin Steinsaltz's *The Essential Talmud*, the *Penguin Book of Jewish Short Stories*, a book on ancient Israel, and Milton Steinberg's *Basic Judaism*. That last, the most important, was a relic of my days with Beverly. I'd read it back then underlining everywhere, entering nowhere.

Now, I read slowly, absorbed, released from the slavery of false pride and ignorance. I loved this clear, concise little book: It seemed so wise to me, and I knew then that Judaism, my religion of birth, could be my religion of choice. I loved the sensible way Steinberg discussed tradition and its modern application in every aspect of Jewish life.

It was a simple discovery to find that Judaism as a religion made sense, was even beautiful. Without having read about the death of European Jews, I don't think I could have understood or been able to appreciate their life, the tenets of a faith I'd known next to nothing about. And so, after feeling seared and overwhelmed by the horrors of 1933-45, I found myself in surprising harmony with my people's religion.

I was primed for still more discovery and change when I arrived at Michigan State University to pursue a Ph.D. the semester after teaching the Holocaust course. I gave a talk at the university's Jewish student foundation, Hillel, about Holocaust literature and had chosen that field for my dissertation, but something very different compelled me. My neighbor at the graduate dorm was Jewish and I accompanied him to what was only my second Yom Kippur service. I didn't fast—I wasn't ready to—but I achieved a nearness to prayer that now spurred a decision that rereading the pamphlet had made certain. Because I needed to be with Jews, I would move into MSU's Hillel co-op. I would live and eat and associate with Jews. What attracted me most about Hillel was not the well-

stocked library but the small *shul* upstairs where an Orthodox congregation (*minyan*) met.

My *Commentary* subscription ran out, and I ordered *Judaism* and *Midstream.*

Living with Jewish students was at first deeply unsettling for me. Did I fit in? Would I feel comfortable? As the routine took over, I realized we were as much students as Jews, maybe more so. This Jewish co-op turned out to be not very cooperative and not very Jewish. We did have one guy who was eternally vigilant and fanatical about kosher food, and some people attended Saturday morning services occasionally. Still, the Jewishness was one of concern for Israel and worry about anti-Semitism, a Jewishness of discussion and jokes, of atmosphere and self-parody. But then, none of the young men or women there was particularly in conflict about their Jewish identity or searching for ways to deepen it.

It was at services that I seemed to have found my pathway. The people there—Modern Orthodox—were relaxed and friendly, and one young couple began inviting me for shabbat lunch. Adina took me through the prayer book and explained what each prayer meant and what you did, and both she and Josh shared their learning in an easy, nonjudgmental way. They were witty, well-read, helpful.

My transitions were smooth. At one shabbat I donned a *tallis* (prayer shawl); at another I found myself swaying back and forth during the Amidah: *shuckeling.* The service began to feel familiar and Hebrew stopped seeming completely foreign and forbidding. After many weeks, I began joining in some of the sung prayers. I began lighting candles on Friday night. I started wearing a *kipa* (yarmulkah) when I read from *siddur* (prayer book) or *chumash* (Pentateuch with commentary) outside of services. I kissed the holy books when I closed them (as Orthodox Jews do) not because I thought I should but because I chose to acknowledge them as sacred and because the act itself felt beautiful. The impulse came from deep inside, where a sense of reverence was growing. Each service I attended gave me more understanding, beauty, more belief, and connection. Prayer, once foreign and contemptible, en-

riched my life. Even when I was bored or tired, being there was the Jewish immersion I had not known I craved.

I had never bothered learning my full Hebrew name until that year in the co-op. I was a *Levi*, my father told me: *Reuven Lev ben Shlomo ha-Levi*. Because *Levis* are supposedly descended from Temple functionaries who sang the psalm of the day, among other duties, this name connected me to centuries of Jews. Up at the *bima* (lectern) saying the Torah blessings, I felt the march of Jewish time, and felt myself a part of it. Perhaps most profoundly, one Yom Kippur, the first on which I fasted, I held the Torah while the plangent Kol Nidre was chanted. It was ineffably moving to me, and that evening I had a dream in which a warm voice sang the words *Av Harachamim*, Father of Mercy. The dream told me that I was welcomed and embraced.

Almost every week, I read the Torah portion in advance, or while it was being chanted, and plunged into the footnotes, feeling very much like a sort of feral child. Why had all this information about Jewish faith and observance been kept from me? And would I ever come to feel knowledgeable, truly at ease among worshiping Jews?

Mordechai Nisan, a visiting scholar from Israel, lodged in Hillel's guest room one weekend and dined with the co-op members. He spoke movingly that shabbat afternoon about shabbat in Israel involving everyone and being a different kind of time. As he spoke, I thought of the shabbat prayer: "Be pleased with our rest." At lunch I'd told him about my background, or lack of it. Stumbling through *Birkat HaMazon* (the sung and chanted prayers after meals), I felt him considering me. When he left, he said, "I hope you find what you're looking for."

But he didn't know that there was another hunger in me as deep as my need to belong and fit in as a Jew. If I were a teenager in the mid-nineties, I'm not sure I would ever seriously date a woman, but given the times and my own conflicts, in the early eighties, I continued to date and enjoy my relationships with women (though the countervailing attraction to men never disappeared).

I found some brief resolution in considering myself bisexual, and there was a great deal of popular literature at the time to give me some ballast.

Moving into Hillel's co-ed co-op, I was thrown together far more intimately with men than I was at the dorm. Rather than sharing a bathroom with one guy, I shared it with several. One of them had an enormous penis and joked about it as often as he could, eyeing me to see what my reaction was. Another became the model for "Eric" in my story "Shouts of Joy." One student talked about his intense camping trips with his "old buddy" and made references to a bisexual woman friend, possibly as unconscious signals. I felt somewhat besieged and afraid of exposure, both enjoying and fearing the random displays of nudity in the men's room, further heightened when someone's friend or boyfriend slept over.

After living in the co-op for a year, I moved out and into my first apartment, but still went to services and events at Hillel. The physical distance was matched by my burgeoning discomfort with Orthodox restrictions on women. Once I overcame the newness and excitement of being part of a prayer community, I felt increasingly uncomfortable with what I saw as the lesser role of women in an Orthodox service and of my own exclusion if I were openly gay.

Josh and Adina once mentioned a congregation they knew where a lesbian had been asked to leave when she came out. I found myself agreeing that it was "a shame," but tried to cover my disappointment when they went on to remark that the woman shouldn't have embarrassed her synagogue in that way. This anecdote told to me in 1981 eventually inspired my story "Dancing on Tisha B'Av," but at the time it was more admonishing than inspiring. The lines were clearly drawn for me. I had to keep part of myself hidden.

Yet it was being grounded in a profoundly, unequivocally Jewish milieu that brought me real depth and success as a write. After the shock of being published at twenty-four, and my parents' violent reaction to the story, I kept writing, but somehow never wrote anything as good as that prize-winning story. It began to haunt me—what if I were like some character in a Hawthorne tale, doomed to be endlessly dissatisfied after the first taste of achievement? But

in 1983, the drought ended. In Michigan, I'd begun reassessing my writing, wondering what I truly had to say and who my audience was. It was easier there to disconnect from New York ideas of success and to decide that being in *The New Yorker* or other national magazines wasn't the only way to find satisfaction as a writer.

I started sending my work to Jewish publications, and the response was swift and amazing. Stories of mine, mostly about children of survivors, began appearing in Jewish magazines and newspapers. Editors loved my work, and so apparently did readers. Now I had an audience and a new sense of mission. For the first time in my writing career, I was thinking less of the glory of being published and much more about reaching people. But my success as a Jewish writer ironically drove me further into the closet. Having finally come to feel comfortable and accepted as a Jew, and established as a published writer, how could I risk either of those achievements by coming out? Especially in a city like East Lansing, whose Jewish community was so small?

Still deeply uncertain about being gay, and at the point where I was finally comfortable in my new Jewish affiliation, I unexpectedly fell in love with a Jewish man I met at the university. Unfortunately, he was married, with children. His research and writing about shame gave me a whole new set of insights about my past, my relationship to my parents, my Jewishness, my homosexuality. I felt the promise of freedom.

There were uncanny similarities in our backgrounds—we went to the same high school in New York, our fathers were in the same business—and it wasn't long before we acknowledged that we were soul mates. You could see it in the way we taught and wrote together. He and I would finish each other's sentences in class or as we worked on a piece of writing. Gersh is not a child of survivors, but he is the son of Eastern European immigrants, and we share a cultural landscape through which we move with ease and recognition together.

Our deepening bond transformed both our lives. Gersh was the first to know clearly what he wanted, and that meant pain for himself and his family at the time. Gersh wanted a life together with me and felt our meeting was *besherit* (fated)—but I couldn't

imagine the possibility. I had never met a committed gay couple, let alone a Jewish one. It took several more years and great pain for us both until I could come to terms at last with what we meant to each other, to finally make a lifetime commitment.

Of course, as we worked all of this out, I withdrew even further from the Jewish community in East Lansing, after having a bar mitzvah at the age of thirty in Hillel's other, egalitarian minyan. My bar mitzvah marked my confidence and sense of belonging as much as it was a temporary farewell.

My Jewish journey was additionally complicated in the 1980's by Gersh's own problems with his Jewish background. His parents forced an unexplained and insensitive Orthodoxy on him from an early age, and our praying together only partially healed his pain and sense of separation from other Jews.

While I drew back from East Lansing's Jewish world, Gersh and I continued to teach and write together as we struggled with coming out. Our lives grew richer through the course we co-developed and co-taught at Michigan State University; the books and articles we wrote together (as well as separately, with each other's guidance); and the many students we reached. The deepening of our love and commitment taught me the reality of that shabbat hymn, *kol ho-olam kulo*: "All of life is a narrow bridge, the important thing is not to be afraid." Just as my writing was beginning to include gay as well as Jewish themes, we bought a house and moved in together, and that move gave me great courage. I was no longer afraid to publish fiction in my own name in a gay publication; I welcomed having my story "Dancing on Tisha B'Av" appear in George Stambolian's *Men on Men 2,* in 1998. Meeting people in San Francisco or Provincetown who had read my work or recognized my name, I felt more settled and comfortable, as a gay writer.

By 1990, I made a giant leap forward by proudly and unambivalently publishing *Dancing on Tisha B'Av,* a book of Jewish and gay short stories that was advertised as such—a book full of as many connections as contradictions. What is the role of gays and lesbians in American Jewish life? How can their dual identities be reconciled? How do children of Holocaust survivors find meaning in their parents' lives? The questions this book raised

had personal relevance for me, but also larger and current social implications.

Until that point, coming out as a gay man seemed to overshadow coming out as a Jew—but no longer. At the first national gay and lesbian writers' conference in San Francisco in 1990, I not only spoke to four hundred people about coming out in my writing as a Jew and a gay man, but I had a pivotal encounter with the writer Jyl Lynn Felman, whom I had not seen in ten years. She had been in my M.F.A. writing program, at a time when neither one of us was out of the closet. When she shared her journey with me as a deeply-committed Jewish lesbian (who also had a Jewish partner), I was electrified and stirred to action. That conference, which drew 1,200 people, opened me up for another one that unexpectedly even more fulfilling.

Gersh and I attended the 1990 Midwest Regional Meeting of the World Congress of Gay and Lesbian Jewish Organizations, in Toronto. The experience was truly an answer to our prayers. There were shabbat services led by a gay rabbi, which the siddur (prayer book) recognized and included the experience of gay and lesbian Jews most movingly, perhaps, before the Kaddish, when we reflected on those who had never had Kaddish (the prayer for the dead) said for them, and on those who had died with their true selves hidden. It was there, at that erev Shabbat, that Gersh and I felt completely ourselves, completely embraced by thousands of years of Jewish tradition and worship. That weekend there were seminars, meetings, shmoosing (and cruising), another powerful shabbat service, and an overwhelming tour of Toronto's Holocaust museum. But the culmination for me was a final dinner, where our table of ten was laden with Yiddish speakers with whom I shared jokes and songs after we sang *Birkat HaMazon*, the grace after meals. My old world and my new world were united, joyously.

Since that time, we have attended World Congress meetings in London, San Francisco, Detroit, and Tel Aviv, appearing on the program in each city. Gersh is the foremost theorist and writer in the U.S. on the emotion of shame, and his workshops have dealt with the intersections of shame with both gay and Jewish identity. I have talked about coming out as a Jew and a gay man and claim-

ing both identities, and have read from my fiction. For both of us, these conferences have been an opportunity to give back to our community of lesbian and gay Jews, to offer what we know most deeply, by way of thanks, because we feel so nourished and connected.

Encouraged by Reform Judaism's efforts to make a place for lesbian and gay Jews, Gersh and I joined our local Reform synagogue as an openly gay couple. Three times now, I have led the synagogue's Holocaust Remembrance Day service. The second time, it was a service I had written and compiled which included homosexuals among the list of Nazi victims.

Gersh and I also belong to a Detroit-area gay and lesbian Jewish group called Simcha (joy), whose services we find far more meaningful than those at our Reform synagogue because they include lesbian and gay experience, and because the group is more intimate and friendly. Being there stills the longing for the closeness and warmth I first felt in the Orthodox minyan (even though I have never been by any stretch of the imagination an "Orthodox Jew"). Gersh and I are integral parts of Simcha, and our closest Jewish friends are there. It's in our involvement with this group and other gay Jewish groups around the country that I feel most committedly Jewish. My extensive reading tour after *Dancing on Tisha B'Av* was published concentrated as much on gay Jewish groups as bookstores, because I felt this was my primary audience.

I have seen that my work is helping encourage other Jewish gay writers to combine both sides of their life in their writing. There's a rich body of work by Jewish lesbians, but far less writing by Jewish gay men; hopefully my work can contribute to the growth of the men's literature. This sense of mission is like what I felt in the late seventies when I contemplated teaching and writing about the Holocaust. But the present mission is based on a deeper and calmer vision. It's truly social action in the Jewish sense of *tikkun olam*, repairing the world.

I'm not remotely as observant as I was when I was attending the Orthodox minyan at Michigan State, and I do sometimes miss the sense of excitement and immersion in ritual I had then. But

I've also learned to accept the fluctuations in my own need to be involved in Jewish activities and rituals.

One of the most moving injunctions in the Torah is that "the stranger in your midst shall be as the native. For remember, once you were a stranger in the land of Egypt." This call is a central part of every Passover Seder. Alienated for so long from other Jews, deeply divided about my own homosexuality, I have felt myself twice strange: Jewish in the gay community, gay in the Jewish community. In each, different, lesser, ashamed. But living with and loving a Jewish man, exploring our Jewishness and gayness together, have made it possible for me to exceed what Evelyn Torton Beck has called "the limits of what was permitted to the marginal." Coming out as a Jew ultimately made it possible for me to come out as a gay man and then work at uniting the two identities. As Beck puts it so beautifully in *Nice Jewish Girls*, the "experience of being outside the bounds of society" as a Jew made me "more willing to acknowledge other ways in which [I stood] outside."

It was almost twenty years ago that I started exploring my Jewish past and wondering about a Jewish future. That search has been inevitably interwoven with coming out and finding love. In that dual journey, writing has been both a catalyst and a laboratory for change. Having just passed my seventeenth year as a published writer and my forty-first birthday, I feel the surprise and joy Lena does in *Light in August* when she says, "My, my. A body does get around."

Glossary

Transliterating the phrases into English from Hebrew or Yiddish creates many different spellings. Hebrew is pronounced in two different ways depending on whether the speaker is using an Ashkenasi (Northern European) or Sephardi (literally "Spanish") from Southern Europe, Northern Africa, or Arabic countires. The sephardic pronunciation is used in Israel and modern Hebrew. Yiddish is a combination of German, Hebrew, Aramaic, Polish, and other languages. We have chosen to leave the transliterations used by the individual authors and to include alternative spellings for some of these words. These definitions are offered to enhance the enjoyment of the essays and should not be considered complete. Two sources for more complete information and definitions are *The JPS Dictionary of Jewish Words*, Eisenberg and Scolnic (Jewish Publication Society, 2001), and *The Joys of Yiddish*, Rosten (McGraw-Hill, 1968).

bar mitzvah—literally son of the commandment. A coming of age ceremony, traditionally at age thirteen, when a boy is responsible for his own religious obligations.

beshert / besherit—fate, destiny.

boychick—affectionate term for boy; can also be used in a sarcastic or critical way.

charoset / haroset—a mixture of apples, sweet red wine, and nuts that is placed on a seder plate, said to represent the mortar and bricks to build the pyramids when we were slaves in Egypt.

daven / davening—ritual bending of the knees during prayer that causes the body to sway backward and forward.

dreck / drech—literally excrement. Vulgar expression for something awful.

fagellas / faygelah (and sometimes feygellah)—literally little bird, used in American-Jewish vernacular for homosexual.

feh!—exclamation of disgust or ridicule.

frum—pious or devout.

gabbai—layperson at the synagogue who is reponsible for keeping ritual order.

goyim—non-Jews.

haggadah—literally "telling," it refers to the booklet used at a passover seder. It contains prayers, blessings, and the order for the ritual of the seder.

kaddish—prayer in Aramaic that praises God. Although it does not mention death it is used at the conclusion of a service as a mourner's prayer.

kayn anyhoreh / kineahora / kine-ahora—magical phrase to ward off the evil eye.

kibbutz—a type of agricultural commune in Israel.

kiddush—literally "sanctification," the prayer that sanctifies the sabbath and holy days. It is recited over wine.

kippah—another name for yarmulkah, the ceremonial head-covering worn by Jewish men to show respect for God when inside a temple, or in general for Orthodox Jews.

kol nidrei—Aramaic, legalistic prayer asking release from all vows made to God that cannot be kept. Also the name of the synagogue service on erev Yom Kippur.

kvell—swell with pride and pleasure, usually over the doings of a child or grandchild.

lehn—read.

lomed vuvnick / lamed vavnik—the 36 ordinary people who are so pure of heart that God does not again destroy the world with flood or fire or so forth. Because no one knows who these 36 are, one is taught to be kind and offer hospitality to all people, in case they are one of the lomed vuvnick.

mezuzah—a small tube containing a scroll with the shema placed on the doorframe of all Jewish households to consecrate the house. Some say it is to commemorate the escape of the Jews from Egypt and the Angel of Death's passing over the homes of the Israelites during the 10th plague.

mikvah/mikveh—ritual bath.

minyan—the minimum number of adult males (10) necessary to maintain a temple and for congregational prayers.

Mishnah—part of the Talmud. The codified core of the oral law.

mohel / moel—man who circumcises the male baby on the eighth day in the ritual of brit milah.

nachas / naches—special joy particularly in the achievements of one's children.

pisk—literally "mouth"; slang for loudmouth.

punim—face.

savta—grandmother.

seder—literally "order"; a ceremonial dinner for Pesach (Passover).

shabbos / shabbat—the seventh day; from sundown Friday night to sundown Saturday.

shalom—salutation meaning hello, good-bye, and peace.

sheggitz / shaygets—non-Jewish male, male form of shiksa.

sheyna—beautiful or handsome.

shiksa/shiksas—derrogatory term for a non-Jewish girl.

shul—temple or synagogue.

sidder—prayerbook.

Talmud—massive compilation of debates, dialogs, commentaries, and commentaries on commentaries interpreting the Torah.

tallis / tallit—prayer shawl. A traditional Jew receives a tallis at his bar mitzvah from his father, from his bride at his wedding, and is buried wearing a tallis.

tefillin—phylacteries. Two thin staps with a square black box on it containing passages from Exodus and Deuteronomy. Wrapped onto the arm in a ritual prescribed way by traditional Jews during morning prayers.

Torah—literally doctrine or law. The five books of Moses or (in English) Genesis, Exodus, Leviticus, Numbers, Deuteronomy.

treyf / trayf—any food that is not kosher.

yarmulkah / yarmulke—see *kippah.*

yiddishe punim—Jewish face.

Bios

David Bergman is a poet, cultural critic, and anthologist, whose books include the poetry volumes *Cracking the Code* and *Heroic Measures,* the non-fiction titles *Camp Grounds: Style and Homosexuality* and *Gaiety Transfigured,* and the anthologies *The Violet Quill Reader* and the *Men on Men* series, among others. With Joan Larkin, he is the series editor for the University of Wisconsin's *Living Out* series of gay and lesbian autobiographies. He lives in Baltimore, MD.

Gabriel Blau is the founder of "The God & Sexuality Conference," an annual academic conference on religion and issues of sexuality and gender. He has spoken in the U.S. and Israel to camp groups, yeshiva students, colleges, and graduate schools and at open lectures. His work as an activist has been covered by both the general and gay Israeli media. He is concluding his B.A. in Theology at Bard College.

David Ian Cavill is a graduate of the Jewish Theological Seminary's Joint Program with Columbia University and holds a Master's of Divinity from Yale University. His pastoral work has included general campus ministry, officiating in synagogues, and time spent as a chaplain with the Boy Scouts of America and campus leadership for the LGBT Jewish community.

Edward M. Cohen's stories have appeared in *Harrington Gay Men's Fiction Quarterly, James White Review, Evergreen Chronicles, Christopher Street, Carleton Miscellany, Evergreen Review, Stories, Confrontation,* and *Nuvein Online.* His novel, *$250,000,* was published by Putnam and his non-fiction books by Prentice-Hall, Limelight Editions, SUNY Press, and Prima.

Rabbi Steve Greenberg is a Senior Teaching Fellow at CLAL—The National Jewish Center for Learning and Leadership. He received his B.A. in philosophy from Yeshiva University and his rabbinical ordination from Rabbi Isaac Elchanan Theological Semi-

nary. He is a graduate of the Jerusalem Fellows program, a two-year fellowship for senior Jewish educators from all over the world sponsored by the Mandel Institute. While in Jerusalem, he was on the curriculum development team of KOLOT, a new organization that empowers Israeli economic, political, educational, and cultural leaders to meet the challenges of contemporary Israeli society. He also serves as the educational advisor of the Jerusalem Open House, Jerusalem's first gay and lesbian community center advancing the cause of social tolerance in the Holy City. Currently, he is helping to carry *Trembling Before G-d*, a powerful documentary about the struggles of gay Orthodox Jews, across the U.S. in an outreach project to open hearts and minds and begin community dialogues on the issues of faith, tradition, and homosexuality.

Daniel M. Jaffe's gay-Jewish-themed novel, *The Limits of Pleasure*, was published last fall by Harrington Park Press. He is the editor of *With Signs and Wonders: An International Anthology of Jewish Fabulist Fiction* (Invisible Cities Press, 2001), and the translator of the Russian-Israeli novel, *Here Comes the Messiah!* by Dina Rubina (Zephyr Press, 2000).

Arnie Kantrowitz was vice president of the Gay Activists Alliance and a founder of the Gay and Lesbian Alliance Against Defamation. He is the author of *Under the Rainbow: Growing Up Gay*, as well as of a biography of Walt Whitman. He lives in New York City with his long-time partner, doctor and author Lawrence D. Mass.

Gabriel Lampert was born and raised in Philadelphia and has lived in the Southwest for most of the past thirty years. He teaches mathematics and sometimes Jewish Literature at New Mexico State University, where he completed a master's degree in creative writing in 1993.

Andrew Martin has been in Los Angeles for almost a year after living in the Caribbean and New York City. He is a graduate of Tulane University in New Orleans. This is the first piece of his writing he has submitted to be published.

Jesse G. Monteagudo is a freelance writer who lives in South Florida with his domestic partner of more than 16 years. His bi-weekly columns, "The Book Nook" and "Jesse's Journal," appear in a dozen print and online publications. Monteagudo has also contributed to more than a score of fiction and nonfiction anthologies, and is now working on a collection of his own non-fiction work. A gay activist since 1976, Monteagudo received a Stonewall Award in 1994 for his contributions to his hometown and a Stars of the Rainbow Award in 1997 for his achievements in the fields of lesbian and gay media and publications.

Julian Padilla is a high school student living in the Southwestern United States. He likes Dali's art, the Sublime's music, and the book *A Clockwork Orange*. His favorite movie is *Requiem for a Dream*. He is fifteen years old.

Lev Raphael is the award-wining author of *Dancing on Tisha B'av* (St. Martin's Press), *Winter Eyes* (St. Martin's Press), *Let's Get Criminal* (St. Martin's Press), *The Edith Wharton Murders* (St. Martin's Press), and other works of fiction, as well as the essay collection *Journeys & Arrivals* (Faber & Faber).

Andrew Ramer is the co-author of the international bestseller *Ask Your Angels* (Ballantine Books) and the author of the Lambda Literary Award finalist *Two Flutes Playing: A Spiritual Journeybook for Gay Men* (Alamo Square Press). His writings have appeared in various anthologies, including *Kosher Meat* (Sherman Asher) and the *Best Gay Erotica* series (Cleis Press). He lives in the San Francisco Bay Area.

Philip Ritari was born in Ohio and has lived in the Boston area for twenty-five years. He studied medieval literature at Harvard and has since mutated professionally into a librarian, a Hebrew calligrapher and Jewish artist, and a software engineer. He also writes poetry and exhibits his digital photography and artwork in the New England area. He lives with his partner, his son, an iguana, and a hedgehog in the Boston area.

David Rosen is Editor-in-Chief of InsightOutBooks and long-time editor of the Quality Paperback Book (QPB) Club. His writing has appeared in *The Advocate, The Lambda Book Report, The Wallace Stevens Journal, Qualiteria,* and the *QPB Calendar of Days,* among other publications. He is the series editor of Triangle Classics and has been the recipient of The 2001 Lambda Literary Pioneer Award and the GLAAD Media Award. He is working on a memoir about growing up in Buffalo.

Jonathan Wald has written and directed four short films which have played at festivals around the world, and produced a short film which won a student Academy Award. His writings have appeared in the anthologies *Kosher Meat, Ells S'estimen: Poemes D'amour Entre Hommes* and *The Badboy Book of Erotic Poetry.* He is currently a graduate student receiving his MFA in film directing from UCLA film school, and he recently received a Fulbright Grant to study filmmaking in Sydney, Australia.

About the Editor

Lawrence Schimel is an award-winning author and anthologist, who has published over 50 books in numerous genres, including *His Tongue* (North Atlantic Press), *The Drag Queen of Elfland* (Circlet Press), *The Mammoth Book of Gay Erotica* (Carroll & Graf), and *Switch Hitters: Lesbians Write Gay Male Erotica and Gay Men Write Lesbian Erotica* (with Carol Queen; Cleis Press), among others. He has published one previous title about gay Jews, *Kosher Meat* (Sherman Asher), which was a finalist for the Lambda Literary Award and the ForeWord book of the Year Award. His anthology *Pomosexuals: Challenging Assumptions About Gender And Sexuality* (with Carol Queen; Cleis Press) won a Lambda Literary Award in 1998. His work has been anthologized in over 150 collections, including *The Practice of Peace, XY Files, Best Gay Erotica 1997 and 1998, The Mammoth Book of Best New Erotica 2002, The Random House Book of Science Fiction Stories, Gay Love Poetry, Nice Jewish Girls,* and *The Random House Treasury of Light Verse.* His writings have been published in Basque, Catalan, Czech, Dutch, Esperanto, Finnish, French, Galician, German, Italian, Japanese, Polish, Portuguese, Russian, Slovak, Spanish, and Swedish translations. His web site is http://www.circlet.com/schimel.html. He currently lives in Madrid, Spain, and in his native New York City.

About the Press

Sherman Asher Publishing is an independent literary press publishing fine poetry, memoir, fiction, Judaica, books on writing, and other books we love since 1994. We publish both regional and international voices that engage us and deserve a wider audience. We are dedicated to "Changing the World One Book at a time."™ Visit our web site at www.shermanasher.com to order our titles.